Bringing Forth the New

Bringing Forth the New

Visual Art and the World of Contemporary China

Michael Maizels

BLOOMSBURY ACADEMIC
LONDON • NEW YORK • OXFORD • NEW DELHI • SYDNEY

BLOOMSBURY ACADEMIC
Bloomsbury Publishing Plc
50 Bedford Square, London, WC1B 3DP, UK
1385 Broadway, New York, NY 10018, USA
29 Earlsfort Terrace, Dublin 2, Ireland

BLOOMSBURY, BLOOMSBURY ACADEMIC and the Diana logo
are trademarks of Bloomsbury Publishing Plc

First published in Great Britain 2024

Copyright © Michael Maizels, 2024

Michael Maizels has asserted his right under the Copyright, Designs
and Patents Act, 1988, to be identified as Author of this work.

For legal purposes the Acknowledgements on pp. ix–x constitute an
extension of this copyright page.

Cover design by Grace Ridge
Cover image © Survival Robot, David Teng Olsen 2019
Image courtesy of the artist.

All rights reserved. No part of this publication may be reproduced or transmitted
in any form or by any means, electronic or mechanical, including photocopying,
recording, or any information storage or retrieval system, without prior
permission in writing from the publishers.

Bloomsbury Publishing Plc does not have any control over, or responsibility for,
any third-party websites referred to or in this book. All internet addresses given
in this book were correct at the time of going to press. The author and publisher
regret any inconvenience caused if addresses have changed or sites have ceased
to exist, but can accept no responsibility for any such changes.

A catalogue record for this book is available from the British Library.

Library of Congress Cataloging-in-Publication Data
Names: Maizels, Michael, 1983- author.
Title: Bringing forth the new : visual art and the world of
contemporary China / Michael Maizels.
Description: London ; New York : Bloomsbury Academic, 2023. |
Includes bibliographical references and index.
Identifiers: LCCN 2023011124 (print) | LCCN 2023011125 (ebook) |
ISBN 9781350341579 (paperback) | ISBN 9781350341586 (hardback) |
ISBN 9781350341593 (epub) | ISBN 9781350341609 (adobe pdf) |
ISBN 9781350341616
Subjects: LCSH: Art and society–China–History–21st century.
Classification: LCC N72.S6 M27 2023 (print) | LCC N72.S6 (ebook) |
DDC 700.1/03–dc23/eng/20230825
LC record available at https://lccn.loc.gov/2023011124
LC ebook record available at https://lccn.loc.gov/2023011125

ISBN:	HB:	978-1-3503-4158-6
	PB:	978-1-3503-4157-9
	ePDF:	978-1-3503-4160-9
	eBook:	978-1-3503-4159-3

Typeset by Integra Software Services Pvt. Ltd.
Printed and bound in Great Britain

To find out more about our authors and books visit www.bloomsbury.com
and sign up for our newsletters.

To Jack
Never forget, a huge vista may open behind the smallest crack in a wall

Contents

List of Illustrations	viii
Acknowledgements	ix
Introduction	1
1 Our Own Arrows	8
2 One Way Glass	34
3 Half of Heaven	62
4 Beyond the Outer Edge	94
5 Degrees of Separation	124
6 Muted Situations	150
7 Survival Robot	176
Notes	196
Further Reading	231
Index	233

Illustrations

Cover – *Survival Robot* by David Teng Olsen, 2019
C.1 *Mao Tse Tung* by Andy Warhol, 1972 8
C.1 *Untitled (Mao Marilyn)* by Yu Youhan, 1994 8
1.1 *Yuanmingyuan: Rebirth* by Huang Rui, 1979 23
1.2 *Borrowing Your Enemy's Arrows* by Cai Guo-Qiang, 1998 31
C.2 *Overture* by Hu Jieming, 2014 34
2.1 *Witness and Game* (Installation shot) by Hu Jieming, 1994 49
2.2 *Accompany with TV* by Hu Jieming, 1996 54
C.3 *Angel #3* by Cui Xiuwen, 2006 62
3.1 *Ladies' Room* by Cui Xiuwen, 2000 84
3.2 *Existential Emptiness* by Cui Xiuwen, 2009 91
C.4 *Civilization Landscape* by Qin Feng, 2004 94
C.5 *Il Silenzio, 1962* by Hsiao Chin, 1962 124
5.1 *Pintura #AO* by Hsiao Chin, 1950 145
C.6 *Muted Situations #22* by Samson Young, 2018 150
6.1 *Possible Music #2* by Samson Young, 2019 167
6.2 *The World Falls Apart Into Facts* by Samson Young,
 2019/2020 172
C.7 *Survival Robot* by David Teng Olsen, 2019 176

Acknowledgements

The impetus for the volume emerged from the author's simple embarrassment. When teaching the global history of contemporary art, I felt woefully unprepared to answer substantive questions about non-Western cultural and political contexts surrounding the objects we studied. This embarrassment was felt most acutely on questions of Chinese material. The Chinese art world, and the nexus of politics, culture, and technology that produced it, was evidently one of the most important development in my own century. And yet I found myself reverting to staid tropes about originality and derivativeness, post-coloniality and Otherhood without any sense I had uncovered much of any explanatory value.

And while the intellectual embarrassment was my own, my efforts to rectify in writing this book would never have borne without the guidance of friends and mentors. Numerous colleagues spent the better part of four years introducing me to the Chinese language, artists of many different aesthetic orientations, and a fascinating, nearly endless ocean of history. Special thanks are due to Adam Au, who acted as an interpreter and editor for many of the following chapters, as well as Eli Klein and Ethan Cohen, who graciously shared the work of their stable and the breadth of their contacts to ensure that *Bringing Forth the New* could appear in its best form. I wish to thank Alex Rehding for sharing a previously published essay as the crux of a new chapter on the artist Samson Young. My deepest gratitude is due to David Teng Olsen, who has been a cherished mentor to me since my days as a postdoctoral curator at Wellesley College. It was from David's art practice and personal network that this book initially grew, and writing it would simply not have been possible without him.

Importantly, I am also grateful to Sy Chan and the rest of the Sumeria Labs group, who have permitted me to continue "bringing forth the new" across the East and West divide as an entrepreneur as well.

And finally, thanks are due as always to my family and my wife Elizabeth, without whom nothing I do would be possible, nor worthwhile.

Introduction

A Center Not Our Own

To an historian of recent art from the West, Chinese contemporary art appears a fascinating, strange terrain. The world is at once brand new and yet already massive—recently canonized international masters and ascendant collector-powerbrokers (many of whom are under 40 years old) are reshaping the world of artistic practice in real time. In the last two decades, waves of museum retrospectives for artists such as Ai Weiwei, Xu Bing, and Cai Guo-Qiang have introduced these figures to Western audiences, while thousands of homegrown contemporary exhibition spaces, many designed by international star architects, proliferate throughout China. Chinese work now accounts for approximately 20 percent of the global contemporary art market, up from less than 1 percent in 2000.

The histories called upon by this work are familiar to those with Western backgrounds, but the way in which these touchstones are reassembled can be strikingly bizarre. The current explosion of experimental work can be traced back to the early 1980s, a period in which greater contact with the West and increased cultural freedom encouraged artists to strike into bold new directions. But any art world that learned about Robert Rauschenberg and Henri Matisse at virtually the same time was bound to produce surprises. These surprises are made all the stranger because even when the pieces are recognizable—as in the borrowings of Political Pop—the interventions intended by the work emerge from a sociopolitical psyche the

outlines of which may be radically unfamiliar. These outlines trace from truly ancient foundations to more recent moments of colonial confrontation and Communist self-rule. When the bourgeoisie has already been officially vanquished, the structuring narrative of the Western avant-garde quickly loses its center of gravity.

Significantly, the dynamics at play in the particular realm of the art world generalize into the larger domains of international politics and emergent technology. Consider the following remarkable statistic. During the same decade in which Chinese artists were first exposed to Western contemporary art, Chinese consumers were first provided access to television. The growth was so staggering that, over the course of the 1980s, one in seven of the world's inhabitants became a television-watching citizen of the People's Republic (see "One Way Glass" in the present volume). Change in the realms of both art and technology is accelerating from even this harrowing pace; as China begins to dominate the world's mobile payment space, artists and entrepreneurs are reimaging the possibilities of a world lived in and through the unblinking eye of the screen. A terrifying glimpse of this imagined reality unfolded in March of 2020, as the rampaging COVID-19 virus confined hundreds of millions of citizens to their homes. The screen became the last narrow portal to what remained of the outside.

"Bringing forth the new" happens at runaway velocity, and with pieces of the past that may be marked by total unfamiliarity. The title phrase is drawn from a pivotal moment in the recent history of China, a speech given to the National Congress of Artists and Writers by Premier Deng Xiaoping shortly after the death of Chairman Mao. Hoping to build consensus for a reformist vision, Deng exhorted his nation's cultural works to bolster its People as the Party prepared to rejoin the global economy. Paraphrasing Mao, Deng emphasized that all laborers, cultural workers and Party leaders alike, were responsible for "weeding through the old to bring forth the new."

But a more sharply articulated vision lurked just behind. Ushering in the future would entail, as he put it, "making the past serve the present and foreign things serve China." This construct of China as the leading vector of world history is difficult for many Westerners to comprehend. It cuts against our own Hegelian sense of destiny, and gives rise to a curious phenomenon in which developmental artifacts from China form a kind of uncanny reflection of our own objects and processes. Inversions that feel out of place as well as out of time. Or as, Vladimir Nabakov put it, expressing a strangeness no amount of research could foresee.

The contents of this volume have been arranged to illuminate the facets of political or technological history with the greatest importance to China and the most underdeveloped understanding in the West. Key examples include the radically different development of axiomatic rights like privacy and political autonomy as well as the simmering conflicts in Taiwan and Hong Kong. Such examples bear out narratives about the shape of the world that are intertwined but nevertheless fundamentally incommensurate. The goal is to induce deep-seated perspective shifts as well as the occasional stomach-drop of historical vertigo.

To briefly expound on one such case study, as of this writing in March 2022, China and the US were both pursuing landmark cases of sedition. And yet, the trials of Hong Kong activist Tam Tak-Chi and the prosecution of the January 6th insurrections could not be proceeding more differently. In the US, less than half of those charged in connection with a destructive rampage inside the halls of power received jail time, and those sentences were often shorter than Tam Tak-Chi's imprisonment while simply awaiting trial. For the crime of leading an anti-government chant in a public park, he was recently convicted on eleven charges including that of uttering seditious words. He is currently awaiting what will surely be a harsh sentence. Correlate, contemporaneous challenges to authority, met with what

each government considers to be strong rule of law protections. And producing results that are worlds apart.

Although these ends may be estranged (which was the motivating factor for the writing), each chapter opens from a comparatively familiar analysis of the work of an individual artist. Visual art is a privileged medium here—its experimental nature and broad circulation through the arteries of international fairs, galleries, and magazines renders it an ideal testing ground for worlds that figure each other over vast distances of culture and history. Hsiao Chin's work provides a lens through which to see the non-Western development of abstract painting, as well as an Asia-centric view of the political reversals taken on during the early Cold War. Cui Xiuwen's work illuminates the conflicted, intersectional relationship between Chinese "self-strengthening" and advocacy for women's rights. David Teng Olsen's *Survival Robot* and Hu Jieming's *Overture* attest to starkly different configurations for technology, surveillance, and freedom.

It should be noted that my selection of case studies is somewhat arbitrary. While the governing criterion was a trade-off between importance to China and ignorance outside, other thematic topics could certainly have been chosen. There is little about environmental issues or Party corruption. Generational breakage, between children of the Maoist era who became parents during the One Child Policy and who have seen their offspring leap into Western-style consumption, is addressed indirectly. Moreover, the selected could have been represented by other artists—Zhang Dali on the cityscape, Wang Guangyi on the import economy, Cao Fei on issues of gender, technology, and visibility. Many additional case studies could be written, and it is my hope here to inspire other researchers, many of whom may share my lack of formal training on Chinese material, to probe additional lines of inquiry.

It must also be acknowledged that I am far from the first author to orchestrate a selection of single-theme essays designed to detach

readers from a Western-centric worldview and better come to grips with a Chinese one. Among the best, most recent examples of this genre is Hua Yu's *China in Ten Words* (2012), and many of the chapters in my own book touch on similar domains. Hua's "Copycat" attends to the rise of *shanzhai* culture that is also explored in this volume's first essay, while "Grassroots" explores concepts of community that are central to its last. Unlike Hua's, however, this volume was not drawn from an autobiographical perspective but was rather produced as part of a long (and problematic) tradition of explications of an Eastern world produced by Westerners primarily for Western audiences. A litany would go from Marco Polo to Henry Kissinger to (within the art world) Barbara Pollack's *Brand New Art From China*. The essential point here is simply to note the position of the privileged travelogue clearly enough to hold it at arm's length. Or maybe permit it to get a glimpse of itself in the mirror.

Finally, a word on the methodology of leading from the visual arts out onto the domains of markets, politics, and technologies is appropriate here. I certainly do not mean to fall into the trap of reading artworks as a facile expression or illustration of a social or economic context. Rather, I am to consider them as subjects of analysis embedded within what the great art historian Irwin Panofsky called "symbolic form"—a mode of depiction that both produces, and is produced by, the swirling of deep, world-historical changes. The significance of Yu Youhan's tightly derivative Warholian works is not simply to demonstrate a differing attitude towards originality. Rather, works such as *Mao Marilyn* are chosen to illustrate a broad-based attempt to appropriate Western innovations, repurpose their most essential components, and then reassemble them into configurations for ends which have little to do with their original context. China's larger relationship with the Far West must on some level be understood through this axis of civilization depreciating by distance from the seat of what historically was known as the Middle Kingdom. As in Middle of World.

This recentering is captured elegantly by many of the artworks analyzed in this volume, but perhaps none more so than David Teng Olsen's *Survival Robot*, a detail of which is reproduced on the cover. The work draws on stitching from recently unearthed Han dynasty funerary armor as well as modern 3D printing techniques to envision a Bitcoin-mining grave soldier who will secure the wealth of generations to come. This book aims to sail into the dust storm of Teng Olsen's future—to dive headlong into the disintegration of recomposition of art, money, power, and history in real time. Predicting the precise configuration of the future is a far subtler, if not impossible exercise. To adapt another iconic phrase from Premier Deng, "it is still too early to tell."

1
我们自己的箭

Our Own Arrows

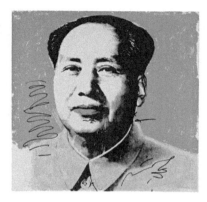

Mao Tse Tung by Andy Warhol, 1972. Image courtesy of ARS.

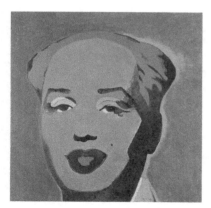

Untitled (Mao Marilyn) by Yu Youhan, 1994. Image courtesy of the M+ Museum.

At a Glance

The question of artistic originality between the US and China is framed as a microcosm for East/West geostrategic trade conflicts with deep historical roots. Namely, the ascription of "mere imitation" to early 90s Chinese artists such as Yu Youhan, Wang Guangyi and Qi Zhilong exemplifies a longstanding European attitude towards the Oriental Other as a mere copyist. This pervasive bias has distorted Western understanding of Chinese intentions not just over artistic ideas but also over trade and manufacturing policies. Key among these policies are the hotly contested joint venture arrangements that have led to pervasive diffusion of Western technologies into the Chinese economy. As the essay below argues, the larger purpose of both sets of borrowing—occurring at the level of artistic experimentation and technological innovation—is not simply to copy. Rather, the ethos is predicated on the necessity to appropriate outside ideas in order to repurpose them for internal aims. This is the meaning of "borrowing your enemy's arrows," a strategy that yields a double vision in the West as we see our own exported assets pointed back towards us.

When it first started appearing in international Biennales and dedicated survey exhibitions in New York, it was difficult to know what to make of "Political Pop," an idiom exemplified by Yu Youhan's *Mao Marilyn* (1994) illustrated at the front of this chapter. An uneasy admixture of East and West, of earnest politics and glib entertainment, of heteronormative authoritarianism and queer détournement. Critics recorded that Western audiences were gratified to witness the flourishing of work they read as direct, anti-government provocation.[1] A thumb in the eye of tyranny, delivered with a Warholian flourish. There seemed no way that artists could be so willful with the cherished image of Chairman Mao, which as of this writing still dominates every denomination of RMB, without intending to strike a blow against the hegemony of the Party.

Indeed, Americans in particular were primed for such sympathies. They had recoiled in horror at the brutal Tiananmen crackdown, and were in the midst of a very public grappling with their own complicity, through the neoliberal expansion of trade and a wash of stories about appalling "sweat shop" labor in such exploitation. What a relief to see an endogenous assertion of individual rights—of anti-government speech, of artistic abstraction—in the face of contemporary despotism.

But the critics themselves were typically quick to impute this uncomplicated attitude into the mouths of others.[2] They, they assured their readers, knew better than to take things at face-value. They had, after all, become properly schooled in the constructed-ness of the postmodern. And they were keen to emphasize, as Holland Carter did, that stylized portraits of the Great Leader were not necessarily seditious. Rather, they bore out "the general popular attitude toward Mao in China: critical but … also deeply nostalgic."[3] Perhaps.

Or perhaps all these Maos had more to do with confirmation bias on the part of Western observers. As numerous historians have since observed, the ascendance of Political Pop was in large part authored by its enthusiastic reception amongst international audiences and

collectors.⁴ Brightly colored, figural canvases steeped in explicit homage to a Western icon like Warhol are beloved by introductory textbook compilers and emergent collectors alike. And Pop Politicos had the double benefit of implicitly appealing to a pernicious Orientalist mindset on the part of their viewers, one that would limit Chinese artistic exploration to a clumsy reprise of American innovations.⁵ An MTV-era expression of Hegel's dictum that "China [is] characterized by a thoroughly unimaginative Understanding."⁶

But perhaps a whole other game was afoot. Some of the earliest critical reception of Chinese contemporary art focused on its inherent incommensurability with outside histories. "The acts of defiance of the Chinese avant-garde" wrote critic Andrew Solomon in 1993, "function very legitimately within their system, but are not designed to be interpreted within ours."⁷ Fair enough. But the moves seemed so easily recognizable. A scoop of Warhol-Lichtenstein-Rauschenberg-style citation of mass mediated imagery. A helping of Neo Expressionist idiomatic painting. A dollop of Duchamp. Combine with relevant Chinese content: the oppressively ubiquitous portraits of Mao, the faceless masses of the Chinese people, the sacredness and artistry of the written word. Bake. And there you have perfectly done Political Pop, Cynical Realism, Xiamin Dada ...

Art and Industry, the R&D Division

The emergence of Chinese art on the world stage in the 1990s was in fact a localized shadow cast by much larger developments. In the late 1970s, with the traumas of the Cultural Revolution still open wounds, the Communist Party of China struggled to point their country in a different direction. Key to this reorientation, which came to be known as "Socialism with Chinese Characteristics," was a program of far-reaching economic liberalization.⁸ Progress was steady, and then

stunning. Over the 1980s GDP doubled, and it was in these heady days that contemporary art first emerged as a cultural and aesthetic phenomenon within China. In the following two decades, roughly encompassing the interlude between the first dotcom bubble and the Great Recession, Chinese GDP grew by an astonishing factor of more than 1,000 percent.[9] It was during this latter period that Chinese art broke out onto the world scene. A moment in which the post-Tiananmen crackdown made political reform impossible to pursue but staggering economic change made cultural stasis impossible to imagine. As described by Li Xianting, the critic who coined the term, the citation-heavy art of Political Pop, "portrays the reality of dissolved meanings."[10] A world with feet on opposite sides of a chasm growing wider every day.

In this brave new world, art was far from the only valuable export in a Kingdom that found itself, all of a sudden, back in the Middle. China became an international manufacturing powerhouse, with the total value of its exports skyrocketing from $25 billion in 1984 to nearly $400 billion in 2003.[11] Today, it ships out well over $100 billion worth of goods *every month*.[12] While geopolitical strategy and local-political chaos each played a part in this incredible growth, China's rapid ascendance as a manufacturing colossus would not have been possible without the worldwide explosion of high technology consumer goods. The story of the last two decades the world over has been one of unprecedented rapid technological adoption. First, it was a computer in every home and then a laptop for every child. Next came a smartphone (or smart watch) for every pocket, an E Reader for every nook, and a drone for every sky. Soon, IoT apologists promise a smart speaker on every sparkling quartz countertop, a smart fridge refilling the contents of its fruit bowls, and a smart thermostat ensuring we never endure a moment of discomfort from ill-regulated temperature. And every year, more and more of these specialized labor crystals are shipped from the ports of Shenzhen.

Back to 1979. In the earliest days of its market reforms, the CCP decided to insist on a negotiating a concession from foreign businesses seeking access to its uniquely massive, and uniquely motivated, labor market. With the legacy of distorted trade agreements forced on the weakened Qing Empire still haunting the political psyche of China, Party leaders knew they needed to protect their market-based experiments from a deluge of foreign interference. Sure, they recognized that massive external investment would be needed to modernize the economy. But this investment would come with a catch. Foreigners wishing to conduct business in China were required to do so only through a Chinese-owned partner or intermediary. American companies could manufacture anything they wanted in Chinese factories, but they couldn't own the factories that did the manufacturing.[13]

These joint venture arrangements rapidly accelerated the transfer of intellectual capital—from quotidian best managerial practices to extremely valuable, patented technologies—from the West to China. Copycats proliferated, most notoriously in fashion. "Tribute brands" grabbed valuable market share from Paris-based luxury designers, while other "unbranded" labels generated lookalike *haute couture* out of the same factories. Literally cut from the same cloth.[14] Similar spates of imitation cropped up in every imaginable sector, and many humorous near-misses are preserved in endless online lists. The Sony Polystation, the BlueBerry smartphone, and the iPohone. A group of enterprising entrepreneurs in the southwestern city of Kunming opened an ersatz Apple store selling either real or fake iPads. It was difficult to tell.[15] This idiom of *shanzhai*, a Cantonese slang term for such off-the-books imitation, lurks not far below the surface in the reception of Chinese contemporary art.[16] A bit of a borrowing, a twist of Rosenquist. Yu Youhan, an almost Andy.

The aesthetic and economic halves of this story hang together with striking, if implicit, symmetry. Consider the rhymes between Steve

Jobs and Andy Warhol, both thinking differently in their distinctive black turtlenecks. The story of bold artistic experiment becomes the tale of visionary commercial innovation. As Tom Crow reminds us, "the avant-garde serves as a kind of research and development arm of the culture industry."[17] Or maybe it fills R&D needs for all industry, not just the merely cultural. And seen in the converse, *shanzhai* is constructed as the negative of avant-garde experimentation, as inimical to research. It is the sterile, simulated soil in which genuine innovation can never flourish.[18] A contemporary, Silicon Valley-centric adaptation of Enlightenment (and even medieval) ideas about the limited capabilities—linguistic, cultural, genetic—of the Oriental imagination.

And it is here that the intertwined nature of all of this becomes extremely interesting, and extremely important. Recent developments have made clear that the ultimate purpose (which may have even been the original aim) of the Chinese joint venture company model was not simply to nibble away at the edges of foreign competition. Rather, local Chinese partners have been collaborating with outsourcers so as to eventually replace them outright, first in China and then on the world stage. Irritating imitators are fast becoming existential enemies. This process is in fact well under way in the art world. While Warhol and Friends still set high water marks on the well-heeled international auction circuit, it is China that is home to most of the world's new museums, and most of its new billionaire collectors.[19] And many of them are choosing to shop ever more locally. Back to the technology world, internet companies like TaoBao and Xiaomi, which began their lives as exacting imitations of eBay and Apple, have matured into global threats to their original models. Moreover, this C2C (copy to China) model is obsolescing; the super-app WeChat is currently locked in a struggle for international dominance in both the social media and mobile payment spaces *with the same product*. And, technologists warn us, the scales are poised to tip, and then freefall,

onto the other balance. The unique parameters of the forthcoming AI revolution—which some have likened to the commercialization of electricity—are nearly all arrayed in China's favor.[20]

What we are witnessing is, perhaps, the tectonic shift of historical gravity from the West to China. Perhaps. As Zhou Enlai famously remarked, it is too early to tell.[21]

Dàqín in the *Longue Durée*

Like many things China, the history of technology transfer and cultural interface is startlingly long. Ambassadors arrived from Ancient Rome, and later, Byzantium, bearing gifts of both local and international origin.[22] Ideas about China percolated back to the West, bearing the imprint of prior paradigms. The Imperial splendor of the East was easy to map onto the curious mixture of attitudes the Greeks felt for those paradigmatic Easterners, the Persians. You could marvel at the scale of the Imperial achievements while ruing the system that had ground such splendor out of its endless sea of peasants. The particular millennial-old paradigm of a society with a massive, semi-skilled manufacturing workforce. And like the Persians, you could definitely dismiss the Far Easterner as decadent; corrupted by luxury and disinclined to put considered reason before instinct. The weather, it was assumed, must play a role.[23]

Contact intensified as European political infrastructure rebuilt itself during in the Middle Ages. Based in part on an apocryphal tale about an Eastern Messiah named Prester John, the thirteenth-century French king Philip the Fair forged a short-lived military alliance with Mongols.[24] Marco Polo famously brought back pasta. The Silk Road continued to shuttle people, goods, and ideas between the largely self-contained worlds of Western Europe and East Asia. In the sixteenth century, the dynamic shifted. The Europeans, and

particularly the Portuguese, had been growing bolder in their self-conception as an international trading powerhouse. These new sea powers began adapting inventions with Asian origins, including the magnetic compass and the tanja sail (which improves upwind travel), discovering that they could obviate the slow and dangerous process of shipping goods long distances over land.[25] And "discovering" much else along the way.

Up until this point, the Chinese did not take a significant interest in matters of Occidental origin. China's own term for its national or Imperial polity since around 1000 BCE has been *zhongguo*, a term typically translated as Middle Kingdom but perhaps more aptly understood as "Center State," with a marked implication of depreciating civilization radiating outward. The ancient Chinese word for the Roman Empire, *dàqín*, simply meant "Greater China" and was probably meant to indicate the settlements in and around Syria rather than the Apennines.[26] Not that it made much difference; the Imperial Courts had never given much regard to the grubby business of "barbarian management" at the periphery.[27] As late as the end of the eighteenth century, China was officially disinterested in the innovations of the West. The Qianlong Emperor famously rebuffed an entreaty from the British King George III, who had been seeking a direct trade agreement to counter the entrenched Portuguese monopoly. In a well-known 1793 letter, the Emperor dismissively informed the distant king that China had no need for British goods, or other "manufactures of outside barbarians," because "Our Celestial Empire possesses all things in prolific abundance."[28] This was painful news for the Brits, whose consumers already had a voracious appetite for Chinese exports. Given long enough, this commercial asymmetry and military miscalculation was going to correct itself in a paroxysm of violence.

The Qing Emperors were occupied with their own problems, many of which they had inherited from the prior regime. The Qing had swept

into power in the mid-seventeenth century, riding a wave of peasant revolts that had been stimulated, indirectly, by the influx of European wealth into treaty ports like Portuguese Macau. The supply of silver, the coin in which peasants were expected to pay taxes, briefly spiked and then, for reasons beyond Chinese control (such as Japan's decision to close its ports to European commerce), quickly disappeared. While court scholars debated the ethical parameters of this new, mercurial effect, there was economic devastation among China's poorest subjects, particularly the ethnic Manchus living on the inhospitable steppes of Northern China. Combined with a climate-related famine, revolt was not long in coming.[29]

Though the Manchurian Qing toppled the Imperial capital at Beijing in 1645, Ming loyalism, spurred in part by ethnic resentment from the Han majority, was stubbornly difficult to extinguish. One loyalist general even ran a splinter state on the island of Taiwan for over twenty years; he had been bent on eventually wresting control of the mainland away from the usurpers (See "Degrees of Separation" in the present volume). It was internal threats like these that worried Imperial policymakers. The ignorant boorishness of the barbarians, who were continually stretching their treaty port arrangements and peddling their unwanted vices, did not rate as a national emergency. It was a matter of law enforcement, not territorial sovereignty, that led viceroy Lin Zexu, an Eliot Ness or Wyatt Earp-type figure, to raid suspected British traders in the treaty port of Canton. He came back trailed by endless chests of illegal opium. His haul, 2.5 million lbs of contraband, was more than a hundred times larger than any bust ever suffered by the *narcotraficantes*.[30]

But what began as a matter of border police and trade agreements escalated into full blown, albeit lopsided, military conflict. The first Opium War ended with profound national disgrace; the Treaty of Nanjing (1842) conceded chunks of sovereign territory to a foreign power and entailed the loss of China's control over its *own* trade policy.

It turned out to be the first in what became known as the "unequal treaties." But the associated phrase, the "century of humiliation" captures the national sentiment better.[31] It is these treaties that lurk in the *longue durée* backdrop of the weaponized joint venture arrangements from which China has recently reaped huge value. It must be with a certain ironic satisfaction that Chinese officials view the earnest sense of injury latent in Western rhetoric about the "unfair" nature of the joint venture system. As Von Clausewitz would have put it, "trade war is politics by other means."

Resetting the Balance: Middle Kingdom Between First and Second Worlds

Just over a hundred years after the Treaty of Nanjing, Mao Tse Tung climbed atop Beijing's Gate of Heavenly Peace to proclaim an end to the horrid Century.[32] In its earliest days, the new People's Republic leaned heavily on support from its Socialist benefactor, the USSR. But Sino-Soviet alliance turned out to be an unreliable partnership for both sides. The aid packages sent by the USSR, when examined in economic hindsight, look to some scholars more like exploitation than assistance. Allies bickered over strategic priorities and short-term tactics. Mistrust of motives proliferated, and rancorous public disputes about the meanings of Marxist doctrinal minutiae broke out between erstwhile Fellow Travelers. Each bitterly accused the other of cozying up to the West. In 1960, 70 percent of China's trade was with the USSR. One decade later, its trading partners were 80 percent non-Communist.[33]

But until the early 1970s, trade with the US was legally non-existent. Washington officially recognized the government of the Republic of China, fighting for survival from its island outpost on Taiwan, as the legitimate government of the whole mainland, and

had barred trade with People's Republic as an enemy combatant after the outbreak of the Korean war (See "Degrees of Separation" in the present volume). Important shifts occurred during the presidency of Richard Nixon. Most famously, Nixon's Secretary of State Henry Kissinger had worked in secret to establish the outlines of new diplomatic relations between Washington and the People's Republic. Nixon's resulting visit to Beijing drove what we would turn out to be a final wedge between the Chinese and Russian Communist parties. The year after the détente, but still locked in the teeth of the Cultural Revolution, China still managed to export more than half a billion dollars of goods to the US.[34]

Nixon's other fateful decision shifted the parameters of monetary rather than diplomatic policy. In the wake of World War II, the US had seized the opportunity to make the dollar into the de facto international currency by agreeing to back every foreign-held dollar by a specified amount of gold on deposit in the US. Instantly, a wildly fluctuating post-war currency, the Deutsche Mark for example, could be fixed at a certain value *on the dollar*, which, by extension, was backed by the international standard of gold. But, by the 1970s, the financial rationale of the Bretton Woods Agreement began to disintegrate. The aims had been achieved, but its costs persisted. While domestically, a strong dollar exacerbated the labor market suffering created by the waning of the post-war recovery, Bretton Woods made the US vulnerable to extortion by foreign governments, who could easily threaten a run on American gold reserves. Seeing the writing on the wall, in 1973, Nixon severed the last remaining connection between the supplies of US Dollars and gold bullion, and thereby accelerated changes already underway in the new economic and political order. Importantly for our story, a floating exchange rate had the potential to widen monetary gaps between economies in different developmental stages—gaps that made it increasingly cost effective to manufacture things overseas and then import them into domestic consumer markets.[35]

With these macroeconomic trends playing out in the deep background, change was sweeping China. In 1978, an ascendant reformer named Deng Xiaoping was emerging victorious from an interparty struggle to control the future of China after Mao's death. He used his annual address to the Central Committee to offer a rebuke of the orthodoxies that had blinded Party government. Borrowing a Han Dynasty era aphorism that had also been a favorite of Mao's, he encouraged his fellow Committee members to "seek truth from facts."[36]

Not, by extension, from Marxist doctrinal encrustation. And new facts were rapidly inbound to the Middle Kingdom. In 1979, Jimmy Carter's administration officially normalized trade with China.[37]

Later that same year, Deng made a historic state visit to the US, where he toured cutting-edge manufacturing and scientific facilities in Atlanta and Houston. The high-level exchange of ideas accelerated into the early 1980s. The Chinese Communist Party made the eyebrow-raising move of inviting Milton Friedman, perhaps the world's most iconic free market thinker, to consult on the planned experiments in market-based economies.[38] The ideas of American futurist Alvin Toffler became a hot topic among Party leaders.[39] Coca-Cola was granted favorable access to the Beijing market.[40]

With characteristic pragmatism, outside ideas were broken into component parts and reassembled into tactics befitting China's unique situation. No more than Marx (or in the future, Bezos), Friedman and Toffler could be adapted. These adaptations were often the result of an internal tug of war between reformers like Deng, who envisioned a radically transformed economy, and conservative forces who saw market-based ideas as dangerous experiments to be harnessed and effectively cordoned off. The result was that the country began to divide itself economically—the planned Maoist economy was to continue with minimal interruption, while the Party simultaneously began to sanction experiments in capitalism.[41] Manufacturers were still required to meet government production quotas, but they became

free to sell any excess they produced. As China began to regain control over former treaty ports like Portuguese Macau, it used the status of territorial limbo as a means to administer self-contained free market zones. Among the first of these pre-planned zones encompassed a small market town named Shenzhen, nestled across the bay from the British administered financial powerhouse of Hong Kong (see "Muted Situations" in the present volume). From 1980 to 1990, the city's gross domestic product exploded from effectively nothing to over well over $1 billion USD annually.[42] Throughout this mindboggling expansion, Chinese partners in joint venture companies absorbed and gradually mastered foreign production principles. And following the logic of the government quota, they were free to manufacture excess and sell the surplus. It was a system designed to encourage local entrepreneurs to copy and adapt Western advances with an eye towards repurposing outside ideas for internal ends.

The Origins of Contemporary Art in China

It was as part of this larger sweep of cultural and economic changes that "contemporary art" emerged onto, and within, China. In the wake of the Cultural Revolution, legions of artists who had been purged for their heterodoxies, as Deng himself had been, were rehabilitated and welcomed back into positions of authority. This point was made explicitly by Li Xianting, one of the most important cultural theorists of the moment and the critic who originally coined the term "Political Pop." The following discussion makes repeated references to his writings—many of which have been recently digitized and are newly available to researchers through the Asia Art Society online archive.

As Li put it in a daring 1981 article, a strict variant of Marxist Social Realism, filtered especially through the ideas of Soviet writer Anatoly Lunacharsky, had become unquestionable orthodoxies that governed

the nation's officially sanctioned cultural output. For example, Hu Man, the founding director of The Beijing Municipal People's Art Studio, had published an authoritative statement that, "denies that there are other creative methods [beyond Social Realism] that can truly reflect life and produce works of positive social significance, so only realism remains." Li's response piece, "Realism is not the Only Right Path" represents the first rocky crumblings of what would soon threaten to cascade into an avalanche of change.[43] His ascension to the editorship of *Fine Arts Magazine* two years later revealed what direction the winds blew.

But the sweeping transformations of the 1980s were only beginning to stir in the late 1970s. An important tipping point occurred in 1976 after the passing of revolutionary hero Zhou Enlai, who was buried with state honors but died at a moment of waning political power. Though widely beloved, Zhou's political rivals prohibited additional displays of public mourning. After months of careful suppression, authorities were overwhelmed as thousands and then millions of people honored Zhou by streaming into Tiananmen Square on the occasion of the annual *qingming* (tomb-sweeping) festival, an outpouring of public sentiment unlike any in the history of the PRC. Though the gathering was eventually ended by police action, a taboo against spontaneous collective action had been broken.

The precedent was undeniably important to cautious growth of unofficial art exhibitions, which would eventually coalesce into a contemporary art scene.[44] One of the most important such gathering occurred in 1979, the same year that Carter and Deng were calling on each other in their respective capitals. After being denied an official exhibition space, the Stars Art Group mounted a guerrilla exhibition featuring more than 150 works on the fences of a park outside the National Art Museum in Beijing. The show, not only radical in its presentation format, made daring use of recently banned painting styles, including nineteenth-century Post-Impressionism, in a way in

which that opened onto a subtle, but daring critique of the status quo. While Wang Keping's satirical woodcarvings were among the most directly provocative pieces, a work such as organizer Huang Rui's *Yuanmingyuan: Rebirth*, now in the collection of the M+ Museum, is more representative of the exhibition as whole. Part of a series that showed the ruins of the Old Summer Palace the work features a pictorial vocabulary drawn seemingly drawn from Picasso and Miro. Anthropomorphized stones huddle together amidst a hazy, shadowless landscape.

The quietness is marked with ambivalence, as is the site itself. On the one hand, the Yuanmingyuan palace had been razed by the British as part of a punitive expedition during the Second Opium War. The ruined fragments attest to the unbridled violence of the European invaders; the former splendor was such that it took an army of 4,000

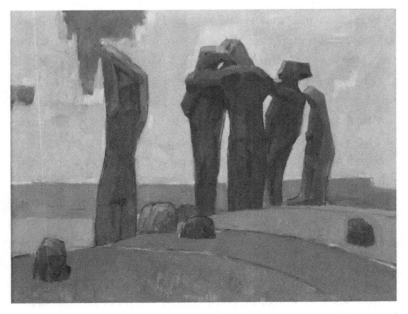

Figure 1.1 *Yuanmingyuan: Rebirth* by Huang Rui, 1979. Image Courtesy of M+ Museum.

men nearly three days to finish the demolition. But yet, the haunted site attests implicitly to the violence of erasure. Systematic neglect from the Party had allowed locals to scavenge building materials, desperate farmers to attempt cultivation, and even undesirable artists to squat amidst architectural wreckage.[45] The site's depiction in a style visibly borrowed from the original invaders begs the question of which nightmare the Chinese nation needed to awaken from.

The unusual artworks arrayed so strikingly and so publicly did not last long. Two days of crowds gathering in front of them was enough for the local police, who moved quickly to confiscate all of 150 plus works. The artists responded with a concerted action of their own, organizing a protest on the 30th anniversary of the founding of the PRC, marching to demand both political democracy and artistic freedom. Remarkably, the Party relented, permitting the exhibition to continue at the Huafang Pavilion in Beihai Park the following month. A year later, a final show would be staged inside the National Gallery. It would attract more than 80,000 visitors and feature such portentous superstars as a 22-year-old Ai Weiwei.[46]

Much has been already been written about the Stars exhibition in the paradigm of the first. The endogenous contemporary art event, the first explosion of art into activist politics. Art historians are always keenly interested in "firsts": the originary use of linear perspective, the inaugural photograph, the first totally abstract picture. The premier stage of an implicit teleological progression towards a predetermined goal. Scientific naturalism. Mechanical reproduction. European Modernism. Or something else entirely? With the focus on the Stars' groundbreaking originality, less historical attention has been paid to the importance of imitation in the exhibition's self-conception. The year following the show, Li emphasized that Chinese artists needed to imitate outside techniques in order to broaden their expressive vocabularies. "It is critical," he argued, "for us to be able to express the thoughts and feelings of the Chinese people." Maintaining

such expression as an explicit goal was all the more essential given that "the form we use is indiscriminately borrowed."[47] Copy, adapt, repackage.

Riding the New Wave Until It Crashes

Those agitating for change remained locked in a perpetual struggle with those attempting to maintain their vision of national integrity. In 1982, Andy Warhol, the world's most famous contemporary artist and one of its most profligate copyists, came for an extended tour. His visit coincided with an attempt by reactionary party members to launch a campaign against "spiritual pollution," which included, among other things, new prohibitions on existentialist philosophy and abstract painting. The Sartre ban was short-lived and its demise was greeted by a florescence of activity in experimental literature, dance, music, and the visual arts that is now historicized under the rubric of '85 New Wave.

It was a moment that, as Li Xianting put it, the heterogenous expressionism of prior moments was morphing into something else. What the New Wave strove to depict was "no longer personal emotions" but rather "the thinking of the whole generation."[48] Capping off the momentous year of 1985, the same National Art Museum that had seen the Stars censored from its extended campus welcomed a monographic exhibition of the artist Robert Rauschenberg, the first such touring retrospective of a contemporary artist to take place within China. Sometimes the "firsts" really do tell a story.

The struggle over the vector of the nation's identity continued in the terrain of economics as well as culture. The rapid success of market reforms was generating vast new wealth, but as critics of China's government were often quick to point out, this wealth was often concentrated in the extended families of well-connected Party

members rather than won on the ostensibly neutral playing field of the free market.[49]

Moreover, the dual economic system was introducing new kinds of strains. When manufacturers were expected to turn over the entirety of their production to the state, the state was able to set uniform prices for basic goods. But when producers became free to sell their excess, they could easily undercut the state's own prices (the fixed manufacturing costs, after all, had been born by the production of the government quota). Middlemen with connections to wealthy manufacturers could add their own layers of profit by buying low and reselling high, transactions that served to reinforce the yawning economic disparity in the ostensibly Communist republic. With these pressures mounting, in late 1988 Deng ordered a widespread liberalization of price controls, which set off waves of inflation, hoarding, and shortages. More consultations with Milton Friedman followed, who predictably recommended more liberalization.[50]

In the spring of 1989, these cultural and economic vectors came to a head. And has happened many times in history, the skirmishes of the art world turned out to be a rehearsal for the larger battles of politics and economics. The highwater mark of officially sanctioned aesthetic experimentalism was hit with the opening of the *China/Avant Garde* exhibition at the National Art Museum—the same museum from which the Stars had originally been barred from exhibiting. The sprawling show featured over 300 works, many of them daringly provocative in conception. Performing artists squatted over chicken eggs, hurled used condoms on the floor, and washed their feet in bowls decorated with pictures of Ronald Reagan—a perfect nightmare of the spiritual pollution that so concerned conservative Party leaders. Indeed, the corrupting stench of capitalism was thick in the exhibition. Perhaps the most literal work in this vein was Wu Shanzhuan's *Big Business,* which constituted a makeshift stall in which 30kg of frozen shrimp, imported from Wu's hometown in a

small city just outside of Shanghai, was for sale within the gallery. The allusions were clear enough. Pace Wu, the purpose of the piece was to attest "that behind the museum and behind even big business, lay the iron hand of the state."[51] As the economic managers of China drew in ideas from Western counterparts, Chinese artists absorbed lessons from Fluxus and Happening events, returning what critic Robert Hughes terms "the shock of the new" back at their own ascendant bourgeoisie.

But the most strikingly prescient moment occurred at, or rather caused, the exhibition's end. Only a few hours after the show opened, artist Xiao Lu fired a borrowed pistol at her work, *Dialogue*, a sculptural tableau featuring a pair of phone booths occupied by figures with their backs turned to the audience. Recent scholarship has worked to reveal the backstory behind Xiao's work, which included grappling with a horrifying instance of sexual assault, as well as an unfinished work from her graduate thesis show.[52] Aesthetic motivations notwithstanding, the response from law enforcement was swift and severe. Private firearms had, after all, been illegal for nearly twenty-five years. Her accomplice Tang Song was arrested immediately and, though Xiao briefly escaped, she turned herself into the police soon afterwards. The exhibition was promptly closed and cordoned off just hours after it opened. The State would only tolerate so much unfettered freedom.

Xiao's personal act of aesthetic destruction turned out to be the first shot in a failed revolution. Two months after *China/Avant Garde* exhibition was closed by police, a new, larger set of young agitators began to gather in Tiananmen Square, just outside the museum's walls. The immediate cause of the gathering was the death of Hu Yaobang, a reformist Party member who had been removed from power for taking what his reactionary colleagues believed to be an overly soft line on burgeoning liberalization movements. When he died three years later in political exile, close to 100,000 students took

to the area surrounding the Gate of Heavenly Peace. The parallels with the funeral of Zhou Enlai were striking. Over the ensuing weeks, people streamed into the Square—possibly up to a million at a time. They issued striking new demands, including an objective news media free of government interference and financial disclosure laws aimed at ending Party nepotism.[53] A hunger strike began, timed to embarrass the Party during a state visit by Russian Premier Mikhail Gorbachev. Sister protests began mushrooming in cities and towns around China. Sanitation problems began to emerge in the Square. Something was going to have to give.[54]

Under mounting pressure from the conservative wing of the Party, Deng reluctantly agreed to use the military to end the protests. He declared martial law in late May, ordering a quarter million troops into the capital. A brief standoff between a sea of effectively unarmed protestors and legions of heavily armed infantry ended with bloodshed. On June 4th, the military forcibly cleared Tiananmen Square, killing hundreds or possibly thousands in the process. Deng's liberalizing emissary Zhao Ziyang, who had been sent out to learn from Friedman and to reason with the protestors, was placed under house arrest where he eventually died. Reactionary forces effectively ended the possibility of meaningful political reform to attend the drastic economic and cultural shifts that were only just beginning.

Art and Export, or the Neoliberal 90s

The international fallout from June 4th was surprisingly short lived. At first, it appeared that China had potentially ostracized itself on the world stage. European heads of state issued denouncement after denouncement and the US House of Representatives unanimously passed punitive sanctions against China, suspending high level diplomatic contact and embargoing arms sales. But Beijing had a

friend in the White House. George H.W. Bush had cut his political teeth with Nixon and Kissinger, and he endeavored mightily to ensure that Sino-US economic relations would not be endangered by a little civilian bloodshed. By July, Bush was finagling loopholes into the arms embargo and finding non-traditional means of continuing diplomatic contact.[55] And in what had evolved into an annual legislative ritual, he again vetoed Congress's request to repeal China's status as a "most favored" trading partner. This was a charade that only had a few years left anyway. Bush's successor Bill Clinton, who had made political hay out of Bush's supposed preference for corporate profits over human rights in China, signed PRC's permanent status as most favored nation into law in 2000.[56] Shortly thereafter China joined the WTO.

It was during the 1990s, as China solidified its position as the world's leading exporter (a rise powered by joint venture partnerships and the explosion of consumer spending on computer products), that Chinese artists entered into the global circuit of the contemporary art world. In the years immediately following Tiananmen, exhibitions began sprouting up in the capitals of the Western art world and the academy: Paris, Los Angeles, the University of Chicago.[57] In 1993, Chinese artists were represented at a dedicated presentation (though not yet an official national pavilion) at the Venice Biennale.[58] The survey was curated by the Italian critic Achille Bonito Oliva, who had risen to prominence in the 1980s as an advocate for what the he termed the *trans-avantgarde*, an artistic ethos that bears out striking similarities to the motivations of Political Pop and Cynical Realism as articulated by Li Xianting.

The former's "The Italian Trans-Avantgarde" (1979) presages the latter's "Apathy and Deconstruction in Post-'89 Art" (1992) in a number of significant ways. Central to Bonito Oliva's ideas was a refusal of the teleological character of European Modernism. Differing from the dictate of earlier forward-guard movements that had born out "a moral character," derived from some of goal artistic or

social reform enacted through the work, the *trans-avantgardist* would assume "a nomad position which respects no definitive engagement."[59] Bonito Oliva made a fitting ally for work that had, as Li put it, "lost the meanings previously assigned to it by former cultural models and values." Both argued that in the ashes of ideology, artists were forced to turn inward for new possibilities. Bonita Oliva welcomed the "landslides of the individual's imagery" as an antidote to "depersonalization in the name of the supremacy of politics." Li heralded the artistic insight that "salvation can only be achieved through rescuing the self." [60] Trauma haunts the worlds surveyed by both writers. The recent failure of student uprisings (1968 in Europe, 1989 in China) ache most acutely. The grievous societal injuries of fascism and forced labor lurk only slightly further back. As Li had written in the 1980s, the defining feature of Chinese art was its "powerlessness"—a quality from which it derives its expressive power but also its melancholy.[61] One could now drink Coca-Cola in the shadow of despotism, with the foreign consumer imports offering both relief from and reinforcement of unilateral Party control.

It is all the more significant then, that it was this moment in the early 1990s that Li cited as "the starting point of modern Chinese art [moving] in a direction of its own choosing."[62] No longer simply imitating the West, China was now playing its own art historical hand. Or, given the scale of everything China, many hands at once. As it matured, Chinese contemporary art began to develop the internal tensions of any major cultural undertaking. Enmity arose between artists who had made a name for themselves abroad and those who had braved a more difficult climate at home. And as the money started flowing—from both speculative collectors and well-endowed non-profit institutions—the question of who could access and control the networks of international exposure became increasingly high stakes.[63]

And as it grew, the edifice of Chinese contemporary art developed an uneasy, and involuntarily, alliance with the Party. Ten years after

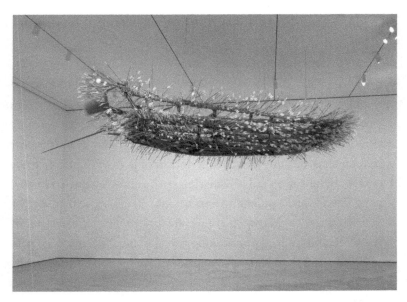

Figure 1.2 *Borrowing Your Enemy's Arrows* by Cai Guo-Qiang, 1998. Image Courtesy MoMA/Cai Guo Qiang.

Bonita Oliva's *Survey*, the People's Republic of China sponsored its first official pavilion at the Biennale. Soon thereafter, artists including `Cai Guo-Qiang and Ai Weiwei were given important roles in representing the country on the world stage of the 2008 Olympic Games, helping to cement the status of both figures as international icons. We will have more to say about Cai in a moment. But Ai Weiwei's status as the most highly recognized Chinese contemporary artist—a status that has brought global renown as well as violent attention from the Chinese state police—encapsulates the pivotal uneasiness of this larger alliance. Much like the free market layer of the dual track economy engineered by Deng in the 1980s, the world of contemporary art in China derives its power from its position both outside of, and in service to, the larger apparatus of Party power.[64]

Once borrowed, the pieces can be constantly reassembled.

Coda, Exploding Christmas and Returning to Sender

With the drumbeat of trade war growing louder every day, Dr. Michael Pillsbury has become a fixture in the right wing American news media. President Trump called him "the leading authority on China." And he has been growing increasingly dire in his warning about China's malign geopolitical intentions. His book *Hundred Year Marathon* has become a frequent touchpoint for American trade hawks, both on conservative television (and as I can attest personally) among finance professionals in bars. It only makes sense that the Fox and Friends set would respond enthusiastically when a former senior foreign relations official promised to reveal "China's secret strategy to replace America as the global superpower." A message, he is not shy to point out, that was ignored by the prior administration. Thanks Obama.

Hundred Year Marathon opens with an argument for the global contemporary art world as a kind of scale model for the larger civilizational conflict.[65] In 2012, the Smithsonian-Sackler gallery invited Cai Guo-Qiang to perform one of his signature fireworks-events at the Museum's 25th anniversary celebration. Cai chose to execute a work that would seem to make a massive pine tree appear from within a shroud of thick black smoke. The commission was heralded in the American media—a gesture of "a revolt against an oppressive artistic culture" said the Smithsonian's own statement—but as an actual event it was fairly difficult to grasp.[66] I remember huddling against the cold as I waited in a throng of onlookers for whatever was about to happen. When each round of fireworks exploded, it sent a tenebrous tree of smoke into the gray November sky. When it was over, I wasn't quite sure I had witnessed.

But, *pace* Pillsbury, a dirty trick had been pulled on all of us. While he was also in the audience that day, "clap[ping] along with the rest" as he put it, he would soon discover the intercultural duplicity underneath the pyrotechnics. Through a secret meeting with an unnamed

defector, Pillsbury learned of Cai's favor among Party hardliners, who reportedly cheer the ironic symbolism of Cai receiving rapturous praise from Western institutions for detonating the cherished symbols of their power. According to an unnamed Mandarin language website that Pillsbury chooses to leave uncited, blowing up a Christmas tree on the National Mall was a particularly delicious victory.

Maybe.

But what is certain is that if he was looking for evidence of meta-strategic geopolitical maneuvering in the art of Cai Guo-Qiang, Pillsbury chose the wrong piece. In 1998, Cai contributed a now iconic work to *Inside/Out: New Chinese Art*, one of the most significant touring retrospectives of Chinese art to take place in the decade after Tiananmen. *Borrowing Your Enemy's Arrows*, a ceiling-mounted sculpture featuring a fishing vessel studded by hundreds of arrows, alludes to an ancient bit of military folklore. According to legend, the ancient general Zhuge Liang faced down a two-front problem—an ammunition shortage and an internal challenge to his command—with a stroke of tactical brilliance. He sent an "attack" against a fortified enemy position, sailing an unmanned fleet onto a lake filled with fog. After the empty armada had been deluged under a shower of arrows, Zhuge managed to surreptitiously retrieve his navy, which was now replete with a cache of missiles.[67]

Borrow, adapt, repurpose. A technology transfer tactic millennia in the making.

And in here lies the uncanny strangeness of broadly constructed *shanzhai*. In looking at the double vision of Youhan and Warhol, or of Jun and Jobs, we are confronted with nothing so much as the points of our own arrows.

2

单向窗口

One Way Glass

Overture by Hu Jieming, 2014. Image courtesy of the artist.

At a Glance

The following essay dives into the work of media arts pioneer Hu Jieming (b. 1957) as a means of examining two important, interconnected histories in China: the glowing world of mass media and the glass and steel terrain of the new urbanism. These histories unfolded quite differently, and much more recently, than their corollaries in the West. In parallel with the cultural, political and economic transformations described in the previous chapter, the 1980s and 1990s also witnessed staggering developments in Chinese technological and urban infrastructure. While television watching was accessible to only a tiny fraction of the population in 1980, by the end of the decade, explosive growth in both domestic set production and broadcast power meant that more than 15% of the world's population had become a television-watching citizen of China. Similarly, China's urbanization rate had been comparable to those of the US in the wake of the Civil War, but the PRC has since become home to all three of the world's largest cities, five of the largest ten, and, incredibly, ten of the largest twenty. As described below, new ideas and new neighbors presented both problems and opportunities.

This knotty crux of transformations is explored through the art of Hu Jieming, whose installations with built environments and television screens emphasize that all architectures created to channel bodies and eyeballs can never be imposed purely *tabla rasa*. In the aritst's work, we find the poetics of resistance in the most surprising of places—a warehouse studded with monitors, a picture postcard from nowhere, a lone masturbator whose bodily rhythms drive the course of mutable music. These disparate works dramatize a kind of mind-state projected on an ancient architectural fabric constantly under the threat of erasure, and a mass of bodies maintained under newly constant surveillance.

The televisions, though they may be precariously deconstructed or mostly obfuscated behind a brick wall, always manage to catch something. A furtive glimpse of a shadowy hallway, a fragment of protest, a tangle of actors performing in pitch darkness for an audience they cannot see. In these works, the physical sense of embodiment—what art theorists were once fond of referring to as the "phenomenological"—is always paramount. Viewers must crouch down to glimpse the monitor perched on a stack of bricks, or they must strain to see the array of screens hidden almost completely behind the walls of a warehouse. In other examples, the bodily registration becomes the subject of the work itself—vital signs are taken during acts of physical ecstasy or sedated boredom and then used as parameters for televisual installations.

This state, of being at once over and under observation, is the starting condition for the work of Hu Jieming, a pioneer of China's video and media art scenes. Though his work remains largely unknown in the West, his career traces through many of the most pivotal transformations of the last three decades. As a young agitator, he participated in protests in Tiananmen Square and, as China's art scene began to expand its international profile in the 1990s, he became one of a select group of artists to tackle the challenge of experimental, electronic media.[1] His mixed-media installations were often read in light of Li Xianting's contemporaneously coined "Cynical Realism," a descriptor meant to capture the sense of increasingly comfortable absurdity permeating everyday life in urban China.[2] As his work matured, it grew to encompass progressively more ambitious interventions—in the history of global art, or the landscapes of contemporary China. Indeed, Jieming's work revolves around surfacing the recent histories of two such interconnected landscapes: the glowing world of mass media and the glass and steel terrain of the new urbanism.

These histories unfolded quite differently, and much more recently, than their corollaries in the West. While the American 1950s have become synonymous with the widespread adoption of domestic television—a new habit that altered political and cultural trajectories at every imaginable level—TV broadcast did not begin in China until the very end of the decade. Fast forwarding from the *Leave it To Beaver* moment to the birth of the MTV generation, American households were watching an average of *seven hours per day* of television, while fewer than one in 100 Chinese citizens even had access to one.³ This disparity began to close in the period of reform following the death of Chairman Mao, as the newly renamed China Central Television began to broadcast government approved content to an ever growing viewing public.

And the contours of this public were evolving in real time. Typically, television-watching in China had been a communal activity, and because of the grand push for urbanization, many Chinese found that they had many more neighbors. At the end of the 1970s, less than 20 percent of China's population lived in cities, a figure on par with the US during the Civil War. Through the course of the 1980s and 1990s, the Party embarked on a program of city-building unprecedented in the history of the world, with hundreds of millions of individuals—equivalent to almost half of the population of the whole of Europe—relocating to cities concentrated along the sea coasts. As of this writing, China has become home to all three of the world's largest cities. And half of the world's largest ten. *And half of the largest twenty.*⁴

New neighbors, and new ideas, presented both problems and opportunities. As reformist premier Deng Xiaoping was fond of saying, "If you open the window for fresh air, you have to expect some flies to blow in."⁵ Take, for example, the seemingly simple issue of broadcasting over the air. Television sets powerful enough to receive approved programming from Beijing were often also capable

of catching contraband content from offshore stations in Hong Kong.[6] This problem only became more pronounced in the decade after Tiananmen, a period in which Chinese society became more urban, more wired, and more subject to political repression. Indeed, the post-1989 imperative—of attempting to hold fast to a cultural superstructure while completely rewriting its economic base—set the stage for the waves of technological change that crested over China in much closer succession than in the West.

It is in thinking through the actual texture of these changes that Jieming's work makes its most interesting interventions. This new space of electronic and physical infrastructure—built to channel bodies and eyeballs in thoroughly predictable ways—can never be imposed purely *tabula rasa*. It unfolds on top of and around prior systems, supplanting old customs and familiar points of habitation. In Jieming's work, we find the poetics of resistance in the most surprising of places—a warehouse studded with televisions, a picture postcard from nowhere, a lone masturbator whose bodily rhythms drive the course of mutable music. These disparate works dramatize a kind of mind-state projected on an ancient architectural fabric constantly under the threat of erasure, and a mass of bodies maintained under newly constant surveillance.

The Surveillance State, Ancient and Modern

If the electronic pervasiveness is perhaps new, the concept of communal self-policing is not. Versions of this construct emerged as a cornerstone of Chinese political thought at roughly the same time that democracy arose in Classical Athens. The foundational figure here is Shang Yang, a philosopher and reformer whose ideas are widely seen as the intellectual bedrock of China's first "Imperial" dynasty, the Qin. Forefather of a doctrine known as Legalism, Shang

advocated for a strong central state, one often premised on harsh penalties for even minor infractions. Farmers who failed to meet production quotas, for example, could be legally enslaved and given as chattel to their more productive rivals.[7] But recognizing that such dictates would destroy the whole of the social fabric if implemented at the local level, Shang articulated a different perspective for village leaders. "Restrict punishments," he advised, "and bind [the people] through mutual surveillance."[8] Such mutuality was assured by the promise of pain meted out not only to criminals, but also to those who failed to promptly report them.

Though its fortunes waxed and waned through the millennia of Imperial Chinese history, the tenets of legalism that promised to ensure the compliance of China's massive citizenry generally grew more influential with time. Later versions of these doctrines, which were grafted into Wang An Shi's *baojia* system (see "Survival Robot" in the present volume), became ever more authoritarian. In the Song dynasty (c. 1000), a principle of collective punishment was debuted, in which entire communities could be punished for unsolved crimes. The first Ming emperor (c. 1400) introduced a system of permits for travel further than 50 km, assigning collective responsibility to each *li* (a group of 110 families) to interdict unauthorized strangers in their midst. If a crime was committed by such an undocumented migrant, the whole village risked banishment to the wilderness. China's last empire, the Qing, elaborated this system still further, requiring that an official record of family-belonging be produced for any kind of travel. Simple failure to register as a guest in an inn could result in a punishment of 100 blows, a potential sentence of death by flogging.[9]

But keeping track of whereabouts is only ever half the story—it was no less important to actively condition the landscape of ideas within which citizens of the Middle Kingdom lived. Even Lord Shang knew this—"if one understands education … there would be no divergent

customs." Education here means something slightly different than in the West. Shang was clear that the goal was not widespread learning. As he tersely put it, "simplicity and ignorance are the real virtues of the people."[10] Rather, as Sinologist Charles Sanft has explained, standardizing the flow of information from the Imperial personage outwards to the various reaches of the kingdom could serve as a great unifier. The goal was to ensure that the Kingdom's expectations were clear and thus that the harshness of punishment could be, to the maximum extent possible, obviated.[11]

In Lord Shang's days, the channels of communication were somewhat limited, with courtly rituals, circulating bronze vessels, and of course royal proclamations serving as important means of disseminating and confirming hierarchy. But even as time went on, the persistence of strong regional variation (as well as the lack of basic education among the laboring classes) limited what could function as "mass media." One particularly well-circulated speech from the 5th Qing emperor (b. 1711) was ritualistically read aloud in local dialects for well over 100 years.[12] But the late Qing witnessed the beginnings of an epochal sea change. As historians Lee Ou-fan Lee and Andrew Nathan have argued, because China lacked European modes of collective political engagement—public debate, electioneering, even central-state infrastructure works—the creation of a mass culture at the turn of the twentieth century occurred "to an extraordinary degree by a single medium": popular print.[13] The growth could be astonishing. In a single year, between 1907 and 1908, the nation nearly *doubled* the volume of both imported and exported periodical issues.[14]

The Qing, the last of China's Imperial houses, fell in 1912. It would be a much different kind of dynasty that would be left with to grapple with how to exploit the myriad new modes of mass communication towards unifying a national culture.

Population and Media Control in Maoist China

After decades of internecine civil and international war, the people of China, as Mao famously put it, "stood up" in October 1949. Just as for the earlier October Revolutionaries who overthrew the Russian Czar, one of the most pressing problems became the manner in which the Communist vanguard should create and disseminate a cultural identity for the new polity. Much has been written about the complex intellectual history of Mao's ideologies, which incorporated Western Marxism (and Georgism) with Chinese ideas from Confucius, Lord Shang, and more recent thinkers like Li Dazhao. However, less attention has been paid to the manner in which the dissemination of these ideas—ancient notions of strict collectivity and Western faith in societal perfectibility—was imbricated in the gradual emergence of a technological China.

This emergence followed a markedly different rhythm than the West. Decades of colonial interference, protracted civil war, and foreign invasion had gravely damaged the already-vulnerable telecommunications network established in China in the early twentieth century. Rebuilding these means of long-distance information transfer—always essential for any centralized Chinese government—of course became a priority, but one that had to be balanced against other seemingly exigent needs for the new socialist state. Like many things China, early versions of televisual constructs would be based on a Soviet model. After studying precedents in Russia and East Germany, the Party launched its own television network on May 1, 1958.[15] There were, however, only thirty or so televisions in operation within the broadcast radius, and penetration rates remained low for decades.

The consumer uptake of the new technology was hampered by a countervailing impulse towards rural and agricultural labor. At the

time of the PRC's founding, nearly 90 percent of the population lived in the countryside, but as the bitter conflicts of the Japanese invasion and Chinese Civil War receded, peasants in search of work began to flock to the cities. One study put the figure at a 90 percent increase in the urban labor force within a three-year period.[16] While precise figures are difficult to determine, such an estimate would indicate a movement of human beings an order of magnitude larger than the Great Migration of African Americans from the rural US south to the industrial north, happening in less than one twentieth of the time. The scale of the population shift is staggering.

While the sheer volume could have on its own compelled a response, a quirk of Chinese political doctrine inherited from the Soviets made a draconian solution inevitable. Namely, the National Party assumed responsibility for the urban, mechanized, proletarian labor force, which the local governments could be expected to provide for their own, presumably self-sustaining agrarian populations. These network externalities stimulated a massive push to both curtail immigration to cities, as well as foster emigration from them.[17]

The solution to limiting influx that emerged over the 1950s is now known as the *hukou* system. While precedents for population control exist within the political tradition and the *baojia* system identified above, neither the Imperial governments, nor the Japanese or KMT occupiers had attempted to curtail intra- or extra-rural migration to the extent that the CCP began to. Such internal migration had historically helped to smooth famines, labor shortages, military conflicts, and other emergencies, but what became referred to as the "blind migration" of tens of millions into cities had the potential to wreck the Party's carefully orchestrated designs for a centrally planned economy. A 1954 order, the "Joint Directive to Control Blind Influx of Peasants into Cities," established the present household-level registration system, which prohibited urban areas from hiring or recruiting immigrants beyond their immediate environs. The

hukou system was officially inaugurated in 1958, and required Party permission (and existing family ties at the destination of origin) for *any* change of residence, even within one's township. Legally sanctioned movement from rural to urban areas was erased almost overnight.

The prohibition of movement into cities dovetailed with political and cultural initiatives to export labor supply back to the country. The programs of the Great Leap Forward and the Great Proletarian Cultural Revolution are comparatively well known in the West, but the scale of the ambition nevertheless remains difficult to grasp. Both initiatives comprised vast programs to modernize agrarian labor and re-orient youth education in one of the most populous, ancient countries on the planet. The fabric of hundreds of millions of jobs and families was uprooted, untold tens of millions were relocated out to the rural periphery, and as many as thirty million perished, most due to starvation.[18] These civilizational projects had as their aim a re-embrace of an agricultural past rather than an address to the future, and as such did not produce the conditions under which the meaningful modernization of telecommunications infrastructure was remotely possible.

But for all the destruction wrought by early Party decision-making, one of the bright spots in the first decades of Mao's rule was the remarkable gains in literacy rates. Statistics predictably differ, but the consensus amongst historians is that Mao accomplished what one study referred to as "the single greatest educational effort in human history"; taking a population of half a billion people and cutting the illiteracy rate in half in two decades.[19] All the better, as Mao knew, to be able to effectively standardize popular ideology. Since the 1960s, his *Quotations from Chairman Mao Tse-tung* has become one of the most widely distributed publications on Earth, easily surpassing all other books except the Christian Bible.[20] It is striking to note that, compared to the earlier films of Eisenstein or Riefenstahl, Communist China's iconic cultural product was a book of aphorisms that was modeled closely on Imperial speeches declaimed in the town square.

It is worth pausing over the so called Little Red Book. The volume is most immediately concerned with establishing enthusiasm and cohesion amongst the far flung and populous state. Channeling Lord Shang, Mao exhorts his followers to preemptively sniff out dissent among their own ranks. "To let things slide for the sake of peace and friendship" or "to hear counter revolutionary remarks without reporting them," he warns, would "open the door" to "embezzlers, swindlers, arsonists, murderers, criminal gangs and other scoundrels."[21] Nevertheless, the rewards for unity in the face adversity were potentially earthshaking. These aphorisms, once they were "grasped by the broad masses" would become "an inexhaustible source of strength" and "a spiritual atom bomb of infinite power."[22]

Those last words were written in the introduction by Lin Biao, Mao's revolutionary comrade in arms. He was, at the time, Mao's chosen successor and head of the state's official news organ, the *People's Liberation Army Daily*. Just a few years (and a rumored coup attempt) later, he would be killed in a mysterious plane crash that still haunts the political psyche of China.[23] Mao's much more peaceful death occurred five years later. While it would be up to his successor Deng Xiaoping to usher China into the age of electronic mass media, very little about Deng's transformations can be understood without reference to the fundamental goals of Mao's media campaign—to keep the nation mobilized of its own volition while at the same time keeping it unified under the direction of the party.

Wiring an Era of Transformation

Mao's death precipitated a fiercely contested struggle for the future direction of the Party, one that, in many respects is still ongoing. Mao's final choice of Hua Guofeng as successor was widely understood as an attempt to placate both the hard liners (the Gang of Four,

headed by Mao's widow Jiang Qing) and the reformers, led by the recently rehabilitated Deng Xiaoping. Predictably, the compromise candidate pleased no one and, after just weeks of maneuver, Deng and the reformists ascended into the leadership. Jiang and the Gang were subsequently arrested for treason—their attempts to seize power indicted as an attempted coup—and were subsequently charged with a host of crimes related to the worst excesses of the Cultural Revolution.

As is discussed at greater length in the previous essay of the present volume, Deng's political vision remained hotly contested and riven by internal contradictions. The aim was to relax the doctrinaire vision of the Maoist era in order to allow China to reap the benefits of true participation in the global economy, while at the same protecting the cultural and political autonomy of the Chinese state. The aim, if we trace the psychological fault lines back to the days of Empire, can be seen as stemming from two deep anxieties: the need to maintain economic and military relevance as well as political and cultural independence from the West. The result became known as "Socialism with Chinese Characteristics"—a centrally planned economy with contained zones of market-based experimentation, accompanied by a tug of war of over how much contemporaneous culture to allow its citizens to access.

Though most literature on the period focuses on economic and policy changes as levers of this grand social redirection, many of the most important shifts happened in, and through, the ascendant mass media. In the aftermath of Mao's death, the nation came together through first-time televisual events that heralded a new era. In 1978, Chinese citizens were able to enjoy the World Cup via satellite rebroadcast from Argentina. Three years later, the nation was gripped by the televised trial of the "Gang of Four," a dramatic event punctuated by a commuted death sentence for Mao's widow, who had been a vociferous advocate for the Cultural Revolution.[24]

Over this period, Chinese citizens grew ever more used to tuning in every day—offerings included up to four daily news programs, seven days a week, broadcast over an ever widening geographic area.[25] Broadcast stations mushroomed all over China; from 52 in 1984 to over 400 by 1988.[26]

Reliable statistics on the precise unfolding of television watching can be hard to come by, but consider the following facts. By the end of the 1980s, China was manufacturing thirty times as many televisions *per year* as it had cumulatively during the two decades of Mao's rule.[27] This explosion of production meant that the viewing public had grown to an estimated 800 million individuals; of the course of a single decade, more than 15 percent of the world's population had become a television-watching citizen of China. This adaptation is even more staggering when one considers the cost of the devices. As economist Li Xiaoping has observed, the average urban worker would have been required to save half a year's salary to afford a new television set. In the countryside, where income levels remained much lower, the purchase of a set was second only to the construction of a second home. In the conflicted 1980s, owning a television became the ultimate symbol of status—in the erstwhile Communist republic.[28]

Given the unprecedented rise of television viewership, it is important to make explicit the expectations about what all those citizens would have been watching. In 1987, Peng Zheng, the head of the Central Political and Legislative Committee gave a revelatory speech to a group of Beijing journalists covering precisely this topic. Reminding his audience that television was the "mouthpiece of the government and the Communist Party," it's primary aims were to "provide a complete and objective view of society and the world," and "offer a set of socio-moral standards based on Marxism-Leninism and Mao Zedong Thought" in order to "encourage and educate the people of the nation to strive to create a socialist civilization." Given

this mandate, strict rules governing broadcast were in order. To quote Zheng again,

> In conducting publicity in the press, radio or television, we must on no account permit the advocation of anything that violates the constitution or the law, or the expression of opinions or reports that negate the leadership of the Party and socialist system; we must on no account allow the spreading of erroneous opinions or cause people's beliefs in socialism to waver; we must on no account allow the use of spiritual opium to drug the people's soul.[29]

This last allusion is particularly telling. Zheng here links the danger lurking in unwanted foreign cultural and political ideologies—a danger magnified by the new openness of China's economy and media space—to the forced importation of opium by the British into the late Qing empire. Trade and communications, so long as they occur within predetermined boundaries, are seen as a means to China's return to international prominence. But there could be no room for concomitant evolution of political power. No foreign poisons disguising themselves under the allure of individual pleasure and freedom.

Which is not to say no one tried. Beginning with the death of Mao, reformer politicians, student activists, and many others agitated for greater participation and transparency in the political process. More than a decade of growing confidence, and increasing urgency, around the need for political reform drew up to a million people to Tiananmen Square in Beijing in the spring of 1989. As detailed in the preceding chapter, the protests were touched off by the death of reformer Hu Yaobang, but expressed pervasive anxiety over economic transformation without concomitant political evolution. Fed up with inflation, corruption, and a stagnant labor market (all exacerbated by the uneven wealth creation of the Party's halting experiments with capitalism) and emboldened by exposure to Western cultural

experimentation within and beyond the arts, a mass of citizens demanded urgent change. When neither protestors nor government would give way, violence was bound to ensure. On June 4th, the Party ordered the Square forcibly cleared, resulting in hundreds, or possibly thousands of deaths.

Among the survivors was the artist Hu Jieming.

Witness and Algorithm

At the time of the protest, Jieming was an unknown young artist, having graduated from the fine art department at the Shanghai Light Industrial College (now called The Shanghai Institute of Technology) in 1984. He trained as painter, studying a mix of traditional Chinese techniques, Soviet style Social Realist models, and the recently permitted objects of the Western canon. He also concentrated on the new domain of industrial and consumer packaging design, a portentous field of study on the cusp of the '85 New Wave, an important precursor to his with technological media in his art practice. He traveled to the United States for two weeks in the early 1990s, a trip that he credits for having expanded the scope of his artistic experimentation.[30]

His first major solo show was held at the East China Normal University in Shanghai five years after the June 4th incident. The exhibition, entitled *Witness & Game*, offers important suggestions for both of Jieming's later subjects as well as the actual techniques of observation and control that his work would explore.[31] The paintings hold in balance a number of unsteady binaries: the hand-painted visage and the bureaucratic ID photograph, the traditional paper of the written decree, and the electronic screen of surveillance, the game of elusion played against the grid of the system.

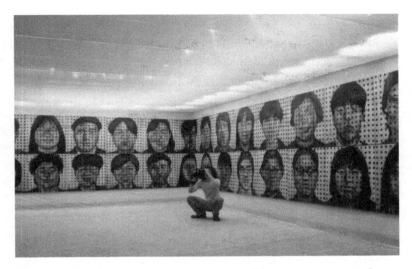

Figure 2.1 *Witness and Game* (Installation shot) by Hu Jieming, 1994. Image courtesy of the Asia Art Society.

This series began with a series of anonymized passport photographs, which he repainted on large sheets of traditional handmade paper. As the paint seeped through, the image would then be repainted in outline on the paper back.[32] These new outlines bled through the front and were repainted again, producing new outlines on the back, and so on. After this iterated procedure, Jieming subjected the averaged images to one final step, overlaying a grid of black dots that enable more systematic comparison between image composites. Stylistically, they bear a marked similarity with Chuck Close's works, but the verism of the American painter is missing from a wall full of averages. In presentation—arrayed in two rows of an edge-to-edge hang—the effect is more Warholian. Halls of immersive shadows and walls of endlessly comparable faces.

The idiom was timely. The year following the exhibition, major steps forward were taken to commercialize the process of computerized facial recognition.[33] While ZN-Face is not well remembered today,

the German university spinout launched in 1995 provided a new computation method to automate a process that had already been well understood by academic researchers for decades. Assisted by human guides, algorithms would measure standardized features (such as the distance between pupils or the angle of a jaw) to determine a match between an ID photograph and surveillance image; a process of matching by reference to a standardized grid highly parallel with the technique behind Jieming's *Witness and Game*. ZN-Face deployed novel a computational approach called Elastic Graph Matching that would permit these many points of comparison to be evaluated at once, and therefore run efficiently on widely available computer hardware.[34] Though it saw limited commercial success, the basic technique remains a cornerstone of numerous international machine vision programs.

Such advanced Western approaches were soon making their way to China. At the end of the 1980s, the Ministry of Public Security commissioned Tsinghua University professor Su Guangda to work on a research project called the "Computer Portrait Combination System" that, combined with the expertise of Chinese expatriates studying overseas and returning home, was finally ready for its preliminary testing phase in 2005. The project dovetailed with a second initiative called Skynet, which deployed cameras into public spaces. By the time of the 2008 Beijing Olympic Games, the system was fully deployed with tens of millions of images for comparison against a growing camera network. Flash forward today, and more than 20 million cameras are now capturing live feeds from all over China.[35]

Conflicting accounts exist in the media of the power and reach of these systems—with Chinese news accounts of surreptitious, peaceful arrests of wanted criminals at public events contradicted by Western skepticism of the practicability of omni-surveillance. While it is hardly an authoritative picture, one unnamed journalist-activist I spoke to in 2019 researching this book related how she had recently feigned an

emergency of a lost boyfriend. The police, using facial recognition software connected to Shanghai's ubiquitous cameras, were able to locate the missing person in five minutes.[36]

The grid becomes the means to track both the face on the screen, and the body in public space.

Architectonic Form

But back in the mid-1990s, Jieming's work continued to drill into the paradoxical conditions of over and under visibility generated by electronic surveillance. After *Witness and Game* Jieming moved into the territory of environmental installation, exploring the mechanics that might be used to produce outputs like the quantified security photographs. *Comparative Safety* (1997) took place in a large warehouse, and featured real time surveillance footage of the warehouse itself. Viewers were able not just to see but to actively control the playback, which appeared on deconstructed monitors resonant with the derelict structures. The piece is characteristic of Jieming's subsequent *oeuvre*, a world in which the thrill of the covert action is intermixed with the sedated boredom of monotony. A world of spaces and screens and all too constant monitoring.[37]

Indeed, large-scale changes were beginning to link these worlds ever more closely.

First, the urban density which has become synonymous with modern China began to accelerate in the neoliberal 1990s. For many decades, China's proportion of city dwellers had been low by international standards. This can be traced both to longstanding effects of the relatively late emergence of industrialization as well as to whipsawing from government policy detailed above. As the command and control autocracy of Maoist policy waned during the 1980s, the trends towards de-urbanization began to reverse course—the decade

saw China move into the middle tier of countries by urban population share. But again, the percentage/number question in China remains imperative. Though its urbanization *rates* remained middling, the numbers are staggering. Between the years 1990 and 2000, China gained 160 million urban residents, the equivalent of adding ten new cities each of which held the combined population of New York and Los Angeles.[38]

The first of Jieming's video works to address this territory was *The Best Strategy is to be on the Move* (2002), an essayistic foray into the heterogenous scenes of the waves of massive migration still unfolding all over China. Jieming's title links the contemporary movement of China's migrants with other wanderings from the political history of the Middle Kingdom. The work references the Long March—the flight taken by Mao's cadre of revolutionary fighters in the face of a superior enemy—as well as the 36 Tactics—a 2,000-year-old compendium of military strategy adapted by the work's title. The irony, of course, is that much of the ongoing migration has been a source of great consternation to the Party.

Though the rise of planned cities grew out of policy choices, it also unleashed an avalanche of unregulated human migration that countermanded the *hukou* system, which still requires family connections and endlessly deferred bureaucratic approvals for a move to be permitted. The scale of the movement is only now being understood by demographers. According to one study, by the year 2000 China was home to a population of 80 million illegal "floating migrants," a mass of humanity 50 percent larger than the combined inhabitants of the US east coast from Washington, DC to Boston.[39] The rationale behind the bifurcated treatment of rural and urban populations—the ostensible self-sufficiency of agricultural communities as opposed to the import-hungry urban zone—has visibly ceased to match reality. Today, rural migrants now seek to join the burgeoning global economy manifesting itself in China's booming

cities. When they arrive, they find themselves denied access to government sponsored benefits such as education and medical care. And the rise of ubiquitous facial recognition technology deployed in public promises to make their daily lives yet more precarious.

But while the plight of these refugees continues to be important to Jieming's art, the specific experiences of one group is always subordinate to a more thematic exploration of the ways in which the two glass worlds—the soaring, weightless skyline of its cities and the bottomless ocean of its innumerable screens—are experienced as imbricated phenomena. By the start of the 1990s, more than 50 percent of China's urban residents had access to a television, an increase of hundreds of millions of viewers.[40] Pressure began to mount over who, and under what conditions, would have access to these new media markets of almost unimaginable value.

In 1993, media tycoon Rupert Murdoch purchased a controlling stake in Satellite Television Asia Region, a Hong Kong-based broadcaster with a license to distribute content into the mainland, for just over $600M. Three months later, Murdoch gave a speech celebrating his intentions to bring informational freedom to the Chinese populace. Channeling his inner Ray Kurzweil, Murdoch declared

> Advances in the technology of communications have proved an unambiguous threat to totalitarian regimes: Fax machines enable dissidents to bypass state-controlled print media; direct-dial telephone makes it difficult for a state to control interpersonal voice communication; and satellite broadcasting makes it possible for information-hungry residents of many closed societies to bypass state-controlled television channels.[41]

By positioning himself a new, neoliberal incarnation of the time-worn Western hero freeing the people of Asia from their own tyrannical government, Murdoch inadvertently insured the Party would bring

Figure 2.2 *Accompany with TV* by Hu Jieming, 1996. Image courtesy of the artist.

its fury down on him. Less than year after his purchase, Murdoch was forced to drop the offending BBC Channel (World Service Television) from Star's package. A litany of entreaties and concessions followed, none of which would repair the damage. Murdoch's Star bled market share to a succession of home-grown, state-sponsored competitors, and he was ultimately forced to sell his stake back to the Party-backed majority shareholder for less than quarter of what he had paid.[42] The CCP was simply not going to allow foreigners to peddle "spiritual pollution" through the airwaves.

Jieming's work captures this seeming paradox—an increase of consumer choice and a concomitant increase of government control. His most literal tweaking of this dynamic can be found in his participation in *Let's Talk About Money*, a 1996 exhibition in Vancouver in which art from China arrived by fax, a show that will explored in further depth in this book's final chapter. However, from

Hu Jieming's perspective, it is the dual posture of technological expansion and impingement closer to home that concerns us here. This idiom is never more direct than in an installation he produced the same year as the fax exhibition. *Accompany with TV* (1996) documents the vital signs of an individual watching television for an entire 24-hour cycle. *Accompany*, which draws on a range of American conceptualist precedents including Brian O'Doherty's portrait of Marcel Duchamp by heart monitor, was followed by *Related to Happiness*. The latter work involved monitoring a lone male subject during the act of masturbation, tracking the rise and fall of excitation via electrocardiogram, using this variable signal to generate procedural music on an accompanying piano.

Both of these works dramatize Jieming's connection to the ethos of "Cynical Realism" and its "senseless reality of the self:" an inchoate subject loosed from the moorings of traditional Chinese culture and cast adrift on the empty sea of postmodernity.[43] A world fraying at the psychological seams, where the atomistic individual is subsumed within a disconnected world of electronic images. Pleasure becomes hollow, yet immediate. But different than his better-known contemporaries, Jieming's engagement with the media space tracks the rising importance of technology to this story—the way in which subjects of the *renmin* did not simply lose their bearings but were turned into objects of data along the way.

The (False) Collapse of History

Since the 1990s, Jieming's work has continued to examine this binary of consuming subjects as data objects. *Overture* (2014), pictured at the beginning of this essay, is one of Jieming's most visually striking works. The piece involved lining the walls of a desolate brick structure with nearly 1,000 television screens, which were barely

visible behind the crumbling walls. The work picks up a number of threads from the earlier *Comparative Safety*; the straining difficulty of observation, juxtaposed with the panoply of potential objects to observe, and the tingling potential of surreptitiously being watched as one watches. Jieming also inverts this dynamic in *Blackboxlab* (2012–13), a challenging installation that placed participants inside a lightproof shipping container. Though their movements were visible to the public through infrared cameras, the darkness was so complete that participants were unable see their own bodies. These works are both redolent of Arthur Schopenhauer's famous characterization of a solipsist as "a madman shut up in an impregnable blockhouse."[44] But in Jieming's world, though we be closed off inside the husks of discarded by the international flow of goods, we are nevertheless always keenly aware of the inaccessible outside looking in at us.

Perhaps Jieming's most prescient work, *1995–1996*, transposed this question of who was watching what into the territory of content analysis. Jieming took photographs every five minutes on every Shanghai television channel for the 24 hours spanning the beginning and end of the eponymous years, installing the resulting black and white transparencies on an open framework of metal pipes. The procedure seems to draw on a number of touchstones of American conceptual art, including Ed Ruscha's systematic sampling, Douglas Huebler's New Year's-spanning exposures, and Richard Serra's televisual jeremiads. But for Jieming, something else turned out to be at play. He would produce a number of works in this idiom, including *The Fiction Between 1999 and 2000* and *100 Years in One Minute*, but 1996 heralded a turning point. On June 20th of that year, the Chinese Communist Party officially welcomed the citizens of the People's Republic onto the internet.[45]

Unlike television, which advanced for decades in the West with little development in China, the adoption of the internet happened in near synchrony. China had caught up, the West had not quite realized

it yet. In the mid 1990s, a period of great hand-wringing amongst the Party elite over the disruptive power of open information borders, fewer than 2 percent of Chinese families owned a computer, and less than 15 percent had ever used one.[46] But over the course of 1996, a steep growth curve began to rise. Internet users increased by an order of magnitude, and would increase by another 10,000-fold over the next two decades. By 2015, there were twice as many daily internet users as citizens of the United States, with internet penetration still below 50 percent. Today, 60 percent of the country is smartphone connected, and its 430 million 5G devices comprise more than three-quarters of the world's total.[47]

The story of this growth has been one of contestation between ascendant entrepreneurs, citizen technology users, and government agents of control, a story that has been widely reported in the West but frequently misunderstood. While a 1996 *Wired* article introduced the idea of The Great Firewall into the American lexicon—a concept referring to the aggregate attempt by State actors to cordon off Chinese networks from Western corrupting influence—the same period produced home-grown Chinese companies that now compete with Western peers in areas ranging from basic chip manufacture to finished consumer devices (bracketing aside the massive export market discussed in the previous chapter). Conversely, natural disasters including SARS outbreaks and the Sichuan earthquake exposed the limits of Party accountability, and the battle for control of the digital narrative has done much to shape the contours of the Chinese Internet, a techno-cultural form that one media studies scholar likened to "the American-ness of American Television."[48]

Given the artist's other investigations, it is striking to note that Jieming's work has rarely addressed the issue of online surveillance head on. I would argue that this apparent omission points to a powerful insight into the reality of the Chinese mediascape. Different than in the West, the issue of surveillance is not reducible to any particular

technological, or even modernist, vector. For nearly the last century, the Occidental imagination has been captivated by the dystopian vision of Orwell, Huxley, and Dick, in which the metastasizing growth of the technologies of observation deluged the axiomatic rights of privacy and freedom.

These rights and freedoms have much different histories in China (see "Survival Robot" in the present volume), and, as we have seen, the necessity of communal self-surveillance long antedates any modernist aspirations to perfect social functioning through the application of technology. But while the US had been a screen-saturated culture for an entire generation before the arrival of the internet, in Chinese cities this interval might be a decade or less. In the still populous countryside, the arrival of these powerful new modes of nodes of connection could be even closer than that.

It is this notion of temporal flattening—an endless horizon where the *longue durée* of history has collapsed down into the perpetual now of the screen—that Hu Jieming's work most clearly dramatizes. Viewers encounter a Virilio-esque acceleration not of the airplane, but of the electron. *100 Years in One Minute* makes this condition explicit; the work reprises the vocabulary of the New Year's pieces—arrays of images on an open metal framework—but rather than sifting for an infra-difference in the arbitrary marking of time, *100 Years* funnels in a great swath of art history, distilling it down to a seemingly endless series of glowing icons. It becomes a digitized take on André Malraux's iconic "Museum without Walls," occurring at the new speed of the instantaneous image.

Coda: From Wuhan to the World

Of course, no exogenous event in living memory has done more to accelerate the progress and adoption of telecommunications media than the COVID-19 pandemic, which as of this writing is still sickening

more than ten million and killing nearly 100,000 people per week. As many artists the world over have done, Hu Jieming addressed this singular cataclysm by returning to the object in his own immediate environs. His *The Thing* exhibition, presented in 2021 in Shanghai as well as the virtual exhibition platform Artland, featured large format photographs of quotidian objects and environments that surrounded the artist in imposed quarantine. The works are highly processed and seem to foreground the flatness and artificiality not only of their own surfaces but the daily fragments they depict. As the body inhabits more of a virtual world, the physical one begins to resemble its pictorial properties.

But the COVID-catalyzed "metaverse" is far from the first time that the artist has used digital montage techniques to flatten the future onto the past. A 2001 series of picture postcards deployed then pioneering uses of image editing to overlay the evanescent images of television broadcasts onto the perduring forms of the China's Imperial past—the Great Wall, the Old Summer Palace, the Temple of Heaven, and others. What often seems as the dizzying acceleration of the present moments lands as a soft cloud of dust against an endless series of older "fresh starts" that have accompanied the passage of epochs and dynasties.

No doubt, digital acceleration will continue shake up the world order in the coming decades. Anxiety over technological superiority forms the backdrop for saber-rattling over GDPR, the dust-up between Huawei and Trump, and numerous other unfolding confrontations between world governments and tech titans. China is already many orders of magnitude ahead of the US in mobile payment processing, a situation many analysts trace back to the fact that there were few Chinese legacy systems (like credit cards) to be supplanted.[49] Experts further predict that the forthcoming AI revolution, which one technologist has likened to the commercialization of electricity, will be largely created in China and exported to the rest of the world.[50] Western technologists and trend forecasters now look to China for

cues as to how emergent possibilities such as live-social shopping and ultrafast last mile delivery will evolve.

Different than in the West, in which the negotiations between powerful entrepreneurs and government actors have been one entangled conflict, China has long treated its burgeoning technology sector as a strategic asset to be managing directly by the State. Rumors as to the evolution of this strategy were effectively quashed during a massive crackdown that took place over the course of 2021.[51] No different than its massive population—for and through which it has built the world's largest network of urban habitats out of, what relatively recently, were dusty villages and empty fields. All the better, as civic planners at least since Haussmann have known, to avoid surprises and to plan for eventualities.[52] It is the lesson of Jieming's work that the management of two glass worlds—the soaring, weightless skyline of its cities and the bottomless ocean of its innumerable glowing devices—are anchored in a common ideology. But the lived reality under the ideology of central planning is never as efficiently controlled as Party leaders might wish. It is subject to the vagaries of human rhythms—of pleasure, boredom, and mobility—and occasionally, through the idiom of art, it catches a glimpse of itself in the reflective glass.

Either the window or the screen.

3

天堂的一半

Half of Heaven

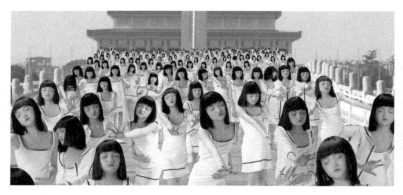

Angel #3 by Cui Xiuwen, 2006. Image courtesy of Eli Klein Gallery.

At a Glance

The following essay explores the uneasy relationship between Chinese nationalism and an implicitly Western feminism through the multifarious work of artist Cui Xiuwen (1970–2018). Though she was one of the first female Chinese artists to reach international renown, and though her practice was deeply engaged with questions of gender and identity, she assiduously avoided the appellation of "feminist" to her art. On the one hand, such categorization seemed to limit the interpretative scope of her art, but her reticence also stemmed from an incisive insistence on the misalignment between a Western rubric and a Chinese project to increase the visibility and autonomy of women. This misalignment is not a simple product of differing worldviews but rather a contestation over the ways in which the Western mission of gender parity arrived in China as part of the projection of colonial power.

As this chapter explores, the ambition to rectify the millennial subornation of women—exemplified by practices of mutilation such as foot-binding and widow suicide—was caught up in a conflict between Western reformers and Chinese revolutionaries, many of whom wanted to strengthen the position of women so that the beleaguered Empire might eject the meddlesome reformers *in toto*. This tension—between a nationalist/Maoist claim to a new equality by fiat and a Western emphasis on the constructed-ness of all modes of subjectivity—animated the evolution of women's liberation in China through the course of the 20th century, and forms an important back-story for understanding not only the work of Cui Xiuwen but the relationship between identities and economies across the East/West divide.

Muffled club music thumps from a distant source, forming a kind of mechanical murmur that flows under a chatter of broken conversations, fractional dances, and endless makeup checks. Figures flash in and out of the mirror-reflected glare. They pause to retouch, readjust, and, occasionally, recount small piles of cash. When the conversations are audible, they are typically about money. Money in short supply from an unnamed man, now threatened with the exposure of an extramarital affair. Money cut off by family and then by friends. Money tucked into waistbands and underwear, or left sparingly on the counter. A micro-universe of consumption, desire, and longing caught in the distended, fish-eye gaze of a hidden camera.

These interwoven fragments comprise Cui Xiuwen's *Ladies Room* (2000), the work that catapulted the artist into international stature. The single-channel video was featured in a three-artist exhibition at the Tate Modern, a show that made Cui the first Chinese artist to exhibit at the prestigious London gallery, and was subsequently acquired by the Pompidou Centre in Paris. The work points towards a knotty confluence of cultural norms shifting in real time at the turn of the millennium—ideas about sexual freedom and subjugation, expression and desire—shifts catalyzed by a ballooning, newly international market economy. Strikingly, the piece surfaces this welter of issues through the most minimal of gestures, the recording and remixing of surreptitious film obtained by the artist as she lingered in the restroom of a popular Beijing nightclub. The title similarly achieves pointed commentary by simple quotation. The eponymous ladies' room was the literal site of the work's filming, but the term opens out onto the loaded construction of "ladies": courtesans or call girls subject to oppression both ancient and contemporary, or modern women in some sense liberated by a neoliberal wash of freedom via consumption.

Ladies Room is but the best-known example of Cui's multifarious practice, which began in painting, grew to encompass a variety of lens-

based and digital media, and then returned to painting shortly before her untimely death in 2018. Throughout her career, she studiously avoided the appellation of "feminist" to her work. On the one hand, such categorization seems to her to limit the interpretative scope of her work to an exploration of gender, and Cui was keen to foreground the ways in which her art waded into philosophical questions typically reserved for male artists: the search for authenticity and meaning, the struggle with creative isolation, and the interpenetration of Eastern and Western histories of art. However, Cui's reticence to accept the taxonomic classification of "feminist" also stems from an incisive cultural politics—an emphasis of the misalignment between a Western rubric and a Chinese project to increase the visibility and autonomy of women.

Indeed, this misalignment is not a simple product of differing worldviews but rather a contestation over the ways in which the Western mission of gender parity arrived in China as part of the projection of colonial power. Eastern traditions, Occidental reformers, and many kinds of revolutionaries collided with one another in late nineteenth-century China, producing an ambition to rectify the oppression of women as part of an inherently nationalist project: that of modernizing the decaying Empire and reclaiming the mantle of Chinese autonomy.[1] This mode of thinking was dovetailed with Marxist logic; women's oppression was seen as symptomatic of the exploitation inherent in a capitalist world order. As such, the official abolishment of gendered discrimination became a point of emphasis in Maoist China. Women, Mao was quick to remind the People's Republic, "held up half the sky."[2] And while stated Party orthodoxy and lived reality remained two different things, this dialectical materialist baseline became the ground onto which a very different kind of Western feminism arrived in China during the opening of the 1980s. This newer iteration was animated by ostensible contradictions: proclamations of essential difference juxtaposed with an emphasis

of the constructed-ness of all modes of subjectivity, a celebration of sexual liberation and a deep suspicion of "economies" of desire.

It was within these moments of cultural encounter that Cui matured as a young artist, and the ongoing friction between Chinese and Western ideas of gender (as well as art and meaning-making) animated her career. What began as embrace of Western vocabularies of painting grew into an embrace of cinema verité and then its opposite—an adaptation of digital manipulation to produce worlds that embodied both plenitude and artifice. Her *Angel* series, illustrated at the front this chapter, exemplifies this period of Cui's career. The artist cast an evolving series of models in poses of archetypal "girlhood," which would be repeated into impossible profusion and air-dropped onto sites of historical, and implicitly masculine, significance. This series gave way to explorations of existentialism and Buddhism, embodied in both haunting narrative scenes and mute, painted geographies reminiscent of American minimalist painting. But to fully unpack this journey, it is necessary to begin to its deepest historical roots of these ideas.

Plowing and Weaving: Gender in Ancient China

Chinese cultural constructions regarding gender norms trace back into prehistory. As in many Neolithic cultures, indirect evidence, such as the parity of grave goods between male and female burial sites, suggests a comparatively egalitarian gender structure.[3] These prehistoric societies may even have been matrilineal, with the subsequent rise of patriarchy intertwined with the advent of pastoralism and private property. But by the time of the Bronze Age Shang Dynasty, women were already subordinated to inferior status.[4] The foundations for millennia of doctrine governing gender relations were formalized in the subsequent Eastern Zhou period, as theorists

began to codify expectation for an orderly government ruled by a plenipotent emperor.

The *Book of Lord Shang* (c. 350 BCE), explored in greater depth in "One Way Glass" in the present volume, exemplifies these attempts. Citing Shennong, a mythical ruler *cum* harvest deity, *Shang* authors reminded their audience that "men plow and women weave."[5] This simple phrase grew into a central ideological pillar of the complex society that governed gender relations over the millennia of Chinese Imperial history, and as such, a few observations are warranted. First, while this separation of plowing and weaving inscribes a gendered normativity onto space either within or beyond the home, this was nominally a distinction devoid of hierarchy. By contrast with Biblical creation of Eve as Adam's "helpmate," both men and women contribute through the sweat of their toil. Second, plowing and weaving were not arbitrarily chosen tasks. Shennong set these examples before the genders as productive, collectivist labors, ones taken to ensure the thriving of a community rather than ones which would waste effort towards private pursuits or idle luxury.

Five centuries later, the Han dynasty produced a compendium on women's virtue and education without precedent in the previous history of China. Liu Xiang's *Biographies of Exemplary Women* was written at a moment of ideological convergence, in which the ascendant empire sought to fuse the governance precepts of *Shang* legalism with the spiritual and metaphysical teachings of Confucianism into a cohesive ideology. The question of what this meant in practice framed an ongoing contestation over the role of women at the Imperial court. This debate was made all the more pressing because of the increasing clout of "low born" women—epitomized by the story of Wei Zifu, who had ascended from a position of slave to Imperial consort to empress after the reigning emperor Wu deposed his arranged (and much older) first wife.[6] Written to halt the attendant moral

unraveling, *Biographies* sought to provide examples of appropriate feminine behavior to which women, from center to margin, could aspire and conform.

Many of the stories turn on themes of subsuming personal desire into collective wellbeing. But the question of duty fulfillment takes on a cast that, to contemporary readers, can appear downright horrifying. The *Biographies* exhorted women to embody the virtues of familial fidelity to the extent of encouraging the practice of suicide and self-mutilation (such as cutting off one's nose to discourage would-be suitors). While few examples survive of dynastic women who actually martyred themselves to adhere to the values of the *Biographies*—suggesting to some modern interpreters that the stories were edge cases meant to illustrate a point, rather than to present realistic behavior to model—the volume nevertheless acquired foundational importance in Chinese society, and countless generations of women were raised to aspire to the values of matrimonial submission espoused in its pages.

One additional qualification is worth dwelling upon. While elite women may have been asked to hew to the values (if not the excesses) of the *Biographies*, many of these values would have been a practical impossibility for those of lower means. For example, the extreme prohibition against remarriage after the death of a husband would have likely doomed a peasant family to starvation. Thus, while a whole nexus of courtly virtues existed for women of commensurate status, these norms might have meant comparatively little in practice for most of the Middle Kingdom's vast population. With work split between plowers and weavers, peasant men and women toiled under a position of ostensible equality born of community survivalism. This is not to say that women were anywhere close to equal to men but rather to suggest that a women's subservience was not tied into an ontological inferiority. In one light, the oppression of women was

thus inseparable from, and perhaps wholly reducible to, their resource dependency.

As such, gender parity at scale would appear actionable with the stroke of a pen.

Gender, Power, and Freedom in Imperial China

While such actions were still centuries away, the succeeding Tang Dynasty (roughly contemporaneous with the European "Dark Ages") has typically been described by historians of China as a moment of comparative equality and equanimity between the genders, and surviving artifacts record women engaged in activities, such as horseback riding and public dancing, that during other times would have been considered beyond the pale.[7] This equality may also be seen in the contemporary popularity of the Ballad of Mulan—a Joan-of-Arc type heroine tale recently made famous by Disney—as well as by the rise of a culture of Daoist nuns. Such nuns, many of whom were widows, lived in richly appointed temples and sometimes enjoyed a life of bodily freedom on par with that of their male counterparts.[8]

But these developments belied an ideological hardening of women's oppression. The *Biographies* spun out a whole profusion of imitative genre tales, in which acts of self-mutilation, suicide, and murder became increasingly pervasive. The result was to draw ever more closely together the ideals of femininity and self-destruction. These fables also proliferated in the subgenre referred to as "shrew stories," tales in which women threw entire dynasties into jeopardy bullying their emasculated husbands into doing their bidding. As the moral center of decision-making is inverted, chaos inevitably ensues.[9]

Some of these stories were no doubt inspired by true events. While local administration over a vast empire was no doubt littered with

examples of familial discord spilling into civil dysfunction, the Tang period also witnessed the sole example of a woman ruling the Middle Kingdom in her own name.[10] Born to a well off merchant family of the disposition to give their female child an education, the ambitious Wu Zetian moved to take a position as an Imperial concubine at age fourteen. Although she impressed Emperor Taizong with her intellect and her physical bravery, she bore no children with him. She did, however, develop an illicit relationship with Li Zhi, the youngest son of his favorite wife. When his two older brothers locked themselves into a Pyrrhic struggle, the diminutive Li emerged as successor to the throne, taking Wu out of the nunnery to which she had been consigned and returning her to court as his own favored consort.

She quickly learned how to operate as the effective power behind the scenes and less than two years after her marriage to Li, she began a brutal campaign against those who opposed her power grab. Over the succeeding decades, rivals would be indicted at show trials and then exiled, mutilated, or condemned to mandatory suicide. When the perpetually feeble Li died of stroke, Wu ascended to throne herself, ruling as both Dowager Empress and Empress Regnant, a title that gave her the power to install or remove subsequent heirs to the throne. After a four-decade rule (six, if one counts the period during which she exercised *de facto* control through her husband), she was eventually forced to abdicate the throne at age 80. And while her successor had her interred with Imperial honors, her reign was held up for centuries as a cautionary tale that warned of the dissolution that flowed from the "unnatural" power imbalance of female leadership. This aspersion remained attached to Wu's legacy until the 1960s, when Chairman Mao's wife Jiang Qing, as part of a power grab of her own, rehabilitated Wu's status as a heroine of Chinese history and exemplar of female empowerment.[11]

In the centuries that followed Wu's reign, the egalitarian tendencies of the Tang began to disappear. The same kinds of artifacts which

had portrayed women horseback riding or cavorting in risqué garments gave way to restrained depictions of proper women clad only in modest dress.[12] These cultural shifts were intertwined with coeval intellectual evolutions. The same moment gave rise to what historians now call "neo-Confucianism," a movement which sought to ground religious and moral ethics within a framework of societal cohesion rather than spiritual enhancement.

These ideas were elaborated by Zhu Xi (d. 1200), an enormously influential thinker whose ideas remained part of the Chinese civil service exam until the twentieth century. While Zhu was comparatively bullish on women's education, his teachings admonished a strict enforcement of gender hierarchy. Though it is likely apocryphal, Zhu has historically been credited with the cultural adaption of foot-binding. According to legend, when he was serving as governor of the city of Zhangzhou, he was gravely concerned about the loose sexual morals of the city. As a remedy, he recommended appropriating an esoteric technique that had been used to shape the feet of female dancers at the Imperial court, turning a method used to form choreographed bodies onto the problem of curtailing female mobility *writ large*. In Zhu's Zhangzhou, large family gatherings such as weddings and funerals were said to resemble a "forest of canes," as few women were able to walk without physical assistance.[13]

When the Mongol invasions swept through China at the end of the thirteenth century, the situation for women continued to deteriorate. The newcomers quickly adopted and promulgated the practice of foot-binding, such that by the end of the Mongol-founded Yuan Dynasty, natural feet for women were seen as a source of ubiquitous shame.[14] The new rulers did not share the Confucian prohibition against widow-remarriage, preferring instead to remarry widows to their deceased husband's brothers. The practice of so-called "Levirate marriage" necessitated the

abolishment of one of the few protections women had categorically enjoyed through the previous history of the Empire: the perpetual rights to their own dowry as a hedge against the possible death of their husband.[15] The erosion of women's few rights—to limited mobility and to fractional property—persisted after the Ming ejected the invaders and restored Han rule to the empire. Testament to the staying power of changed attitudes can be seen in the tale of Empress Ma, the wife of the first Ming emperor Hongwu. During the first New Year's celebration of the new Dynastic reign, a resident of the capital made a lantern featuring a woman with a watermelon, understood as a veiled reference to Ma's "ungainly," unbound feet. Hongwu had the man's entire family, even distant relatives, summarily executed.[16]

And as the practice of foot-binding became *de rigueur* for families of means, the cult of widow chastity deepened alongside it. The Imperial state began awarding testimonials of merit to chaste widows, and public monuments such as shrines or arches began to emerge to honor those who had defended their chastity with their life, particularly through the act of suicide.[17] And as is the case during many episodes of cultural suppression, the counter-impulse began to grow as well. The late Ming witnessed the emergence of the anonymously published *Golden Lotus*, which detailed the lurid escapades of arch-villainess/femme fatale Pan Yunu, an ancient consort tied into the early mythology of courtly foot-binding. The eponymous lotuses refer to the shape of Pan's feet, a form that binding was intended to emulate. The book, which was aimed as a Voltaire-esque satire of the excesses of the nobility, was officially banned for centuries as pornography. However, it attracted a widespread readership amongst progressive members of the elite, and has since been hailed as a literary milestone, in part of because of its complex, agential treatment of its female characters.[18]

Freedom of movement, desire, and property, always bound up in one another.

Chinese Women, European Missionaries, and New Nationalisms

The Ming period also witnessed one additional development of deep significance for the history of gender. As discussed in greater detail in "Our Own Arrows," it was during the late Ming that the Middle Kingdom came into sustained contact with Europeans. For most of this period, such contact was limited to distant trading outposts and the occasional diplomatic emissary to the Imperial court. These emissaries, however, grew more common and more ambitious with time, and became ever more earnest about proselytizing their strange religion. During the reign of Yongli, the last of the Ming emperors, Jesuit missionaries achieved a major victory—they convinced several members of the inner court, including the emperor's aging mother, his wife, and eventually, his heir, to convert to Christianity.

Such conversions were motivated at least in part by a desire to shore up the foreign support needed to buttress the Ming against mushrooming upheavals in the countryside. These upheavals were catalyzed by famines but greatly exacerbated by wild currency fluctuations introduced through trade with the same Catholic foreigners the Ming were attempting to cultivate as allies. But entreaties to Rome went unanswered, and the Ming Dynasty crumbled in the face of the Manchu rebellion in 1644. The new Qing emperors sought to stamp out such religious interference, introducing anti-witchcraft laws that included reference to Christians, but to little avail. Through the course of the 18th and the first half of the nineteenth century, Catholic Jesuits were joined in ever greater numbers by Russian Orthodox and Anglo-American Protestant missionaries. Campaigns against foot-binding quickly became central to this work, especially among the Protestants, a community that counted a significant number of women among their ranks.[19] These missionaries shared

their horror at the practice both to their Chinese converts and to the faithful back home, which created significant international embarrassment for China on the world stage. A pattern of Western shock at Chinese human rights abuses, motivated by a mixture of genuine outrage and political convenience, that has continued to the present day.

The abolition of foot-binding, and by extension, the liberation of women, became increasingly identified with reform efforts intended modernize the Empire. The urgency of such reform became increasingly clear in the wake of the lopsided defeat suffered by the Chinese during the Opium War. The resultant movement for "self-strengthening" sought to absorb the useful parts of Western achievement (mostly in the arenas of science, technology, and warfare) while holding onto the essential characteristics of Chinese culture.

Importantly, these developments occurred in parallel with the emergence of what is now called "first wave" feminism in the English-speaking world. But while cross-activation did exist, particularly on the issue of foot-binding, the cultural and political goals were enormously different. In the West, the movement for women's suffrage, for example, was intimately connected to other progressive reforms, such as the abolition of slavery and the passage of temperance laws. These social goods were pursued for their own ends, as well as to achieve a more equitable and harmonious civil society. By contrast, within China, agitation for women's equality was almost without exception framed as part of an increasingly fervent nationalism. The need to improve the lot of China's women was articulated as an imperative to improve their efficacy as empowered wives and mothers capable of sharing the burden of modernizing China, and perhaps, finally ejecting the meddlesome foreigners.[20]

The nation proved in need of additional defense. The Qing suffered another humiliating defeat in 1895 in the Sino-Japanese War, after

which Tokyo became a hotbed of expatriate Chinese radicals. These reformers counted in their midst increasing numbers of women. Probably the best remembered today is Qiu Jin, whose "A Respectful Proclamation to China's 200 Million Women Comrades" became a watershed moment in the history of Chinese gender politics. Qiu's origin story forms a kind of microcosm of the collision of Chinese nationalism and Western reformism at the turn of the twentieth century, a collision which lies at the heart of the complex relationship that contemporary Chinese political ideologies maintain between ancient tradition and Occidental interference. Qiu's grandfather had been a Baptist minister, and her family permitted her latitude to educational and social opportunities typically reserved for boys.[21] She married the son of a wealthy merchant, but her emergent revolutionary spirit made her a bad fit for a traditional domestic role. She left her husband and two children behind to pursue additional study in Japan, as the reigning Dowager Empress Cixi had encouraged after China's defeat in the Sino-Japanese War. She helped to established women's advocacy groups in Eastern Russia—dressed in male clothing—cultivated her study of martial arts, stoked ethnic resentment of the Manchu Qing empire, and yearned for a revolution.

For Qiu, women would occupy a central role in the transformation to come. In her iconic "Respectful Proclamation" she heralded a call to action for women of every generation: "grandmothers, you mustn't say you are too old ... girls, no matter what, never have your feet bound." The stakes were enormous. As victorious Japan had strengthened itself by the modernization of the female half of its population, so China's fate hung in the balance. As Qiu put it, "if we fail to rouse ourselves, it will be too late after the nation perishes."[22] And she fully intended to lead the charge herself. In 1907, Qiu returned from Japan to head up the reformist Datong School and plot insurrection. Authorities caught wind of her plans to foment an uprising in Anqing

and tortured her to extract a confession. When she refused to admit her involvement, she was publicly executed as a seditionist on the basis of her writings.

But the drumbeat of revolution continued to grow louder. The trail blazed by Qiu was followed by a subsequent generation of female revolutionaries, including the prolific anarchist writer He-Yin Zhen. He-Yin studied at the progressive Patriotic Women's School run by Qiu's collaborator Cai Yuanpei, and like Qiu, made her way from reformist Shanghai to revolutionary-minded Tokyo. Once there, she became an energetic organizer and incisive critic, elaborating arguments that presaged subsequent calls for global socialist revolution. He-Yin was just as an ardent a revolutionary as Qiu, but a more elaborate theoretician. Developing ideas from Marx and Engels (newly translated into Japanese the same year as her arrival) as well as the ideas of South African feminist Olive Schreiner, He-Yin elaborated a line of argument that is strikingly modern and uncompromising. As He-Yin put it in 1907

> For thousands of years, the world has been dominated by the rule of man. This rule is marked by class distinctions over which men— and men only—exert property rights. To rectify the wrongs, we must first abolish the rule of men and introduce equality among human beings, which means that the world must belong equally to men and women.[23]

For He-Yin, this asymmetry concerning the right to hold property functioned as a kind of poisonous crystal seed, infecting institutions and social norms ranging from marriage to state religion with the taint of illegitimate oppression. To resolve the question of women's equality, and thereby to set the nation back on the path to self-sufficiency, one would need to do away with the system of private ownership. And all of the cultural trappings built on top of it.

The (Non) Place of Gender in Chinese Socialism

Five years after He-Yin's publication of "On the Question of Women's Liberation," the unthinkable happened. In 1912, the oldest and largest empire in the history of the world succumbed to a cascade of brushfire revolts that grew into a revolutionary conflagration. The power vacuum created by the toppling of the Qing dynasty can be hard to fathom; the disparate revolutionary groups fought for a tangle of opposing agendas that embraced traditionalism and radicalism of nearly every imaginable stripe. An uneasy alliance developed between the widely respected Republican revolutionary Sun Yat Sen and the former Qing military commander Yuan Shikai. But the provisional government was compromised from the start, and was unable to either exert control over its own territory or effectively represent China on the stage of world power politics. China had been barred by the Allied entente (and Japanese occupying forces) from sending combat troops to fight in Europe's Great War, and was again humiliated by compromises to its territorial integrity agreed upon at the Treaty of Versailles.

Broad dissatisfaction with the pace of post-revolutionary social transformation gave rise to more strident demands. Promulgators of the so-called New Culture Movement demanded a thoroughgoing political and cultural break with the past. One writer pithily summarized the movement's goal as jettisoning "Mr. Confucius" in favor of "Mr. Science" and "Mr. Democracy."[24] A literary and scholastic corollary, suitably titled the Doubting Antiquity School, gained traction among the nation's leading intellectuals. A young political thinker named Chen Wangdao first translated Marx into Chinese.

Importantly, the New Culture Movement was allied in spirit with a coalescing movement for women's liberation. Organizations such as

the United Women's Associations and the Progressive Association for Women's Participation in Politics came into being during the 1920s, and focused substantial energy on legal, professional, and educational equality for women. These political developments paralleled the emergence of the so-called "modern woman," identified by her participation in a landscape of previously unimaginable consumer and lifestyle choices.[25]

These developments were made possible by an historically unstable political situation. When the consensus Republican leader Sun Yat Sen died in 1925, a split emerged between the followers of Sun's lieutenant Chiang Kai Shek and a splinter sect of Chinese communists led by Mao Tse Tung. From the beginning, Mao's Communists were avowedly committed to women's causes. In only the second year of its existence, the nascent Chinese Community Party passed a "Resolution on the Women's Movement," which adapted formal guidelines for the advancement of women's position in the new China.[26] Mao continued to emphasize the importance of women, and women's liberation, to the broader socialist struggle. In his 1927 "Report on an Investigation of the Peasant Movement in Hunan," Mao forwarded the unprecedented argument that today might be called intersectionality—highlighting the ways in which peasant women had been doubly oppressed as a result of both their class and gender.[27] While Chiang's GMD government, which was locked in armed conflict with Mao's faction, began on a note of liberalism with regards to women's issues, it quickly reverted to a deep conservatism that sought to restore women to a place of traditional passivity. Chiang's New Life Movement argued for a broad return to traditional Confucian ideals, one which would entail the right of a husband to prohibit his wife from earning income outside the home.[28]

As detailed in "Degrees of Separation" in the present volume, Mao's Communists were eventually victorious over Chiang's Nationalists. After declaring the new People's Republic of China in 1949, the

New Marriage Law was among the first pieces of legislation enacted by Mao's government. The law raised the marital age to twenty and specified, for the first time, that both parties were required to give their consent to the marriage. The rule became an important part of larger campaigns of land reform, aiming to prevent the forced sale of daughters to predatory landlords.[29] The law was popularized in the countryside by an aggressive propaganda campaign, and encapsulated by Mao's slogan that "men and women are equal; everyone is worth his (or her) salt."[30] This motto became a precursor to Mao's most famous statement that "women hold up half the sky." Personal equality, as always, stemmed from an equal contribution to the collective labor of the nation.

New organizations mushroomed in the wake of the revolution to support the adoption of a new set of cultural norms. The All-China Women's Federation absorbed the membership of a number of prominent female revolutionary leaders, and assisted with implementation of laws designed ameliorate gender inequality. Important gains were registered. After five years, 90 percent of marriages were registered as compliant with the new legal mandate. When literacy statistics were first formally tracked in the early 1980s, the women's literacy rate was more than 50 percent (by comparison with ~40 percent in total for India).[31] Female education at all levels increased by 50 percent between 1950 and 1990.[32] Women joined the industrial workforce in heretofore unimaginable numbers. According to one study, of the women who married between the years of 1966 and 1976, 92 percent were employed outside the home.[33]

Significant gaps nevertheless remained, especially in the countryside. The larger land reform process (of which the Marriage Law had been a part) had already engendered substantial conflict and, as historian Gail Hershatter has emphasized, there is scant evidence that local leaders had either the ability or the motivation to see the law widely implemented.[34] Progress, when it did come, was

uneven at best. Changing norms around divorce catalyzed a wave of violence and suicide amidst China's rural female population. Women were systematically unable to access favorable positions in the new economy, and if they succeeded as an exception to the rule, they were almost always paid less.[35]

And when the destruction of Mao's Cultural Revolution began to sweep through China, the cause of women's advancement was caught up in its teeth. Strong links persisted between a demarcation of femininity (and female-specific issues or identities) and the ostensible false consciousness of Occidental, bourgeois ideology. The errant division of male and female identities was deeply embedded in Chinese revolutionary ideologies, and the earnestness of the desire to erase the differences between men and women may be difficult to comprehend in the West, where generations of feminist thought have emphasized the irreducibility (Second Wave) or arbitrariness (Third Wave) of gendered subjectivity. By contrast, early revolutionary thinkers such as He-Yin Zhen had emphasized novel concepts such as "*nannü*" (男女), a neologism meaning essentially "man-woman." As He-Yin wrote in 1907

> By [saying] "men" (*nanxing*) and "women" (*nüxing*) we are not speaking of "nature," as each is but the outcome of differing social customs and education. If sons and daughters are treated equally, raised and educated in the same manner, then the responsibilities assumed by men and women will surely become equal. When that happens, the nouns "men" and "women" would no longer be necessary. This is ultimately the "equality of men and women" of which we speak.[36]

This erasure of gender by cultural reformation, an idea with ancient roots in the quasi-equivalence of plowing and weaving, would find an expression by a path of least resistance in Maoist doctrine. The Three Great Differences he aimed to erase were between manual and

managerial work, urban and rural populations, and agrarian and industrial labor. There simply was no Fourth Difference for men and women—holding up half the sky was presumably equivalent and sufficient in a world of limited Party resources to affect transformation on the entire fabric of society.[37]

This ideological elision created the fault lines into which sank the organizational edifice built by and for China's women during the first half of the twentieth century. With the aspersion of Western meddling hanging over the notion of "feminism," the All-China Women's Federation was disbanded in 1966, and for nearly a decade through the Great Cultural Revolution, no female-centric political or economic organizing would permitted.[38] With gender hierarchy officially abolished, little need persisted for those dedicated to the advancement of anything other than Party orthodoxy.

Difference, and Much Else, Returns

Following the death of Mao in 1976, a number of developments important for our story begin to unfold alongside and within one another. At its broadest level, the period of 1976–89 was a time of enormous economic expansion with an uneasy cultural corollary. As explored in greater details in "Our Own Arrows" in the present volume, the economy of China went through a world-historic growth spurt, with GDP doubling over the course of the 1980s. Beginning with Mao's secretive negotiations with Nixon and continuing with his comparatively liberal successor Deng Xiaoping, economic activity grew ever more intertwined with international capitalism. The question that dogged the party resonated with the struggle of the late Qing—how to adapt the techniques and technologies of the more powerful outside world from which the Empire had been cut off, while holding onto control of the cultural and political systems by

which China defines itself? As Deng famously quipped, "if you open the window for fresh air, you have to expect some flies to blow in."[39] Contemporary art was, in its own way, one of those "flies," emerging in the late 1970s and increasingly finding its own institutional voice as the memory of Mao's autarchic control over cultural output faded into historical memory.

The Party continuously struggled to ensure that their central planning encompassed all facets needed for a thriving economy. And in the late 1970s, a monster appeared to be lurking in the domain of demography. Even with the wholesale violence through which Mao prosecuted the Great Leap Forward and the subsequent Cultural Revolution, China's population was poised for an expansion that might even outpace the economy. Life expectancy rose dramatically as infant mortality fell.[40] China's population itself approximately doubled between 1949 and 1976. When put up against the US, the numbers are staggering. In the same two and a half decades, the US added approximately sixty million people. China added that many people, on average, every four years.

In 1979, the Party introduced the now infamous "One Child Policy." While exceptions persisted (such as those for ethnic minorities, or disabled parents), the Policy had deep repercussions for the generations of Chinese citizens born after Mao. According to the Party's own published statistics, 400 million births were prevented, and with them concomitant pressure on urban space, government services, and natural resources. To enforce limitations on family size, after the birth of their first child women were required to submit to the implantation of an IUD (customized so as to be irremovable without surgery). If they managed to have a second child, they were forcibly sterilized by tubal ligation. All told, more than three hundred million were implanted, and a hundred million were sterilized.[41]

In addition to the traumatic consequences of hundreds of millions of involuntary medical procedures, the Policy introduced other unforeseen complications. The productivity of the Chinese economy was imperiled as family size shrank, base labor pools dried up, and the mean age of the population began to drift upwards. Moreover, anti-female bias, officially dispelled by Maoist revisions of culture, was clearly visible in the demographic aggregate. Scholars estimate that China has become home to well over 30 million additional males, evidence of a horrifying epidemic of gender selective abortion, adoption, and abandonment. The gender imbalance intersected with an economy and a culture changing in real time. As detailed in "One Way Glass," the post-Mao era was also witness to one of the largest and most rapid processes of urbanization in human history, and as migrants began pouring into a host of new export-focused cities on China's south and west coasts, economic and cultural reconfigurations around gender were bound appear.

Perhaps the most pointed of all of these was the rampant rise of prostitution. According to official statistics, the incidence of arrest for a prostitution-related crime exploded by an astonishing factor of 20,000 percent between 1982 and 1997.[42] The perceived cause of this proliferation varied considerably by ideology. Orthodox Party leaders were quick to blame the importation of "spiritual pollution," a phrase adapted from the nineteenth-century battle against the scourge of opium but that has come to refer to the corrupted decadence of the West. Western commentators, in turn, were likely to point the finger back to China's ostensibly regressive patriarchal culture, and the gender-imbalance that such culture created through the One Child Policy. But perhaps a subtler point was in play concerning the means and opportunity for the sale of sex. Mao's diktats had given women the means: the legal right to possession of their own bodies as well as equality in the pursuit labor, while the neoliberal reforms of the 1980s

Figure 3.1 *Ladies' Room* by Cui Xiuwen, 2000. Image courtesy of Eli Klein Gallery.

had introduced vast new markets of buyers with disposable income and uprooted familial attachments.

It was amidst this ferment that Cui Xiuwen came of age as an artist.

The Artist in Context

Cui was born in 1970 in the remote northern city of Harbin, approximately 500 miles northwest of Vladivostok, Russia. She grew up in a large family and enjoyed a comparatively unstructured childhood, recalling that her parents treated the siblings like "sheep" who were "put out graze in the wild."[43] Her creative energy began to express itself early, and she recalled a prescient incident to an interviewer from the Tate in 2013. In middle school, Cui learned about

Wu Zetian, the female emperor from the Tang period, a lesson almost certainly connected to Jiang Qing's then-recent efforts to rehabilitate Wu's historical reputation. Cui remembered the deep impression made not only by Wu's female bravery and military heroism, but also by her advancements in calligraphic script. Inspired by her new heroine, Cui decided to reinvent the characters composing her own name. She chose a homonym so that her name would be pronounced in the same manner, but written with characters of a completely new meaning. Instead of her given 秀 (beautiful) and 文 (culture)—"cheesy and mundane" in the artist's estimation—she choose 岫 for mountain caves and 闻 for news.[44] The news from mountain caves: shades of the storied tradition of bandit hideouts (see discussion of *shanzhai* in "Our Own Arrows") and a declaration to issue one's own singular truth.

At around the same time, she began to find her way towards art, remembering that she would draw "relentlessly" in the margins of her schoolbooks.[45] She went onto pursue formal education in oil painting at Northeast Normal University, focusing on the basics of observational technique while, thousands of miles to the south, the cultural experiments of the 1980s were crashing headlong into tragedy in Tiananmen Square. The dust had mostly settled from the so-called June 4th incident when Cui made her way to the Central Academy of Fine Arts in Beijing in the mid 1990s. At CAFA, the nation's most prestigious art school, Cui studied a mix of Western theory—Freud and Foucault in particular stood out in her memory—as well as an eclectic assortment of modern and postmodern art. Her paintings from this period clearly bear out her engagement European painting traditions, particularly the jagged pictorial space and raw brushwork of German Expressionism. Her *Rose and Peppermint in Water #10* (1996) links this received idiom with the work about to emerge. Graphic black lines trace the contours of a male nude and female figure—possibly a painter, possibly another model—leaning

suggestively over a small stool. The cinematic, over-the-shoulder perspective links the viewer into a chain of observation that inverts the gendered expectation of the gaze (male model/female painter). The sexualized, ambiguously autobiographical depiction of the female figure would return, in a substantially altered context, in Cui's mature work.

After graduating, Cui briefly participated in the idiom of "apartment art"—a broad-based trend among experimental Chinese artists in the 1990s to produce small-scale projects out of salons conducted in communal apartments. She helped to found an all-female co-op called the Sirens Art Studio, but soon departed Beijing for additional study in Paris.[46] Upon her return, Cui pivoted to a primarily lens-based practice, which began with video but would soon encompass digitally manipulated photography as well. Importantly, after her return from Paris, no men would appear as subjects in her art.[47] It was in the wake of her return from Europe that Cui shot *Ladies Room*, which drew together a complex of unsteady binaries around freedom and exploitation, socialism and the leisure economy, sexuality and agency at the cusp of the new millennium.

Without overreading the purposefully laconic piece, two additional pieces of bookended contextual information are worth noting. First, Cui's recent European travel suggests the possibility of reading *Ladies Room* within the larger history of depictions of courtesans and prostitutes. These depictions, particularly Manet's iconic *Olympia*, are central to the story of European modernism, and were themselves made possible by a confluence of changes in patterns of urbanization, family life, leisure economies, global markets, and methods of telecommunication. In this light, *Ladies Room* functions as a fascinating counterpoint: a new, unflinchingly direct and yet humanizing look at the sex trade as metonym for epochal social changes. But a look, or a gaze, through another end of the telescope—

the perspective of a Chinese female artist working in a technological rather than painterly medium.

And it is in this second, perhaps postmodern, mode that the additional bit of contextual information becomes relevant. The year after *Ladies Room* was shot, China officially joined the WTO, an affiliation made both possible and necessary by the exploding export market for handheld electronics like the camera which Cui used to film in the lavatory. China's membership in the WTO brought with it a bracing acceleration of the social and economic upheavals subtending the profligate exchange of sex and money caught up in Cui's hidden lens. In a distant rhyme with Toulouse-Lautrec's *Moulin Rouge*, we get a fluorescent-lit glimpse of a world tipping over the precipice of unimaginable change.

Though it is by far the best-known work, *Ladies Room* is in fact part of a trio of related pieces that explore the broad historicity of desire. In both of the other works, Cui turns the camera on herself.[48] While the risqué *Twice* (2001) depicts the artist caressing herself and engaging in phone sex with an unseen interlocutor—again reprising the interconnection between the techno-economic and the sexual—it is *Toot* (2001) that situates this examination back in deep history. *Toot* begins with Cui clad, mummy-like, in toilet paper, which is soaked in water and slowly dissolves over the course of the work. The visual vocabulary is reminiscent of Yoko Ono's well known *Cut Piece* (1964), in which Ono's clothing dissolves into ribbons as audience members slowly cut it away. But different than the vulnerability of Ono, Cui emerges from her depicted ordeal seemingly triumphant, with arms raised in defiance.

The work's more deeply historical address comes through its score, in which the canonical folk song *Ambush on All Sides* is played on the Pipa, an ancient Chinese instrument comparable to the Western lute. The selected moment of *Ambush* overlays romantic tragedy on

top of the political, as the favored courtesan of a doomed rebel leader kills herself rather than allow herself to be captured and defiled by the encroaching Han army. The work opens onto dark themes—widow suicide and rape as a weapon of war—but yet Cui insists that these have in some sense been metabolized. For Cui, the dissolving paper serves as metaphor for the dissolving bonds of the past, with the climactic release symbolizing the artist's newfound freedom to create in the wake of tradition rather than within its strictures.

Uniform History and Beyond

This attempt to recast masculine history through a reimagined confluence of gender and technology links the above group of video-based pieces to a subsequent body of digitally manipulated photographs produced over the next ten years. These works all feature an "everywoman" female protagonist, a partial stand in for the artist herself, proliferated and distributed through a scenographic of Eastern and Western history. The first of these pieces, *Three Realms* (2003) features a school-aged girl, dressed in the iconic uniform of the Young Pioneers, and composited into all thirteen roles of Leonardo Da Vinci's *Last Supper*. The follow up work *One Day* (2004), finds casts of the same juvenile character reduplicated into the courtyard of the Forbidden City in Beijing. These works oscillate in tension between seemingly incompatible universals: the typologies of religious characters and secular orders, the ubiquitous weight of both Chinese and European civilizational narratives. This is especially true of *One Day*; the iconic red-walled courtyard had been famously depicted by breakout Chinese contemporary painter Yue Minjun in his searing *Execution* (1996), a waking nightmare of mass production, indoctrination, and destruction that draws together the violence

of Tiananmen Square and Francisco Goya's haunting depiction of Napoleonic firing squads in the *Third of May* (1808).

In a poetic logic similar to her explication of *Toot*, Cui argues that these wave patterns of historical trauma can be made to cancel each other out through the process of artmaking. While the Young Pioneer uniform was personally significant to the artist, "a mark of belonging to a certain generation" as she put it, the character inhabiting her works enables a kind of collective depersonalization. "Let the girl bear the consequence of history," Cui declared. "Let her balance herself in the process of breaking up, converging, evolving, and duplicating."[49] Indeed, these processes are made literal at multiple levels—the convergence and reduplication of historical tropes and ideas, the imagistic manipulation of entire worlds populated by digital doppelgängers, and subsequently, by the next series in which the holotype character is depicted as pregnant. In the *Angel #3*, illustrated at the front of this chapter, endless copies of the now teenaged model spill forth from the Hall of Supreme Harmony (an anchor of the outer court of the Forbidden City). The profusion is suggestive of many things at once: opulent displays of Imperial might, the bottomless past of feminine fertility, the circulation and profusion of digital copying. Woman as past, present, and future.

It is, in this light, an apposite moment to address Cui's complex relationship with the frequent ascription of the term "feminist" to her practice, an ascription she strove to resist. As she told *Artslant* magazine in 2011, "I don't appreciate having such title put on my work. I think it's very limiting," noting that, "in China, I don't feel like such a distinction is made."[50] Cui here indirectly flags the incommensurate histories of women's liberation noted above—in the service of individual freedom, or national strengthening; the embrace of essential difference or the sublimation into a universal; the intersection of oppression from a colonial or patriarchal vector.

In light of this complexity, Cui endeavored to preserve her own room to maneuver in ways that did not adhere to the received orthodoxies of Western thinking, or as she astutely observed, Western curatorial frameworks that served an instrumental role in the international art market.

Which is not say that she did not view her work as a means to reconsider history, and agency, from the perspective of a Chinese woman. As Cui told the Tate in 2013

> Chinese society has always given men more rights and opportunities than it has to women. This is a historical problem passed down from many years ago. In our early history, there were matriarchal tribes. At a surface level, gender seems simple, a matter of our flesh and bodies. But the relationship between men and women goes much deeper than this. So in my work, I am often trying to push a bit further into this relationship.[51]

Significantly, her citation of China's matrilineal prehistory is itself inscribed within its own historiography. Many of the relevant fragments of archaeological evidence to support this conjecture came to light just before Cui's childhood, and their interpretation was framed within the dominant ideology of the CCP. Namely, the existence of equanimous gender relations that antedated Imperial history fit squarely with the Marxist conjecture that the invention of private property (and the attendant problem of filiation and inheritance) was tied into the subjugation of women. This contrasts markedly with the Western feminist line or argument that the repression of the feminine—whether the originary sin of Eve or Kristeva's ontogenic rejection of the maternal body—is itself the conceptual cornerstone of a civilization that cannot but be organized as a patriarchy.

Nevertheless, as Cui emphasizes, her attempt to "push further" can neither begin nor end with a freestanding concept of gender. Elaborating about the origins of oppression *in toto*, Cui explained that

Figure 3.2 *Existential Emptiness* by Cui Xiuwen, 2009. Image courtesy of Eli Klein Gallery.

"It was not just a gender problem; women were not the only ones who suffered … the first problem is human nature, the second is about standing up as a person, and the third is gender."[52] These comments, made in November 2013, reflect an unfolding pivot in her work, onto the dynamics of what might described as self-actualization. This later body of work reflected a deepening of her engagement with both the Western tradition of existentialism as well as traditional Chinese Buddhism. The aptly titled *Existential Emptiness* series returned to the schoolgirl-aged character, resituating her away from the sites of history and into a desolate, snow-covered landscape reminiscent of Cui's native Heilongjiang province.

This series deploys a novel take on the reduplication of *Angel*. Rather than the superabundance of digital copying, here the young girl is accompanied by a physical double, a life sized doll that seems at once to function as companion and encumbrance.[53] While the works are similarly produced as digital photographs, they borrow the visual vocabulary of traditional scroll painting: extremely elongated horizontal formats, spare tonalities, and perspectival space washed away into a haze of ethereal fog. These oppositionalities map onto the expected dualities—yin and yang, body and soul, the emptiness of Sartre and the disembodied transcendence of the Buddha.

A self coming to know itself by means of reflexive recognition. But with the feminine posited as the universal.

Coda: Following Into the Light

Existential Emptiness would be the last of the photographic works Cui would execute. Following this series, she returned to the medium of painting, executing a number of works of geometric abstraction that embraced the idiom of Russian constructivism and the materials, such as Phoebe bournei wood, of historical Chinese craft traditions. These geometric works became the basis of a monumental installation realized at the Arthur Sackler Museum at Peking University in 2016. A series of rooms was filled with colorful geometric constructions that folded into the physical architecture and landscaped grounds beyond the museum, each of which abstracted progressively more from the corporeal to the spiritual.

The Body space—minimalist-style spatial forms fabricated in a palette derived from ancient Chinese painting—precedes a zone dedicated to the Heart, which frames a massive "Scholar's Rock" in colorful scaffolding. These are followed by a Spirit installation (cascading neon forms reminiscent of a Nauman or Flavin corridor) and finally an open space of Destiny which recapitulates the vocabulary of the prior rooms. Computer visualization guided the color selection for the final room, so that the afterimages of the perceived objects would cancel one another out.[54] Cui described it as a space of possibility into which she could "release her life and art."[55]

It was to be a prescient, haunting description. Unbeknownst to even her closest collaborators, the artist was gravely ill. Shortly after the close of the exhibition, she passed away after a solitary battle with cancer at the age of 51. She left behind an ambitious body of work that

remains difficult to classify in totality, and characteristically resistant to embodying any kind of universalizing female subject position. "I want my work to be seen as made by an individual, not made by a woman," she told an interviewer in 2011, "I think the goal of art is to realize our own individuality, which is beyond gender." Beyond its limitations, but nevertheless animated by their variable construction. Rather than reduce the feminine to a singular position from which Cui, or any other artist, could speak, her art insists on the possibility of the feminine as itself a universal subject—one from which fundamental questions about the meaning of history, limits of human nature, and the possibilities of technology can be seen through different though nevertheless familiar eyes.

4

超越外部界限

Beyond the Outer Edge

Civilization Landscape by Qin Feng, 2004. Image courtesy of the Ethan Cohen Gallery.

At a Glance

The following essay examines the work of Qin Feng, an ethnic-majority Han artist from the contested area now territory called Xinjiang. Qin's work, which seeks to hybridize Eastern and Western sources into a new kind of pictorial and gestural language, becomes a prism through which to see the millennial conflict over the territory that sits in the foreboding crux of Turko-Islamic and Chinese civilizations. Importantly, Qin's work does not directly address this conflict; he has assiduously avoided political commentary for reasons that likely stem from both his biography and from his larger artistic project. While his own family suffered significant reprisals political dissention—for which they were exiled to Xinjiang in the first place—Qin's own practice has turned on the amalgamation of fragments from numerous cultural and civilizational moments. It is filled with, as the image on the cover of this book illustrates, a kind of dust that floats towards the future.

And yet, Qin is one of the few prominent contemporary artists from Xinjiang and one of the only one figures that incorporates touchstones from Uyghur language and culture in his works. As such, his engagement with this material becomes a singular prism through which to see the dominant Han ideology of the Western Territories, one in which the reach of modernity can finally dissolve the inveterate false consciousness of resistance to civilization.

In Qin Feng's work, ink washed forms leap and flow boldly over dramatically large canvases, each one an instantaneously formed impression of an artist's momentary gesture. Often, thin red ribbons run in, among, and through deep black depressions, spooling together in the composition's visual centers. Indeed, Qin Feng's ink painting is striking for the way in which its mark-making maintains visual interest at different scales, a feat most often associated with the iconic Jackson Pollock. Feng has indeed drawn repeated comparisons to Pollock and other AbEx luminaries such as Franz Kline.[1] His work is indeed informed by their examples, as well as numerous Chinese touchstones both ancient and modern.

Qin's formal education as an artist began at the Shandong University of Art and Design, where an emphasis on mural design incorporated classical techniques from both Asian and Western art. His immersion in media spanning fresco and ink-and-brush calligraphy complemented an intensive, nearly solitary engagement with emerging trends in contemporary art. He contributed works to a range of official exhibitions during the New Wave of the middle 1980s, and then shifted his practice to Germany. Once abroad, he discovered a renewed interest in the traditional Chinese vocabulary of calligraphic ink, but reimagined through the bold gestural abstraction of Western modernism.

Though he is most frequently compared to the canonical figures of the New York School, one of Qin's most striking series directly recalls the works of land artist Robert Smithson, whose practice seems relevant to painterly gesture in only the most oblique possible way. Rather, Smithson's practice was focused on the irreducible materiality of site and its abstraction into the "non-site" of representation. In different works, these abstractions took the form of veristic images, verbal descriptions, or literal extractions of sampled material. All three of these modalities came together in one of Smithson's most important

projects, the *Yucatan Mirror Displacements* (1969). Dense green jungles, dusty deserts, and destitute beaches all reflected in the same impassive mirrors, which were then rephotographed and presented as freestanding works. The double displacement of representation and place through image.[2]

Qin employs a similar tactic in the *Civilization Landscape* works (2004–12), in which accordion books of calligraphic figures—executed in massive proportions—are photographed back in the landscapes from which their iconography is drawn. Clean black edges sit against neatly planted crops, grainy brushwork stands out against sandy desert crossings. An abstraction of place is refracted into the medium of text-image, and then again image alone. In speaking about these works, Qin insists that he aimed to "remove the cultural specificity" of the words and gestures he drew upon, instead preferring to focus on their qualities as "primary marks." Such generalizing intentions, however, seem belied by the works in this series that limn Qin's upbringing in the Western desert landscape. A landscape and an upbringing in which he came into frequent contact with Muslim neighbors.[3]

How Qin came to be born and raised in these Western badlands is a story all its own. His great grandfather was a part of a generation Han Chinese—the historically dominant ethnic group of the Chinese Empire—who were exiled to the far Western territories in the wake of a brutal campaign of reconquest.[4] The distant government sought to bring the frontier region under more effective control, and began to repopulate devastated towns and countrysides with undesirables exported from mainstream society on the Empire's eastern coasts.[5] These resettlement campaigns formed a part of a millennial strategy to bring this forbidding area at the nexus of Chinese, Islamic, Turkic, and Russian civilizations into the orbit of the Middle Kingdom. Waves of mutually attempted genocides and resettlements have washed over the desert valleys for uncountable

centuries, with an identifiable through line of rebellions, retributions, and reprisals dating nearly to the invention of writing.

The endless contest over the territory now called Xinjiang, but which has also been known as Altishahr, Dzungaria, and countless other names, is vital to understand the current controversy over China's treatment of its Muslim Uyghur minority, arguably the hottest contemporary human rights flashpoint between China and the West. Importantly, Qin's work does not directly address this conflict; he has assiduously avoided political commentary for reasons that likely stem from both his biography and from his larger artistic project. While his own family suffered significant reprisals for political dissension—for which they were exiled to Xinjiang in the first place—Qin's own practice has turned on the amalgamation of fragments from numerous cultural and civilizational moments. It is filled with, as the image on the cover of this book illustrates, a kind of dust that floats towards the future. And yet, Qin is one of the few prominent contemporary artists from Xinjiang and one of the only figures who incorporates touchstones from Uyghur language and culture in his works. As such, his engagement with this material becomes a singular prism through which to see the dominant Han ideology of the Western Territories, one in which the reach of modernity can finally dissolve the inveterate false consciousness of resistance to civilization.

The Long History of the "Western Regions"

The land now administered as the Xinjiang Uygur Autonomous Region is an enormous, largely inhospitable expanse of over a million and a half square miles. It is shot through by rugged mountains and seemingly endless deserts, and contains the remotest point of land from any sea on earth. The territory has historically been divided into a northern and southern half. The former is primarily a grass-filled steppe, the latter an

expansive, searing desert. These zones, which together comprise more than a third of China's land mass, are bisected by the soaring Tian Shan mountains—a perpendicular, East–West extension of the Himalayan range. The area has been the site of contact and conflict between peoples migrating from Eurasia, East Asia, and the Indian subcontinent since such migrations were recorded to have begun.[6] A litany of some length is unavoidable; it is important to address how irresolvably ancient the dispute over this territory has been.

There is no getting underneath it, the conflict goes right to the bedrock.

Archaeological evidence suggests that the first inhabitants of this region arrived during the late 3rd millennium BCE, a movement that coincided roughly with the building of the Egyptian pyramids. The newcomers were likely an admixture of formerly settled farmers hailing from what today is the eastern border region between China and Russia. These original inhabitants were eventually joined by additional waves of explorers from both the central plain of China as well as ancient Persia who arrived by way of Indo-Afghanistan. Evidence from funerary objects as well as farming techniques suggests a vibrant exchange of ideas moving in both directions.[7]

Any such frontier cultural zone is, in the long run, nearly certain to become the site of mutual antipathy. Subsequent histories allude to armed conflict between nomadic herders and the centralized Chinese state dating back at least to the Shang Dynasty (c. 2400 BCE), with the details of the back and forth violence between them lost into the dust of history.[8] Given that the lineage is for all intents and purposes endless, the reprisals flanking the conquest of the Quanrong by King Mu of Zhou (c. 950 BCE) is as good a place to begin as any. It certainly sets the stage for a type form to come.

Indeed, before diving into the details, it is worth dwelling for a moment on the fact that the Zhou/Quanrong pattern generalizes with high fidelity for many subsequent centuries. Like a record on a groove,

the story kept repeating itself all along China's Western frontiers. Irrepressible nomads would repeatedly aggrieve their Imperial neighbors, who would set out on a punitive expedition. The invasion would become permanent as the State attempted to pacify the area. Chaffing against the imposed colonial rule, the local populations would eventually coalesce, rebel, and toss out the hated invaders. And then the cycle would begin anew as emboldened raiders encroached ever further onto the settled societies they had recently defeated. Perhaps the clearest way for Westerners to envision the conflicts is to imagine the war between Native Americans and American Settlers happening in perpetuity, because each side lacked the capability to actually finish the other off.

These steps describe the King Mu episode to a T. According to *The Discourses of the States*, an Imperial history authored approximately five centuries after the fact, conflicts had been flaring between the Quanrong people and Western Zhou state in the area now known as Shaanxi, then the western frontier of the Empire. In approximately 950 BCE, King Mu, an historical figure so ancient he is recorded as having consorted with Divinities, began a campaign of reprisals against the nomadic Quanrong.[9] Though he was advised against the ethics of what his advisors perceived as unjustified aggression, his campaign was victorious. He captured the tribal kings as well as totem animals, establishing what turned out to be 200 years of dynastic rule.

The reign of King You, Mu's 5th degree grandson, was ill fated from the beginning. A massive earthquake struck the year that he ascended to the throne, which soothsayers construed as definitively a bad omen. He was, according to records, an unwise and ineffective ruler. He deposed his queen and disinherited her children, installing in her place a favored concubine named Bao Si. Once on the throne, Bao became difficult to please, and You dissipated his limited attention with idle games for her amusement. Among the most stupid of their favored pastimes was the practice of setting off false alarms (in the

form of signal fires) warning of impending invasion by the Quanrong. King and queen amused themselves by watching their nobles hasten to battle stations with no attack in sight. Eventually, the deposed queen's father, the Marquess of Shen, formed an alliance with Quanrong, who sacked the Imperial capital of Haojing, killing the Emperor, capturing the interloping courtesan, and effectively ending the Western Zhou dynasty.[10]

One can extrapolate some version of this story playing out at different geographic and temporal scales along a thousand-mile frontier stretching through some of the most forbidding terrain on earth. Such episodes have been unfolding without significant interruption since before the founding of Rome and continue to the present day. Back in the days of the Quanrong, their sack of Haojing in 775 BCE kicked off five centuries of independence, which was often indistinguishable from internecine tribal warfare and punctuated by continued aggression against the fragments of Zhou. Zhou's dynastic successors, the Qin, came back to reclaim the area, for good this time, five centuries later. With the victory of the Qin, the frontier of "China" as a polity was pushed one degree further to the West.[11]

Expansion Fills the Void

But amidst this swirling destruction, the history of the world was being paved. Qin's reconquest of the area surrounding Haojing, which would become known as Province of Shaanxi, anchored China's first Imperial dynasty and bequeathed cultural artifacts such as the Terracotta Warriors. But its most enduring achievement was to seed the eventual formation of the Silk Road, inarguably the most significant infrastructural achievement humanity has ever accomplished. As the Persian Royal Road had been completed in the interregnum between Zhou and Qin control, it became possible to forge a link between the

Mediterranean and East Asian worlds, which had previously been separated by an expanse as uncrossable as any ocean.[12]

Predictably, the Chinese connection to these developments is threaded through with the history of conflict between nomadic tribes and Dynastic forces. Coincident with the waxing and waning of Qin and Han Dynasties, steppe peoples were engaged in perpetual wars of annexation and annihilation against one another. A particularly impactful example of such conflict was the war between the Yuezhi and the Xiongnu, another tribal confederation from the area now roughly corresponding to Mongolia. The Xiongnu were dealt a major defeat by the Qin army in 215 BCE, which in turn pushed them to turn against their tribal neighbors to the west. For a hundred years, the Xiongnu harried the Yuezhi and pushed them ever further westward, and therefore into greater contact with the Saka and their Bactrian-Persian connections yet further behind the setting sun.[13]

Xiongnu aggression also eventually turned back against the Chinese themselves. The Han, successors to the short-lived Qin, at first attempted to placate the Xiongnu, sending material tributes as well as putatively royal daughters (often conscripted commoners) to marry off to Xiongnu tribal leaders.[14] Qin leaders also built massive repelling earthworks, flickering precursors to what would eventually become the Great Wall more than 1,500 years later. When neither would protect against Xiongnu raiders, Emperor Wu of Han set out to crush the nuisance once and for all.

His first act, which took longer than he likely intended, was to try a bit of military diplomacy.

He sent the ambassador Zhang Qian on a mission to solicit the aggrieved Yuezhi against their tormentors the Xiongnu. The inquiry turned into a ten-year exploratory voyage that changed the history of the world. When he eventually returned, he brought back no military assistance but rather unheralded knowledge of the tribes to the West.

Even more importantly, he became the first Chinese written witness to come into direct contact with the Greco-Bactrian world. The equivalent to European history would be some combination of Marco Polo and Christopher Columbus.[15]

His notes, with the hindsight of history, are downright eerie. After describing the large settlement surrounding the area around Balkh in present-day Afghanistan, which was then being overrun by Yuezhi warriors, Zhang noted with some surprise that the capital city was a site in which "all sorts of goods are bought and sold."[16] Zhang's perplexity might be lost on Western readers familiar with the legacy of Alexander the Great. But to Zhang, the existence of a large civilization capable of generating valuable trading goods yet further over the Western horizons would have been as fundamental a discovery as the presence of the uncharted continents on western shores of the Atlantic. Zhang's journey would ultimately yield a domain map of the eastern half of the Silk Road that Chinese emperors would follow in their conquests for subsequent centuries.

But in the immediate term, when Zhang return to Wu's court after a ten-year absence, the Emperor finally decided to take matters against the Xiongnu into his own hands. He sent tens of thousands of Chinese cavalry to ambush tribal horse-mounted warriors at markets scattered along the border, with the subsequent pursuit lasting for hundreds of miles through inhospitable deserts and mountain passes. The defeat of the Xiongnu helped to stabilize what was quickly becoming a vital trading artery. In the centuries that followed, international commerce expanded to such a degree that the Han sent an official envoy to Rome itself around the year 100, a moment which also saw the expansion of a complementary sea route from Chinese-controlled territory in modern day Vietnam along the coast of India to Roman-held Egypt. Western artifacts began to turn up in trading ports spread from Xinjiang to Korea. Roman artisans began to imitate Chinese silks, much to the chagrin of moralizing Stoic philosophers.[17]

The states of Han China and early Imperial Rome were more similar than is widely understood, especially in their treatment of the tribal peoples who stood in the way of their expansion. Much as expansion into Germany and Scotland helped to formalize a descending ladder of civilization away from Rome, Han's defeat of the Xiongnu crystallized a doctrine that had long been implicit in the Dynastic worldview. As articulated by the first-century BCE historian Sima Qian, the wars against the Xiongnu, the Yuezhi, and before them the Quanrong and numerous others, had been justified as part of the expansion the Huá (華 literally "the magnificent," but more frequently translated as "the civilizational") at the expense of the Yí (夷—"the barbarian"). The Huá–Yí distinction was in some ways similar to the American concept of Manifest Destiny but without quite the same impulse to territorial expansion for its own sake. Barbarian lands, as the distant holdings of inferior beings, were by definition without much value. Rather, what mattered was the protection and expansion of the Huá state itself, whether by the conquest or voluntary assimilation of the migratory peoples at its periphery.[18]

Although versions of this construction had lain underneath Imperial ideology for centuries, the formalization of the Huá–Yí distinction marked an accelerating divergence between the Imperial state its nomadic neighbors. The same could be said for the contemporaneous Roman world, which had been systematically destroying the tribal cultures of its neighbors in Northern and Western Europe.[19] While Caesar famously either killed or enslaved the majority of the Celtic population of Gaul, a rough analog in devastation (if not administrative prowess) can be found in the breakaway Han general Ran Min. In the year 350 CE, Ran began to whip his followers into what would be described as a fit of genocidal frenzy today. Following on from a series of military victories, Han followers of Ran slaughtered up to half a million men, women, and children from the Jie, Qiang, and Xiongnu peoples. The rampage is

responsible for the effective disappearance of three of the main East Asian tribal groups from the face of the earth.[20]

Religion, War, Identity, and Endless Sand

But unlike Caesar's ranging conquests, Ran's paroxysm of violence did not set his regime on a stable footing, and his putative dynasty collapsed after his death just three years later. This was the way the Eastern world was moving. An increasingly fragmented landscape of claimants and counterclaimants asserted conflicting dynastic rights, while tribal warlords rushed back into the power vacuum left behind. They remained locked into perpetual struggles with each other.

Trade on the Silk Road fell to desuetude, as empowered nomads found little to gain from trade but outsized profits in banditry. Fortunes rose and fell in proportion to the might of Empires both Eastern and Western, reaching a temporary apogee with ascendance of the Tang and the maturation of the Byzantine Empire in the seventh century. The Silk Road was reopened, reclosed, and reopened again as Tang forces waged battles against steppe peoples from present day Mongolia to Tibet. By 640, conditions were stable enough to permit the opening of a Tang Embassy in Constantinople, which Emperor Taizon thought to be interchangeable with Rome. After all, how much attention did the Westerners pay to the shifting locale of the Chinese Imperial capital?[21]

But the Tang soon found themselves in confronted by a new neighbor with an Imperial scale to rival their own. In the late 740s, general Gao Xianzhi ranged further west than any previous Chinese commander had ever ventured, seeking to prosecute the previous victories against the nomads deep into the forbidding mountains at the elbow joint of the Tian Shan and Himalayan mountain ranges. The shadow of these ninth-century wars between the Tang, the Turkic

tribes (including the Uyghurs), and the Kingdom of Tibet still casts a pall over contemporary world events.

Gao's military success was abruptly ended when he ran into the *mujahideen* sent from over the horizon by a new entity on the scene, the Abbasid Caliphate. The Abbasids had recently entered into a protective alliance with Tibet, a capstone to a remarkable story that can only be gestured at here. One generation saw them turn a virtually uninterrupted victory campaign into an Empire that stretched a thousand miles from the Arabian Peninsula to what is now Uzbekistan. What the foot soldiers made of their new battlefield, supported by eighth-century logistics, is beyond unthinkable. The combined Tibetan-Abbasid forces inflicted defeat on Tang, but in a reversal of alliance characteristic of the mountains, the *mujahideen* were soon enlisted to help quash the rebellion of a breakaway Tang general. The Muslim mercenaries were given lands in reward, and joined a growing population of Islamic, Jewish, and Zoroastrian traders from the Silk Road who now made homes in China.[22]

Despite sticking it out for several centuries, the Tang lost the capability to project power deep into the mountains, and eventually rolled back to the plains around Xi'an like the Han before them. The power vacuum left behind sucked in a new generation of tribal alliances, the most significant of which (for the present discussion at least), was the Uyghur-dominated Kingdom of Qocho. The Kingdom stood as a sovereign entity from the ninth to twelfth century and as a vassal state until nearly the 15th. Remarkably, the reign of Qocho stands as the longest, continuously running polity in the area. The modern CCP is several centuries behind.[23]

The shifting cast of religion and identity behind of all of this is pivotal to unpack carefully. Most modern scholars agree that the Uyghurs, as a Turkic sub-group, originally adhered to a form of shamanism centered on the sky god Tengri.[24] Their religious affiliation, from this point forward, becomes a point of political contention. The Tang, in

subjugating the tribes, successfully encouraged their conversion to Buddhism. The now mostly Buddhist Uyghurs continued to fight with neighbors of every religious persuasion until they submitted themselves as vassals of the supra-regional Turkic Alliance known the Qara Khitai. Qara Khitai would likely have made little historical impact were it not for their absorption into the world-changing Mongolian Empire soon after they themselves absorbed Qocho.

The details of these stories are being fought out in the headlines of the twenty-first century. In 2019, the Chinese Communist Party released a contentious report on the religion of the Uyghurs that was covered by almost every major newspaper on Earth. Despite the fact that the vast majority presently identify as Muslim, the CCP maintained that "the Uighur conversion to Islam was not a voluntary choice made by the common people, but a result of religious wars and imposition by the ruling class."[25] This assertion may be fair, but could just as easily be applied to the Tang who bore with them the teachings of Buddha. Moreover, the details of these ancient skirmishes are, in a certain sense, fundamentally irrelevant. The whole question of the "true religion" of the Uyghurs—Muslim or Buddhist—was cast aside completely when the Sky God Tengri burnt the whole world to a cinder under the sword of Genghis Khan.[26]

This largely overlooked point of religious inspiration for the Mongolian conquests matters because everything that happened afterwards has been an argument about what was true *before* Genghis's Tengri-worshipping horde conquered what became the largest contiguous empire in world history. Subsequent reconquest by waves of the Turko-Islamic and Chinese forces—the Chagatai, the Dzungar, the Qing, the Yettishar, and the People's Republic of China—have been attended by charges and countercharges of liberation and foreign occupation for the last eight hundred years.

The global consequences of the Mongolian conflagration—which included the annexation of territory stretching from Japan to Poland

to Palestine—far overspill the bounds of the present chapter. A high-level list would include the dissemination of Chinese inventions such as paper, gunpowder, and the compass to the Middle East and Europe. The plague soon followed in their wake. Power balances across Sunni, Shia, Buddhist, Hindu, Orthodox, and Catholic kingdoms were thrown into profound disarray, with chaos magnified as the sprawling Empire broke apart almost as quickly as it was built.[27]

Predictably, the Tarim basin region became the crux of one of these breakages: between the Yuan Empire (founded by Kublai Khan, grandson of Genghis) and the Chagatai Khanate (a rebooted formulation of the Qara Khitai that gradually converted itself to Islam over the fourteenth century). The Uyghurs allied themselves with whichever external political entity held the most military sway, and would provide the most independence. They were initially united with the Yuan, who positioned themselves as the dynastic heirs to Imperial China despite their Yí-like origins. The Buddhist *cum* relapsed shamanist Uyghurs eventually broke the alliance as they were in some mixture coaxed or conquered into joining the *jihad*-inspired Chagatai Khanate at the end of the fourteenth century. To what extent their subsequent conversion to Islam was "authentic"—either rooted in history or made voluntarily—remains a contentious issue. Significantly, the Chagatai victory over Qocho typically marks the end of the Kingdom as freestanding entity.[28]

The Heart of Western Darkness

For the next several centuries, territorial claims and counterclaims led to continued bloodshed, but in some ways the external stakes of the conflict dropped. In the centuries of its operation overland, the Silk Road gradually lost its monopoly on East/West trade to the sea-borne alternative, such that by the time of the founding of European trading

outposts in East Asia in the sixteenth century, the fight for control of the Tarim Basin was motivated primarily by questions of territory and religion rather than economics. The Uyghurs found themselves subject to countervailing claims coming from Chinese, Turkic, and Islamic powers, and were soon detached from the Chagatai Khanate by the Dzungar Khanate, a neo-Mongolian tribal confederation famous for its camel-mounted artillery. The Tibetan-Buddhist Dzungars proved to be particularly brutal overlords, and drove the now-Muslim Uyghurs into an alliance with Chinese Qing Empire in the late seventeenth century.[29]

The Qing ascension is important to explicate briefly, as it was the changes the Qing introduced to the Tarim Basin that form the true basis of contemporary contention. The Qing had risen to power in the early seventeenth century on a wave of peasant revolt, and their success ousting the Ming made them the second "Barbarian Dynasty" to rule China. The Qing, as ethnic Manchurian outsiders, were well positioned themselves to claim the dual heritage of the Mongols and the ethnic Han Empire. Except, from their perspective, the Mongolians had demonstrated that "China" as a polity was not an ethnic concept at all. It was a civilizational one. The Mongolian reversion into the Yuan demonstrated definitively that the Yí could be made into Huá by adopting correct customs and beliefs.

This unique historiography positioned the Qing to make a daring political argument: "China" need not stop at ethnically Han borders. Rather, the reaches of the Middle Kingdom should extend, if not as far as Poland where Genghis had taken them, then at least to the outermost reaches occupied by the Tang and Han Dynasties over millennia.[30] While the Uyghur-dominated Kingdom of Qocho holds the record for longest continuous reign in the area, it is the successive dynasties of China with by far the greatest number of cumulative years in control. So who is to say definitively to whom the place belongs?

Importantly, the Qing made the most successful, earnest attempt to bring these faraway zones into Chinese society rather than simply under central Chinese taxation. The Qing had themselves been denied political power, and even food, as subject Yí on the steppes of Manchuria not long before. They outlawed the derogatory Yí distinction for all peoples in the Western Zones.[31] They built cities, converting a dusty trading fort at Ürümqi into a modern metropolis that is today larger than Los Angeles and home to ambitious scientific research at Xinjiang University. It was the Qing, in fact, who united the northern plains and southern deserts of the region into a new place, which they termed Xinjiang and began to administer as China's newest fully vested province. The Qing theorized their presence out West as a utopian venture, and this perspective is key to understanding the Chinese view of the problem.[32]

Beyond visions of a "Huá Man's Burden," the Qing found themselves drawn into the perpetual Western wars for reasons of *realpolitik* as well. Since the founding of their Dynasty, the Qing had been engaged in protracted conflict with the pugnacious Dzungars. Unwilling to brook a thousand-mile confederation of hostile tribes sniping at their borders, the Qing chased the Dzungars all the way back up through the Western mountains to which they strove to retain control. They found it easy to solicit help from their on again, off again allies, the Uyghurs. Victory was won, but it was never stable. Rebellion after rebellion ensued until the Dzungars were deemed simply to be ungovernable. In the middle eighteenth century, the Emperor Qianlong decided to try some old fashioned justice drawn straight the ancient predecessors he claimed as his own.

With eerie shadows of Ran Min's savagery, Qianlong ordered the destruction of the entire Dzungar people from the face of the earth. As historian Peter Perdue has argued, Qianlong's repeated written commands belie resistance from those actually being tasked to carry out the grisly orders. They were told to "show no mercy," "massacre

these crafty Zunghars," and instructed that any attempt at surrender was a ruse to be treated with the utmost prejudice. Generals were rewarded for "exterminating" political leaders and their administrators, absorbing their wives and children in the process.[33] Up to 80 percent of the population, almost a million people, perished from a combination of war, starvation, and disease between 1755 and 1758. The Dzungars soon disappeared from the history books, just like the Xiongnu, the Quanrong, and countless others before them.

The whole devastating episode, which is little discussed in China, may be difficult for Westerners to understand. The parallels with the European atrocities committed in the New World and in Africa are numerous, and should put the lie to the notion that colonial genocide in the name of civilization is somehow a Western invention. And yet, the comparison with the Spanish destruction of the Aztecs, or the Belgian savagery in the Congo, is partial at best. The millennia of roughly symmetrical conflict between nomads and Huá makes the story more complex, as does the minority status of the Manchu Qing themselves. Perhaps the clearest analogy would be to imagine that Irish rebels toppled the House of Stuart and ascended to the British throne themselves. How might they have handled the realities of Caribbean slave revolts or tribal land claims? If they intended, as the Qing certainly did, to demonstrate their fitness to carry the mantle of civilization, they might have been yet more brutal than the British themselves. The Qing, for their part, took up the Yí issue with the zeal of the recently converted, handling both the carrot and the stick of Imperial rule with millenarian fervor.

The Qing certainly shared with the European colonial powers the proclivity to use newly emptied lands for a variety of opportunistic ends. They resettled as many as 25,000 Muslim Uyghur allies and their families on the former Dzungar tracts, and gave estates to their own Manchurian bannerman.[34] They encouraged the voluntary migration of ethnic Han and Hui Muslims (descendants of Silk Road

traders and favored Abbasid mercenaries) from centers out into the forbidding countryside.³⁵ They also used the former Dzungar territories as a dumping ground for undesirables, a category that encompassed common criminals spared from execution as well as political figures fallen from favor. Among the most significant of these was Lin Zexu, architect of the noble but ultimately failed policy to keep British opium out of China (see "Our Own Arrows" in the present volume for further details). Lin took the opportunity to produce several groundbreaking studies of Turkic and Muslim culture in the Far West, and the presence of political officials like Lin proved instrumental in helping to integrate these regions more fully into the Qing's administrative apparatus.³⁶

Among those in the high-level retinue sent out to the Western badlands at this time were Qin Feng's ancestors.

Trauma Enters Modernity

The move to establish not simply tributary relations but actual jurisdictional control all the way to borders of the former Abbasid empire (present day Kyrgyzstan) was always shadowed in violence, no matter how noble the intentions may have been. Of the numerous revolts that smoldered against the Qing in eighteenth- and nineteenth-century Xinjiang, rape of tribal or Muslim women by Han or Manchu soldiers is commonly cited as either the initial spark or the final straw. Regional leaders would then band together in anger, kill all the foreigners they could lay their hands on, and seize their local garrisons. The Qing would respond with organized force against a revenge seeking mob, and were always victorious. They would often make an example of the rebels with ghastly executions.³⁷

Their grip on the place wavered, but never collapsed. They were most seriously challenged in 1865 by the Emirate of Yettishar, a

Muslim-Turkic principality that might be roughly likened to an East Asian version of Afghanistan under the original Taliban. Yettishar even had the support of British and Russian governments as pious freedom fighters, but for their would be subjects the strictures of *sharia* were no substitute for the actual government infrastructure provided by the Qing. The area occupied by the nascent Emirate was soon reconquered by for the Qing by Zuo Zongtang, known worldwide as the namesake of General Tso's Chicken.[38]

Remarkably, when the Qing Dynasty collapsed in 1912—bringing down with it millennia of Imperial control—the state's grip on power in Xinjiang was comparatively untroubled. After a brief skirmish, control was won by the capable Han administrator Yang Zengxin, who would rule over the area for the better part of the next twenty years. Over his tenure, Yang consolidated government control over the fractious tribal leaders, famously empowering the Muslim Hui to police the Muslim Uyghurs. He cultivated friendly relations with the new Soviet state on his borders, and eventually oversaw the opening of Soviet consulates in places like Ürümqi and Kashgar, with reciprocal Chinese consulates opened in Russian held cities such as Tashkent, Zaysan, and Andijan. These diplomats looked increasingly to Yang at Ürümqi, rather than the uncertain leadership in Beijing, for their marching orders.[39]

Chinese state control over Xinjiang gradually solidified under the Nationalist and then the Communist governments in the first half of the twentieth century, though the area predictably remained a flashpoint for rebellion. Turkic-Muslim led breakaways were attempted in 1920 and 1932; the latter led to the brief formation of the Turkish Islamic Republic of East Turkestan along the approximate previous borders of Yettishar. Or Dzungaria or Qocho from the Buddhist-Tengrist days. Following old habits, the area was reconquered by the Chinese Nationalists, who promptly lost most of the territory to a Russian-backed Uyghur alliance who declared a Second Turkish Islamic Republic of East Turkestan.

The Russian appearance on the scene only magnified the longstanding ethnic and religious tensions of the area as they introduced a new variable, adherence to either Capitalist or Communist ideologies, over which one side or another could resort to violence.[40]

By 1950, the Mao's Communists had emerged as the clear winners of the challenge to succeed the Qing as the governing body of mainland China, and they began to turn their attention to Xinjiang with urgency. The whole area had indeed become something of an emergency for the newly established government. A rump Nationalist party was already deeply entrenched on Taiwan, where they remain to this day as unreconciled belligerents (see "Degrees of Separation" in the present volume). A second Nationalist splinter sect—this one mixing into a Soviet satellite state already riven by deep ethnic rivalries—might have spelled disaster. Something had to be done.

Sensing that a new approach to the problem was warranted, or perhaps simply weary after more than two decades of continuous fighting, Mao decided to try the olive branch. He brought a victor's peace to the Nationalists, established a treaty of mutual cooperation with the distant Russians, and promised comparative independence to a famously restive Turkic population. How much independence and to whom such promises were made quickly becomes shrouded in mystery. Mao's deputy Deng Liqun had been in the Tarim Basin to negotiate with the Islamic Republic leadership, who were then invited to a Party Congress in Beijing to solidify the agreement. The plane carrying all five of the Republic's leaders went down *en route* to Beijing, killing all aboard. The nature of the crash, officially declared an a weather-related accident, is subject to considerable dispute. Notably all the Republican leaders were buried with state honors—their deaths made them into martyrs for the cause of the Chinese unity.[41]

However, not all citizens of the territory now fallen back under Chinese control bought into the Party line. Mao's enemies did indeed have a way of dying in auspiciously timed plane wrecks, and resistance continued against Saifuddin Azizi, Mao's hand-picked figurehead for administering Xinjiang. Though Azizi is given credit for pushing through an official renaming of the place—which is now known as the Xinjiang Uygur Autonomous Region—the status of the "autonomy" has always been more myth than administrative fact. Following the precedents of the Qing, the Communists actively encouraged Han migration to the area for purposes of civilizational development, while at the same time seeking to avoid the trappings of colonial occupation. Both civilian and military Han immigrants were encouraged to avoid "scrambl[ing] for land with indigenous people," as the Party diktat went, but the well-meaning advice served to reinforce economic and political asymmetries to the continued disadvantage of the Uyghurs.[42] They could not, after all, be at once economically integrated and politically liberated.

The asymmetry between Han and Turkic-Uyghur has continued to spur revolt, not that such conflict has ever truly ceased in the millennia in which the area has been inhabited. Mao's thoroughgoing Cultural Revolution, which sought to stamp out any resistance to the Party in the nation's traditional power base, had the paradoxical effect of weakening Party authority on China's periphery. Sensing an opportunity amidst the chaos, a rebooted East Turkestan People's Party declared a third iteration of an independent Uyghur state—conceived along Marxist-Leninist rather than Maoist lines and backed by the Soviet Union. The short-lived insurrection imploded in the 1970s, but its cause has continued to live on.[43]

Against this backdrop, Qin Feng came of age as an artist.

Gestures in the Vacuum of Time

Qin began his life on the hardscrabble plains. His father had fought along with Mao's forces in the Communist "liberation" leading up to 1950, but fell under suspicion during the Cultural Revolution because of his fluency in Russian as well as Kazakh, Mongolian, and Arabic, languages that Qin would inherit. His mother bore ten children, only five of whom survived to adulthood. Qin recalls his family was viewed as part of the local privileged class—a neighboring Kazakh family had so many children with such high mortality rates they had begun to resort to naming them only by number.[44]

Qin grew up in the wide-open spaces of Xinjiang, studying mural painting in high school but chafing against the received limits of the medium. At 22 years old, he left to attend art school at Shandong University, more than a thousand miles to the East, undertaking a curriculum which blended study of traditional Chinese calligraphy with canonical Western artworks. Independently, Qin sought out knowledge of international contemporary practices, and would soon hit on a mature style in which the grand gestures of Abstract Expressionism were read against the mark-making of classical Chinese calligraphy. These works have brought Qin Feng considerable renown, including acquisitions at major international museums including the British Museum and the Metropolitan Museum of Art.

As Qin's profile was rising through exhibitions in Germany and then the United States, a new round of resistance to Han control in Xinjiang was beginning to gather steam. After the implosion of the Soviet Union in the early 1990s, Turkic states such as Kyrgyzstan and Uzbekistan found themselves suddenly independent, and numerous agitators inside Xinjiang yearned to follow their example. Growing impatient with the lingering strains of rebellion, and with echoes of historical punitive expeditions against the Dzungars and beyond,

Premier Li Peng issued a stern warning in a 1996 communiqué. Explicitly citing, but not explaining, the involvement of the United States in "openly supporting the separatist activities inside and outside of Xinjiang" Li promised to "defend ethnic unity and social stability ... with great political sensitivity and pride" by "alienat[ing] as much as possible the very small number of ethnic separatists and criminals who commit serious crimes and striking hard against them."[45] With those words, the infamous Strike Hard campaign was born.

Li's strategic plan for Xinjiang must be understood as both an extension of centuries of punitive expeditions as well as a vindication of sorts in the wake of the June 4th incident in Tiananmen Square five years earlier (see "Our Own Arrows" in the present volume). A full-throated military crackdown had seemed necessary to save the regime, and while the CCP took significant heat in the court of international opinion, there were few lasting consequences. The Party felt all the more secure in pursuing pacification by whatever means necessary. But the requisite means kept becoming more draconian. Islamic *meshrep* festivals were outlawed, and when their celebration continued, repression with tear gas and live ammunition followed.[46] Such incidents catalyzed further violence, such as a string of bombings with shrapnel-packed explosives in Ürümqi.

These uprisings would have lurked far in the backdrop as Qin returned to China after nearly two decades abroad. He found his native country much changed—the Party had developed closer economic ties to the West and much more confidence in its own ability to project power on the world stage. On the financial side of the ledger, China's export-fueled economy enjoyed remarkable growth during the 1990s. But after acceptance into the World Trade Organization in 2001, China's GDP growth accelerated to nearly 10 percent year over year, an unprecedented expansion for an economy already producing a trillion dollars per year. And after the worldwide

economic crash of 2008, the CCP was in a position to introduce the largest fiscal stimulus package offered by any major economy, and China became the first to emerge from the crisis.[47] The Party also began to embark on a pronounced campaign of cultural diplomacy—opening up a string of Confucianist attachés throughout Africa and, famously, hosting and "winning" the 2008 Olympics in Beijing.[48]

Qin himself also returned to China in a triumphal mode. In 2006, he founded the Museum of Contemporary Art in Beijing, and began teaching at the prestigious Central Academy of Fine Arts in the following year. In 2008, he produced a major exhibition at the MOCA-Beijing, which included an array of sculptural objects and ambitious installations alongside his now highly sought after ink and brush work. It should be noted that that this "expanded calligraphy" has been the focus of attention for the artist, both within the exhibition and the critical frame around it. The show itself was dedicated to Bada Shanren, a seventeenth-century courtly ink painter, and most of the interpretative essays seek to locate Qin's work on the axis of Dynastic China through Western painterly abstraction.

However, it is in the sculptural and installation works that one sees the indirect evidence of Xinjiang's fractious history piercing through, shards of glass glinting in the endless sand. Take, for example, the series of *Post Koran/Post Bible/Post Dao De Jing Ceramics* (2005). Created in collaboration with artists from Jingdezhen, China's master porcelain village, the massive pots draw on elements from each liturgical alphabet, seeming to collapse under their visual weight into a pool of painted spermatozoa. All religious texts are at best partial answers, and all dissolve under the simple humanness of their founders and adherents. This same mode animates a pair of parallel projects which featured interventions in books with English, Chinese, and Uyghur script. Holes are cut into bound volumes, and visible pages disappear under curtains of incomprehensible words. Occasionally, a bit of structuralist semiotics pokes through,

reinforcing the arbitrariness of all language. But the titles—*God Where Art Thou* and *Allah Why Don't You Wake Him Up*—call out for something of the Divine.

But, as the artist insists, such glancing allusions give way to "pure abstractions." Ink and form slice through space, whether on sprawling paper scrolls or dipped onto a grove of suspended trees as in the striking *Limits of Growth* installation. Even when the works visibly draw on elements from English, Mandarin, and Uyghur alphabets, they are made to be deconstructed then "reconstructed and deconstructed again."[49] He strives after "an alternative art form that encompasses both multicultural/ethnic as well as contemporary art and new media languages."[50] His background in Xinjiang is presumed to help with his readiness to transcend cultural difference. In Qin's art, we see ethnic, religious, and linguistic specificity dissolved under the superior force of world history.

And while this construct belongs to Qin Feng, it nevertheless draws from a set of deeply rooted Chinese ethical and legal traditions. The sprawling implications of ideas such as the Celestial Empire (天朝;) and the Harmonious Society (和谐社会) are beyond the scope of this chapter, but for the purposes of the present discussion, one of their most important implications is to reject as false consciousness any resistance to "civilization." And in this context, the notion of civilization itself is equivalent to the political hegemony of the Chinese state. It was under this aegis that the Han and the Tang brought *Huá* to the *Yí* in the mountains, it is why the Qing returned and why the modern CCP has insisted on staying. As the place is understood to be within the polity of China itself, and any local challenges to its Chinese-ness are *de facto* illegitimate. Such challenges are nearly always blamed on a mixture of foreign agitators, the distortions of religion, and the same Yí spirit that has spurred revolt against Dynastic authority from time immemorial. And as such it must be met with emphatic force.

Coda: "The Inexplicable Reality of Today"

In the glaring light of the present day, this emphatic force looks downright ghastly. The present cycle of rebellion and repercussion can be dated to a wave of anti-government rampages that were spurred by the international spotlight of the Olympics, an event coincident with Qin Feng's debut in Beijing. In 2008, two Uyghur separatists drove a truck into a column of police trainees out for a jog, then hopped out of the ruined vehicle to attack the cadets with machetes and grenades. Sixteen people were killed.[51] A few months later, a pair of buses was bombed. Months after that, a massive race riot broke out in the city of Ürümqi in which the mostly Uyghur crowd killed nearly 200 Han Chinese citizens. Smaller scale anti-Han violence continued seemingly without interruption, including a series of anonymous attacks on strangers with syringes.

It was a machete wielding gang of separatists that killed nearly three dozen people in a train station that finally brought the hammer down. In 2014, one month after the knife and sword attack at Kunming Railway Station, President Xi Jinping came to Xinjiang clean house. He threw out the reigning milquetoast governor and replaced him with Chen Quanguo, a hardened former chief party officer in Tibet. According to documents leaked to the *New York Times*, Xi instructed his new appointee to show "absolutely no mercy."[52] Qianlong's orders against the Dzungars, and Ran Min's destruction of the Xiongnu, echoed in the sprawling mountains.

Two years later, Chen stood in front of a throng of armored soldiers flanked by tanks and helicopters to announce the beginning of a new era of Strike Hard, a "smashing, obliterating offensive," that would "bury the corpses of terrorists and terror gangs in the vast sea of the People's War."[53] What has happened since has been denounced by every major human rights group in the West. A sprawling set of

internment camps have been built to "reeducate" wayward Uyghur subjects; up to a million people have been held in such facilities for arbitrarily long sentences without ever facing trial.

The American State Department has relayed horrifying accounts from numerous former detainees. These survivors reported beatings, torture with electricity and prolonged stress positions, sleep deprivation, and forced feedings and druggings. Particular cruelty was reserved for political and religious dissidents.[54] One unfortunate soul related how he had been in left in solitary confinement in the dark for several months. Loved ones who returned to such facilities to claim the remains of family members who died in custody have described their bodies as "unrecognizable." There have been credible accusations of executions held for the purpose of organ harvesting. Some of the most stomach-churning accounts detail horrific episodes of sexual assault by prison guards on female detainees. Several witnesses have recalled prolonged episodes of gang rape and sodomy with electrified instruments, with the women subsequently subjected forcible IUD implantation or even hysterectomy.[55] Words fail in the face of such barbarity.

Words fail, but patterns recur. At the risk of ahistoricism, the present monstrosities suggest some kind of a window into the many previous rebellions spurred by repeated episodes of sexual violence carried out by representatives of Dynastic authority. Such a description recalls the Ush Rebellion of 1765, an uprising against the Qing superintendent Sucheng for his habit of kidnapping Muslim women, holding them hostage, and sexually assaulting them for months on end. The incensed local population declared their desire to eat the man alive. When Qing security momentarily had its attention divided, the rebels leapt at their chance, capturing Sucheng, his senior leadership, and his royal guard in a citadel and slaughtering them to a man. The Qing army promptly marched backed in, installed a new governor, and carried out thousands of grizzly executions.

The pattern generalizes beyond Ush. Over and over again the project of "civilization" becomes inextricably bound up with separating local winners from losers, a process that by design or accident plays upon intra-regional conflicts that run even deeper than resistance to outsiders. Respect for tribal culture remains the letter of the law, but as Dynastic control deepens, specific ideas and customs are seen as rootstock of rebellion and discord. Rape is deployed as a weapon of war and a perquisite of occupation. A metastatic penal system grows to control the population the State had intended to uplift.

Indeed, it is this structural similarity that seems to confirm to Beijing that no better way exists. As President Xi stated in 2021, "Practice has proven that the party's strategy for governing Xinjiang in the new era is completely correct."[56] In fact, the present CCP considers the present system—which relies heavily on electronic surveillance—to be an enlightened successor to previous regimes, and a marked improvement on the treatment of native peoples by European colonists. In March 2022, spurred by the rising pressure on its behavior in Xinjiang, the Party issued a remarkable, twenty-page complaint detailing accusations of genocide perpetrated by the US government against Native American peoples. The report acidly concluded with the observation that "is imperative that the U.S. government drop its hypocrisy and double standards on human rights issues, and take seriously the severe racial problems and atrocities in its own country."[57] Words that should not excuse evil, but that should cause reflection in the minds of Western critics. Beijing is no more ready to surrender Xinjiang than Washington is to lose the state of California.

Talk of retreat is preposterous anyhow; from the CCP's perspective the region is thriving. Xinjiang has a quarter trillion-dollar economy—the same as Finland—and is one of the world's most prolific producers of high-quality silicon for use in solar panels. The

region has even produced a groundbreaking contemporary artist whose work plumbs the endless histories on the Silk Road only to watch them harmonize into the pure abstractions of the present. In a rare bit of biographical self-reflection, Qin Feng has simply stated that he hopes his art will reflect "the vast, harsh natural world of my homeland, its tragic and brilliant history, and the murky and inexplicable reality of today."[58]

5
度 分离

Degrees of Separation

Il Silenzio, 1962, 1962. Image courtesy Hsiao Chin Art Foundation with thanks to 3812 Gallery.

At a Glance

The following essay explores the early work of Hsiao Chin, a pioneer of abstract painting born in China, trained in Taiwan and exposed to Western experimentalism through its connection to prewar Japan.

But it is the postwar period that primarily concerns us here. With the ashes of conflict II still cooling in the backdrop, bitter Axis enemies made peace with Allied combatants in the name of halting the advance of global Communism. This pivot-in-conflict was particularly pointed in Taiwan, a tiny spit of land that served as refuge for the Chinese Nationalists who were driven off the mainland by Mao's victorious CCP. Taiwan was a portentous port in a storm, having long occupied a position both within and beyond Chinese control. The island had been dismissed throughout most of China's Imperial history as a valueless wilderness, and its native peoples were first systematically contacted by adventurous groups of Chinese fisherman and Dutch traders at almost the same moment in the early seventeenth century. The territory traded hands between Dutch, Spanish, Japanese and renegade Chinese forces—a fractious, multiply determined colonial history that set the stage for the still unresolved conflict over the both the island and the government of the mainland itself.

Chin's painterly abstraction emerged within this singular political backdrop, and his career matured as he traveled through the only-recently former Axis power centers of Italy and Spain. His works from the middle 1950s—no less radically abstract than those of his near-contemporaries Jackson Pollock and Mark Rothko—not only complicate the familiar story of modernist painting as a fundamentally Western enterprise, but also speak directly to the ways in which this newly international set of artistic ideas grew out of an emergent shift in the global balance of power.

It seems almost trite to observe the ways in which his canvases speak in a kind of East/West polyglot: the color washes and fluid lines of traditional calligraphic training, intercut with the crackling, knife-cut disruptions of mid-century European painting. Indeed, hybridizing these worlds has been the career-defining ambition of Hsiao Chin, a pioneer of abstract painting who was born in Shanghai, educated in Taiwan, and spent the remainder of his career working between the US, Europe, and Asia. His works from the middle 1950s speak to a quest for a pictorial language no less radically abstract than that sought by his near-contemporaries Mark Rothko and Jackson Pollock.

His works from the middle 1950s not only complicate the familiar story of modernist painting as a fundamentally Western enterprise, but also speak directly to the ways in which this newly international set of artistic ideas grew out of an emergent shift in the global balance of power. As critic Edward Lucie Smith has written, "Hsiao Chin is a striking example of this complex process of assimilation and rejection" that inheres in the construction of canonically Western art history.[1] Indeed, given his distance from New York, Chin came to his mature style remarkably early, which he would go to iterate within the territory of chromatic, lyrical abstractions over the course of the next six decades.

But it is the post-war period that primarily concerns us here. With conflagration of the War a still recent memory, former Fascists made quick alliances with their former enemies to combat the new mutual threat of global Communism. This reversal was particularly sharp in Taiwan, a tiny spit of land that served as refuge for the Chinese Nationalists who were driven off the mainland by Mao's victorious CCP. Taiwan has a deeply relevant history here, though one largely unknown in the West. Throughout most of Chinese Imperial history, the island was dismissed as a wasteland, and its native peoples had their first sustained contact from both Chinese and Dutch outsiders in the early seventeenth century. The territory traded hands between Dutch, Spanish, Japanese, and renegade Chinese forces—a fractious, multiply-

determined colonial history that set the stage for the still unresolved conflict over both the island and the government of the mainland itself.

Chin's work was born out of this fractious, multiply-determined colonial history. His position near the global forefront of artistic experimentation was due in part to a singular educational lineage which reprises the political history of the island. Chin studied under Li Zhongsheng, a respected artistic innovator who had fled to Taiwan along with Chiang's armies, who was himself a student of Leonard (Tsuguharu) Fujita, a pioneering Japanese figure who was among the only artists from East Asia to mingle with the Fauves and Cubists in Paris as their works were unfolding in real time.[2] Chin's own work would come to depend on his own peripatetic orbit through a world conditioned by *realpolitik*, an idiom of abstract painting developed through travels to the only-recently former Axis power centers of Italy and Spain. Chin's emergence as an artist was intimately bound up with the larger ideologies to which creative experimentation was to align itself. An early Cold War expression of the tussle over which ends should justify the means of new artistic visions: imagining a centrally planned collective, or expressing a radically atomistic individual? This vexed question of "autonomy" as either a collective or individual exercise has everything to do with understanding Chin as a Taiwanese painter.

But fully unpacking to this history is impossible without first attending to the long history of Taiwan, a subject with very limited awareness in the West.

The Ancient Pre-History of the Archipelago

The area's first inhabitants arrived approximately 30,000 years ago, fully twenty millennia before the invention of farming in the fertile crescent.[3] Archaeological evidence—mostly chipped stone tools—suggests human habitation gradually dispersed itself though the north

and central parts of what became an island 20,000 years later, after sea levels rose to create what is now the Strait of Taiwan. This original culture seems to have endured with little change for approximately forty additional centuries—about the same temporal gap separating the present moment from the construction of the Egyptian pyramids. A major shift emerged around 6,000 years ago, with the rise of the "Dapenkeng" culture which, linguistic evidence suggests, spread as far afield as Easter Island, New Zealand, and Hawaii. Innovation continued, albeit at a pace more slowly than the changes sweeping the nearby mainland. Iron was introduced synchronously with the rise of the Roman Empire, an introduction that did much to shape the balance of power between the villages on the trading coasts and those who had settled in the island's forbidding central mountains.[4]

Contact between the island and mainland China remained limited for a very long time. Imperial policymakers were, by the year 1000, managing a population of around 90 million people spread over a million square miles, and they saw little value in projecting power beyond their shores.[5] With the exception of a military incursion that returned with thousands of captive aborigines in the early seventh century, there was almost no official contact between centralized Chinese authority and the island of Taiwan for over 1,000 years. Sea currents and wind patterns made the 100-mile ocean journey uncommonly hazardous, and it was not until the fourteenth century that the "barbarian" Yuan dynasty established an outpost on Penghu, a tiny point of land two thirds of the way across the Strait of Taiwan.[6] The narrow remit of Imperial power focused on maintaining the status quo with the potentially dangerous natives, as well as what historian Young-Tsu Wong characterizes as a "half-hearted performance" aimed at curbing piracy. The lawless territory had indeed long served as a gathering place for smugglers, but these otherwise fearless brigands often preferred to conduct their illicit trade from the safety of their ships, rather than risk disembarking on the island itself.[7]

Then, everything began to change all at once.

In 1510, Portuguese explorers became the first Europeans to establish a permanent settlement in east Asia, occupying progressively greater territory in the island group of Macau. Three decades later, the Portuguese became the first Europeans to record an encounter with Taiwan, dubbing the landspot *ilha formosa*, or "beautiful island." In the late sixteenth century, a group of shipwrecked Portuguese sailors spent three months grappling with malaria and aboriginal violence before being forced to flee for Macau—a journey of over 500 miles—on a makeshift raft. But it was the Dutch who truly came to stay. Seeking to make up for lost time with Portuguese control of Macao and Spanish establishments in the Philippines, the Dutch East India company began pushing hard for a trading base in the Chinese periphery.[8] The Portuguese violently resisted Dutch attempts to encroach on their entrepôt on Macau, and the Ming authorities then pushed them off Penghu. Lacking other good options, Dutch commander Martinus Sonck ordered a retreat from Penghu towards Formosa. They settled on the inlet of *tayowan* to erect Fort Zeelandia, the first permanent European structure on the island.

The colonial history at this point becomes Byzantine in complexity. Alliances and enmities between distant European kingdoms (Spain, Portugal, and the Netherlands) and Asian empires (China and Japan) quickly change and permute, along with an ever-shifting landscape of pirate outlaws and aboriginal leaders caught up in the broader struggle. But over the next four decades, the Dutch managed, with great effort and considerable bloodshed, to centralize their control over the island. As they did so, they sought to divide and subjugate (if not entirely conquer) the aboriginal population. Villages were burned, and taxes were levied on exported deer hides.[9] Translators and missionaries were beheaded or otherwise mutilated in reprisal. Asymmetric treaties were formed, rebellions ensued and were eventually put down. The Dutch sought to weaken the aboriginal

hold on the island by encouraging Chinese immigration, with the newcomers working to raise sugarcane and other export crops. The Chinese proved to be restive as well; one particularly entrenched insurrection, the Guo Huaiyi rebellion, was crushed by the Dutch and their aboriginal allies only after the death of thousands of Chinese.[10] But as would be repeated in the history of the island, such alliances could be quick to turn back around.

Colonial Conflict, Through the Mirror Darkly

The consequences of distant events were soon to engulf the fragile hold established by the Dutch on Formosa. As discussed in several of the other essays in this volume, a confluence of economic and political factors served to destabilize the Ming dynasty, and they were eventually toppled by Manchu warriors from the Northern Steppes who would begin China's last Imperial dynasty, the Qing. But the historical unfolding of such dynastic succession—especially when the split breaks along ethnic lines—is rarely as straightforward as timelines and history books may make it appear. While the end of Ming is typically dated to the 1644 sacking of Beijing, ethnic Han loyalists of the old regime mounted armed resistance against the perceived usurpers for the next four decades. Among the most stubborn of these resistors was the warlord Zheng Chenggong, the son of a Japanese mother and the erstwhile Ming emissary to the Dutch, Zheng Zhilong. Better known by the anglicized honorific Koxinga, the younger Zheng burned with resentment after the Qing betrayed his father.[11]

Defeated on the mainland, Koxinga fled to Formosa to reclaim the island as a base from which to launch a broader *reconquista* of the mainland. He allied himself with the aboriginals who had, previously, worked with the Dutch to control the Han migrants.[12] After a brutal three-month campaign—punctuated by a zealous

campaign of beheadings—Koxinga became the first ethnic Han-Chinese ruler of Formosa. Three months after that, he was dead of either malaria, syphilis, or a sudden bout of madness. His son Zheng Jing built up the strength of their nascent kingdom by forging an uneasy peace with the Qing and by offering free aboriginal land to mainland Chinese refugees. But when he died without a legitimate heir of his own, the infighting amongst his generals fatally weakened their already precarious position. After a decisive naval battle off Penghu, Qing troops landed in Taiwan in 1683, and put an official end to the last of Ming resistance. Koxinga's brief kingdom would, in epochs to come, be cited as a legitimating precedent for territorial claims by a wide range of conflicting parties. These conflicts could be just as genocidally violent as any collision between First Nations peoples and European colonizers in the New World, but the multi-sided nature of the territory claim, the remarkably late moments of contact, and the ambiguous goals of the outside powers would produce a story of considerably more complexity than the received, linear narratives of conquest and exploitation.

Indeed, back in the seventeenth century, the Qing were of two minds about what to do with the new Imperial territory. They had intended to quash a rebellion, not to conquer, let alone rule, a distant island wilderness inhabited by unrepentant dissidents and barbarians. The reigning Kangxi Emperor articulated the received disdain for the island, referring to it as "a ball of mud" with "nothing [gained] by possessing it," and "no loss if we did not acquire it."[13] Ultimately, only a limited attempt was made to bring Taiwan into the orbit of Middle Kingdom. Efforts were primarily aimed at restricting Chinese immigration into untamed aboriginal areas with the intention of minimizing conflict from which there could be limited possible gain.

These conflicts could indeed be dangerous, and the barbarity of the Taiwanese aboriginals loomed large in the contemporary Chinese imagination. According to one famous eighteenth-century account by

a Chinese traveler, "the wild savages" ranged within a forest "so dense that you cannot see the sky" and lived "in lairs and caves, drinking blood and eating fur."[14] But as elsewhere in the world, the economic imperative for colonial expansion continued to build; Taiwan was discovered to be a lucrative source of sulfur (for gunpowder) as well as land ideal for tea cultivation. By the mid-eighteenth century, a north/south dividing line was drawn, separating the western, coastal part of the island, within which native populations had grown accustomed to dealings with colonial outsiders, and the eastern, mountainous half, home to those who had been removed, even from time immemorial, from the iron trade.

The line was of course predictably pushed further and further back, such that by the end of the nineteenth century the Qing were officially pursuing the policy of *kaishan fufan* (開山撫番), usually translated as "open the mountains and pacify the savages."[15] At its high water mark, the island was inhabited by approximately 2.5 million people—with 2.3 million Han Chinese concentrated primarily on the western coasts. But *kaishan fufan* never came close to fulfilling its aims. The requisite Qing military strength was continually engaged in outside entanglements, including with the British, the French, and then the Japanese. Following their defeat in the Sino-Japanese war on the eve of the twentieth century, the weakened Qing Empire ceded control of the island to Japan.

Japanese Dreams for *Kōzankoku*

Japan had long maintained its own set of claims on the island, and were arguably the first outside power to sustain incursion or invasion on Taiwan in many millennia. In the late fifteenth century, as Europeans were beginning to establish permanent outposts in South and East Asia, Japan was undergoing its own period of consolidation and colonial expansion towards the south and west. Imperial

advisor Toyotomi Hideyoshi (1537–98) is a particular key figure here. After guiding Emperor Go-Yōzei's successful reunification of the Japanese mainland, Hideyoshi laid out an ambitious plan for conquest abroad. Best remembered for his invasion of Korea, he also sought to annex Portuguese holdings in India, Spanish territories in the Philippines, as well as the "unclaimed" island that the Japanese knew as *Kōzankoku*. In 1593, Hideyoshi's general Harada Magoshichi led an incursion onto Taiwan while *en route* to do battle with the Spanish in the Philippines. In 1609, Emperor Go-Yōzei's sent the noble retainer Arima Harunobu to attack Taiwan, an event reprised for a third time by Murayama Toan in 1616. Though the details vary, the results were largely the same. All incursions were repulsed by weather, disease, and strident resistance from the island's First Nation inhabitants.[16]

But the technological and bureaucratic advantages enjoyed by Japan's nineteenth-century successors to these abortive missions changed the outcome. Meiji Era expansionists pointed not only to these historical attempts at annexation (which antedated any European presence on the island) as well as Koxinga's matrilineal Japanese heritage—a thin, but nevertheless extant precedent for Japanese claims on an island embraced only half-heartedly by their Chinese rivals. In the winter of 1871, the hawks finally had their opportunity. A fleet of Japanese ships was shipwrecked by a powerful typhoon and as survivors washed up on the southern shore of Taiwan, they were "rescued" by a group of Paiwanese aboriginals.

Confusion between the two camps ensued when the refugees were brought upland to the village. Fearing the worst, they set out to escape, a move that seemed to the Paiwanese to confirm their ill intentions. Aboriginal warriors set out into the bush looking to hunt down their erstwhile rescuees, returning with more than 50 heads that were then mounted outside the village as a gruesome warning to potential traitors. The Meiji government of Japan demanded restitution from

the Qing, who maintained because these "raw" aborigines were beyond the reach of any outside law, no compensation was due. The Japanese, in turn, took this as an opening to launch their own punitive expedition to Taiwan, the success of which demonstrated the precarity of Qing control over Formosa more broadly.[17]

Twenty years later, with Qing military on the brink of defeat after the Sino-Japanese war, Meiji military planners went to great lengths to ensure that the brokered treaties would leave Japan in control of Taiwan. Fearing this transfer of control, a group of local Chinese elites declared an independent Republic of Formosa, support for which was largely limited to their own circle and a few mainland government functionaries willing to cede control of the island in order to deny it to Japan. Strange political events ensued, as Qing emissaries shamefully insisted on conducting a handover ceremony for a territory that had declared independence from the safety of a ship. With shades of pirate days gone by, the Japanese became the fourth colonial power in as many centuries to lay claim to the island. Upon assuming the handover, regiments of Japanese marines put quick work to the organized Formosan Republicans, and the autonomous government collapsed within six months.[18]

But official status and operational administration are two different things entirely. Japan quickly found itself locked in a cycle of escalating violence, the opposing side of which was made up of a messy collision of interest groups: those that sought a reconciliation with Qing China, those who wanted an independent Taiwan by and for Han-Chinese migrants, and numerous, autonomous groups of aboriginals who generally hated the Japanese but were often otherwise indifferent to which other party constituted their most expedient allies. A simmering guerrilla war brewed over a political entity created by the Dutch and subsequently claimed by both major Asian empires as well as bitterly opposed factions of its own inhabitants. The violence could turn ghastly, as when the nascent Japanese air

force felt compelled to bombard entrenched aboriginal positions in the arboreal mountainous with air-dropped mustard gas.[19]

It is against this frightening, fractal-like conflagration over cultural origins and political claims that the art historical threads of our story first emerge.

Art Deco in the Expanded Sphere

The artist Fujita Tsuguharu (soon to become Leonard Foujita) was born in Tokyo in November 1886, a moment in which Japan was just beginning to solidify its grasp on Formosa. Though this territorial expansion was long envisioned, its nineteenth-century manifestation was inextricably bound up in the specificities of the unfolding Meiji Restoration. Catalyzed as a response to the American gunboat diplomacy of 1850s, Japanese reformers sought to frame a process of thoroughgoing societal transformation as one that would *restore* the Empire to glory. Meiji reformers broke the power of the aristocratic Shogun class, and with decision-making authority now centralized with the emperor Mutsuhito, it became possible to quickly Westernize the economy and military. Confucian hierarchies were dispersed in favor of European-style bureaucracies, telecommunications and railway links were forged, and exports began to jump. The old expansionist impulses were given new urgency: Japan sought to adapt European practices of colonialist expropriation before finding itself subject to them.[20]

It was within this context that the young Fujita decamped almost immediately from his studies at the prestigious Tokyo Fine Arts School and sought to make his way to the burgeoning world of the artistic avant-garde in Paris. He threw himself with abandon into what must have been a supremely strange world of artistic and sexual experimentation—throwing lavish parties and involving himself with a seemingly endless string of models. He developed a signature style

that might be characterized as visual Meiji. Recognizably Japanese in its use of *sumi* ink and precision calligraphy brushes, Fujita's work after arriving in Paris quickly adapted the color washes and fractured visual planes characteristic of the Fauves and the early Cubists. Older artistic styles waft through his *oeuvre* as well, with weightless scenes of young lovers and solitary cats that seem equally derived from the oneiric worlds of *Ukiyo* prints and Symbolist canvases.[21]

Fujita's radically distinctive personality powered a rapid rise and fall. Fêted as one of the few commercial successes of the inter-war Paris art world and honored by the governments of both France and Belgium, overnight success encouraged profligate spending. In the early 1930s, he abandoned his mounting debts and his third wife, bringing the mistress who would become his fourth along for a whirlwind tour of Latin America. When that adventure began to lose steam, he eventually returned to a radically transformed Japan. His international success—predicated on a selective fusion of Japanese and Western sources and techniques—seemed an embodiment of Meiji aims, and he became something of a celebrity in Japan. Along with Seiji Tojo, another Japanese student artist who had briefly collaborated with the European Futurists, Fujita came to lead the aptly-title Avant-garde Western Painting Research Institute.

In 1933, the Institute received an enthusiastic initiate who had recently left China in search of greater exposure to the cutting edge of European artistic experimentation. The young Li Chun-Shan (also known by the variant Li Zhongsheng) had enrolled at the Department of Fine Arts at Nihon University, but after encountering the exhibition *Original Avant-garde Paintings from Paris and Tokyo* at the Tokyo Metropolitan Art Museum, he found his way to Fujita's Institute, where he went on to cultivate an extended relationship with the elder artist.[22] Li's works from this period demonstrate a probing ambition to push even beyond what was understood to be transpiring in Europe. Absorbing a heady mixture of ideas from Freud and Kandinsky, Li's painting under

the tutelage of Fujita attempted to explode the psyche whole cloth onto the canvas, presaging a logic of what we might call "psychic ejaculation" most famously articulated decades later by Jackson Pollock.

Li stayed in Tokyo for three years, joining the Experimental Black Western Painting Society and staging a number of important exhibitions. But between 1937 and 1938 both protégé and mentor found themselves sucked up into the changes sweeping over China. Fujita had the honored position of a military attachment, serving as an illustrator and propagandist embedded with Japanese units fighting in Manchuria. Li returned to share the international forefront of creativity with China's next generation as an instructor at the National Hangzhou School of Art.[23]

Strikingly, teacher and pupil found themselves returning to the opposite sides of a war.

Degrees of Separation

The war, out of which the modern schism of China/Taiwan would be born, had already been decades in the making. The last of China's Imperial dynasties, the Qing, collapsed in 1912 after a period of prolonged unraveling. The disintegration of the world's oldest, largest Imperial state created a grand power vacuum which drew in all manner of agitators, revolutionaries, and warlords. A new political order began to coalesce around the revolutionary leader Sun Yat Sen, who had himself fled briefly to Japan before returning to establish a new Republic of China. Recognizing that the path to a new unified nation-state would require a painstaking military campaign against dissidents and separatists—and operating under the pervasive view that Manchurian Qing had themselves been foreign usurpers—Sun set out to reconquer the contested northern parts of China. He sought to build internal consensus and strategic external support,

and formalized a tactical alliance with the Soviet Union and Chinese communist militias in 1923.[24]

Two years later he was dead of cancer, and a bitter rivalry broke out among his disciples as to who would carry the banner of revolution. Within two more years, warring factions of Sun's followers would become each other's primary antagonists. After a brief, internal struggle, Sun's foremost lieutenant Chiang Kai Shek assumed leadership of the nationalist Kuomintang (KMT) and began a vicious campaign to purge the recently-allied Communists from its ranks. His armies occupied Shanghai in April 1927, unleashing a massacre on Communists and civilians that left thousands dead. In response to the "White Terror," the communist wing formed an "Red" army of its own, which concentrated on small-scale guerrilla actions against the KMT.[25] The KMT, for its own part, remained focused on territorial reunification, which meant consolidating and holding the contested terrain in the country's north. This zone was not only a hotbed of ethnic Manchurian separatism, but also the site of important frontiers that abutted Korea, Russia, and (over a short span of ocean) Japan.

As on Formosa, Japan had eyed these distant Chinese holdings as ripe for detachment. The Empire had managed to stake landholding claims along the strategically significant Southern Manchurian Railway. In 1931, the Japanese secretly dynamited a section of their own railway, and used the event as pretext for a punitive expedition against the Chinese dissidents that they held responsible. The resulting offensive—a manufactured version of the reprisals against the Paiwanese villagers—became the beachhead from which Japan attempted to launch a full-on invasion of mainland China. This second Sino-Japanese war would metastasize into the Eastern theater of World War II, and would kill tens of millions of civilians, the vast preponderance of them Chinese. But Chiang at first dismissed the seriousness of the Japanese threat, insisting that the KMT focus first on "internal pacification" (i.e. war against the Communists) and then turn to "external resistance."[26] It was only after he was kidnapped by

one of his subordinates that Chiang grudgingly agreed to a temporary truce with the Chinese Communist Party (CCP).

The alliance lasted only as long as the larger war, and with the Japanese surrender in the wake of the atomic bombings at Hiroshima and Nagasaki, KMT–CCP fighting began again in earnest. Seasoned by more than a decade of continuous conflict, each side was confident in its own operations as well as its support both by the citizens of China and the international community. Against the hardening backdrop of an international Cold War, the governments of both the US and the USSR sought to encourage their proxies to find a peaceful resolution, but mutual distrust and aggrievements poisoned such a possibility from the outset. Moreover, his belief that the American military would not leave his Christian, capitalist government to fend for itself led Chiang to overextend his political hand. Eventually, an exasperated General Marshall convinced President Truman that the Chiang should be left to his fate.[27]

By 1948, Chiang's KMT was in irreversible retreat. Beginning in August of that year, leaders of Republic of China (the political wing of the KMT) began to systematically relocate their remaining military supplies, as well as cherished cultural heritage, to the most defensible possible position—the island of Taiwan recently vacated by withdrawing Japanese forces. And just as the days of the Ming, Chiang's military exodus catalyzed a larger flight of refugees, fearing the usurpation of the Chinese mainland by illegitimate tyrants. Among those refugees were the painter-teacher Li Zhongsheng and his future protégé, the fourteen-year-old Hsiao Chin.

Hsiao Chin and Early Abstraction in Taiwan

The Taiwan to which they fled was, even for the standards of the island, in a politically complex situation. Chiang had decamped to Taiwan under legal precedent previously set with Churchill and

Roosevelt in Cairo; upon defeat, Japan would restore all stolen land (including Taiwan, Penghu, and Manchuria) to China. But when the moment of this defeat arrived, there were competing claimants to the government of China itself. Chiang and the Republic of China claimed *de jure* legitimacy—they were broadly recognized by the international powers as the successors of Sun Yat Sen and therefore as the representatives of the modern nation of China. By contrast, Chairman Mao and the *People's* Republic of China were in *de facto* military control of what had recently been the Middle Kingdom. Possession being nine tenths of the law, Chiang was left governing the only splinter of Chinese territory which he could hold and defend, an island that had been written off for most of history as too fragmentary to be worth integrating into China itself. As in the days of Koxinga, the distant island was refigured as the last refuge of the legitimate rulers.

And as Koxinga (not to mention, the Dutch, the Spanish, and the Japanese) had discovered, a chasm existed between proclamations of political authority and functioning civic control. Tensions quickly escalated between the local population—who sought many divergent political visions for Taiwan—and Chiang's army, which was viewed as more akin to an occupation force than a government in exile. After a 1947 uprising against the ROC had to be brutally suppressed at the cost of thousands of lives, Chiang had no choice but to declare permanent martial law.[28] This fiasco nearly led to the last unravelling of his support from the US government, but shortly thereafter, Mao elected to intervene in the Korean war. When Chiang's forces defeated Mao's Red Army at the Battle of Guningtou, they solidified both their military independence from the mainland and their geostrategic necessity to the capitalist West.[29] An uneasy status quo was born: reunification as an official goal, but one with no stated terms or timetable that either side, pitched in disagreement, could object to. A strange political standoff that continues to the present day.

It was against this conflicted backdrop that Hsiao Chin began his career as an artist, moving from the Provincial Teacher's College to the experimental art studio founded by Li Zhongsheng in 1951.[30] As Chin has recalled, Li was an uncommonly inspiring and open-ended instructor, encouraging students to discover their own direction as inspired, rather than determined, by the study of tradition. Touchstones ranged through calligraphy, landscape painting, Chinese opera costume, and even the audacious Juelan experimental group that had been active in pre-World War II China.[31] Chin's surviving works from this period record a similar educational journey as traced by predecessors Li and Fujita—traditional East Asian materials and techniques integrated abruptly with the radically abstract visual vocabularies of European modernism.

On New Year's Eve of 1955, Chin and a group of contemporaries formed the Ton Fan Group, widely considered to be the first experimental art collaborative in Taiwan.[32] Literally translated as the Eastern Painting Society but known more colloquially as "Eight Bandits," Ton Fan artists were marked by their thoroughgoing rejection of Chinese and Japanese aesthetic orthodoxy. Instead, these artists aimed to situate their work within a new international avant-garde. As they wrote in the Group's founding manifesto: "Our country's conception of traditional painting is fundamentally similar to that of the modern world ... the infinite artistic treasures of China [will] have a new place in today's world trends and walk down a large, forever changing road."[33] The sentiment might have been laudable, but China's (or Taiwan's) relationship with the "large, forever changing road" of postcolonial power politics was far from given.

Different than in the West, in which abstraction was doubly marked in its politics—as both vaguely leftist in its avant-garde agitation as well as inherently individualistic in a more conservative reading—in Taiwan non-representational painting was seen as a retreat from politics *in toto*. Indeed, there was a political safety in the

abnegation of pictorial content, which risked association with the Social Realism of the Chinese (and Russian) communist alliance. In a recent interview, Chin framed this high stakes binary in the starkest of terms: "If they believed that you had anything to do with communism, they would just shoot you. So the safe way to be an artist was to do abstract painting—no one could accuse us!"[34] The freedom of mental interiority contrasted markedly with the stifling conservatism of the reigning political climate. Life or death, in the swirl of a brush.

Chin's remarkable comment insists on a reframing of the issue of the interconnection between American abstract painting and the larger cultural front of the unfolding Cold War, an issue that has only recently begun to receive the attention that it deserves. As art historians including Francis Frascina, Michael Leja, and Erika Doss have shown, the leading edge of American painting proved to be a remarkably ally of convenience for those in the American government charged with fighting the Cold War on a cultural front.[35] Initially dogged by associations with European intellectualism (and by extension, the long reach of the Soviet International), the New York School soon morphed into a visual shorthand of remarkably concise political power. The paintings of Pollock, de Kooning, and Rothko were "heroic gestures against the void" as one contemporary critic described them, and the void could just as easily become political rather than existential.[36] Over the course of the period under consideration, the CIA funneled funds into a cultural think tank run by Nelson Rockefeller, president of MoMA and erstwhile director of wartime intelligence in Latin America. These funds were then disbursed to support close to three dozen international exhibitions for MoMA's chosen cadre of abstractionists, advancing the cause of freedom one gestural brushstroke at a time.[37]

However, little scholarly attention has been paid to the counterpoint dynamic unfolding across the world in East Asia—revolving to a new axis of allies reconfiguring itself month by month. Just as

the Rockefeller Brothers Fund was collecting its first government contract, Japan was signing the San Francisco Peace Treaty, which officially ended the American occupation and set the terms for a new international cooperation between nations that, six years prior, had become the first nuclear antagonists in history.[38] This same dynamic was in full swing in Marshall Plan Europe, where yesterday's bitter fascist enemies were quickly morphing into today's bulwark against the advance of communism. This remarkably taut pivot has been missing from the broader reception of international abstract painting—an embrace of the radical freedom of the individual taken on within cultural contexts that, extremely recently, had given rise to the most destructive kind of fascism the world had ever seen.[39]

And indeed, it was within this new network of allies that Hsiao Chin began to share his painting with the world.

From the Eastern Group to the Single Point

In 1956, Chin left Asia for the first time, departing to Madrid to study with a scholarship sponsored by the Chinese and Spanish Cultural and Economic Association. He arrived at the Academia de Bellas Artes in Madrid, an august eighteenth-century institution that had briefly been directed by Francisco Goya. But the adventurous Chin, much more interested in the future of European practice rather than its past, found the environment stifling. He soon abandoned his formal studies and the scholarship that went with them, decamping for the comparatively bohemian coastal city of Barcelona in which the aging giants of Picasso, Dali, and Miro were still active in their studios.[40]

In his journey eastward, Chin crossed what had recently been one of the most violently contested borders on the European continent: between strongholds of rival Republican and Nationalist governments

that had each claimed to represent the legitimate, reformed continuation of a recently crumbled monarchy. The parallels between the contemporaneous Chinese and Spanish Civil Wars of the 1930s are striking—an internecine conflict over historical legitimacy, national self-determination, and economic progress that was quickly drawn into the vortex of global war. Indeed, Francoist Spain would have in many ways reminded Chin of Chiang Kai Shek's Taiwan, a nationalist dictatorship looking to modernize its economy while relinquishing as little social or cultural control as possible.[41]

These ambitions of modernization had drawn these otherwise dissimilar nations into parallel positions within the emergent Cold War world order. Looking to bolster the strategic global footprint of nations arrayed against communist expansion, the US government had recently been forced to cast aside objections and welcome Chiang and Franco into an increasingly unsavory network of friends and allies. In 1953, President Eisenhower signed the Pact of Madrid, breaking the diplomatic isolation of the Spanish government that had, until recently, been a staunch ally of the Nazis.[42] The following year he was forced to send American forces to prevent the Chinese army from invading Chiang's Taiwan.

In Barcelona, Chin discovered a spin-off of the interwar Jazz culture that had fascinated Fujita. In the early 1950s, Barcelona had become home to Spain's first "Hot Club"—a take-off of the iconic Parisian Hot Club—which played host to luminaries including Bill Coleman, Louis Armstrong, and Count Basie.[43] Chin quickly moved into this city's cultural orbit, participating as a visual artist in the fourth edition of the intermedia Jazz Salon as well as the Salon de Mayo, one of the largest gatherings of contemporary artists in post-war Spain. He was selected as a top young artist at the Salon in 1957, and enjoyed the recognition of his first solo exhibition at the Museo de Mataró. Significantly, he began to sign his name "Hsiao 勤," insisting on the dual East/West nature of his artistic ambitions.[44] At the same, Chin

Figure 5.1 *Pintura #AO*, 1950. Image courtesy Hsiao Chin Art Foundation with thanks to 3812 Gallery.

worked to connect his Taiwanese peers into his newly discovered *milieu*, coordinating a dual presentation of Ton Fan work in Taipei and the Galeria Jardin in Barcelona. While considerable negotiation was necessary to show this experimental work in Taiwan—Chiang saw his government as preserving the traditionalism of Chinese culture—Ton Fan recognition continued to grow abroad, including Chin's co-founder Li Yuan-chia's participation in the 1957 Sao Paulo Biennale.[45]

In Spain, Chin began to fully embrace the ambition for abstraction to which he had only hinted in Taiwan. He produced a series of untitled *pinturae* that, in hindsight, hit most of the iconic stylistic elements of the period: the elemental formalism of Franz Kline (another student of Japanese calligraphy), the scumbled, off-white surfaces of Cy Twombly, and the overburdened figuration of late De Kooning.

A particularly evocative pairing exists between Chin's *Pintura AO* and Robert Motherwell's contemporaneous *Elegies to the Spanish Civil War*. An American and a Taiwanese painter making work in the shadow of a Spanish disaster neither of them had witnessed. A disaster that, because of exigent geopolitical needs, was being written out of history in real time.

AO was painted in 1959, the last year of Chin's sojourn in Spain. Feeling the pull of the art practice beyond the somewhat limited purview of Barcelona, Chin made his way to Milan, which was a comparative hotbed of artistic experimentation.[46] He made contact with Gabriele Mazzotta, an arts publisher whom he had met at the 1957 Venice Biennale, a week in which Chin would have had peak exposure to the world of American abstraction including Mark Tobey and Mark Rothko. Through Mazzotta, Chin quickly made his way to the center of the Italian avant-garde. Among his first collaborators was the Argentinian painter Lucio Fontana, with whom he could converse with greater ease in Spanish.

Italian post-war experimentalism was, notably, almost unique for its willingness to approach the culturally radioactive legacy of the recently deposed fascist regime. Alberto Burri, perhaps the best known amongst Italy's unofficial art of the *informel*, had in fact served as a combat medic during Mussolini's invasion of Libya. He was captured by the Americans and, barred from practicing medicine, became a self-taught artist at an American POW camp in rural Texas. Upon his return to Italy, Burri developed a reputation for haunting assemblages of burlap sacks and other ephemera, frequently subjected to the cruel blaze of the blowtorch.

These gestures are often read by art historians in juxtaposition with Fontana's iconic slicing of the painted canvas—a surgical cut and a savage attempt at suture.[47] As scholar Jaleh Mansoor has recently argued, the metonymic object of attack in such works was the encroachment of unwanted American allies. Burri, Fontana, Manzoni, et al. were motivated by resistance to Italy becoming "a laboratory

for capitalism's development into new markets."⁴⁸ A political climate in which Chin would have felt right at home: a resistance against American hegemony mitigated by a structural need for American protection. An ongoing cultural attempt, on both sides of the uneasy alliance, to unthink the recent brutality of fascism.

Although he could be scathing in his rejection of the Italian *arte povera* movement, it was in Italy that Chin claims he truly understood his own cultural worldview. As Chin recalled in a recent interview, "I went to Europe to learn more about my own culture. I began to learn about Chinese culture in Europe."⁴⁹ His earliest Italian works conspicuously lack the violence of his new compatriots. Instead, Chin returned to a pared down vocabulary of a few massive *kasure* strokes (in which the brush is allowed to run out of ink to reveal the component pigment colors) paired with a small geometric shape hovering near the picture's border.

These elementary forms became a kind of visual metaphor for the *punto* movement, which Chin founded with the painter Antonio Calderara and the Japanese sculptor Kengiro Azuma in Italy in 1961.

Punto was conceived as a reply to the reigning approach of American abstraction, rooted in an expressive individual ego. As Chin explained in 2018, "we thought that that was passe. Because you didn't bring any new message to the art work. Therefore, we thought we should work out some way to express art differently."⁵⁰ Their point of departure would be an embrace of the impersonal—the *punto*, or dot, as an a-personal, axiomatic building block, a metaphysical element that, as art historian An-Yi Pan has characterized it, was seen by the group as "solemn, pure, positive, eternal and constructive."⁵¹ The movement gained some international traction, with additional members of Ton Fan, such as Li Yuan-Chia, joining an enlarging cohort of artists from Germany, Spain, and the Netherlands who managed to stage exhibitions in locations ranging from Barcelona to Zurich to Taipei.

Scholars of the period have noted analogs to the contemporaneous Zero movement, especially in light of the Eastern metaphysics

introduced into the latter group by video artist Nam June Paik. However, the aesthetic philosophies of the groups were markedly different; with the Zero impulse to deconstruct the tissue of art and electronic media running counter to the Punto aspiration for wholeness. The emptiness of the naught and the fullness of the point. Nevertheless, as part of an emerging front of global contemporary art, resonances between Punto and far-flung corners of experimental practice take on additional importance. A unifying current runs from the Gutai impulse not to "alter matter" but rather to "impart life to matter" through Joseph Beuys' shamanistic take on conceptual art and all the way to the experiments in the western deserts of the US.[52] A broad based artistic effort to push back against what sociologist Max Weber called "the disenchantment of the world."[53]

For students of Weber, it was this rationalizing impulse that created the fault lines along which broke the history of modernity. A gleeful destruction of ancient encrustations—religious superstitions, cultural norms, geographic limitations—counterpoised with a yearning to rebuild a new totalized system. A Great Leap Forward, or a Thousand Year Reich, architected by the latest in statistical modeling. Matter and Spirit. Old ends and new means. Former enemies and forced allies. A reversal of polarities in geopolitical power, refracted through the lens of an art world newly able to interact with itself all over the world.

Coda: The Long Road Home

Chin completed a sweep of this reversal over the next two decades. He continued to orchestrate exhibitions between Europe and Taiwan, and himself arrived in New York in the 1960s as waning favor of abstract painting created a vacuum into which poured a florescence of ideas: pop, minimalism, conceptual art, video, Fluxus process, and performance. From New York, he began to explore the broader Americas, teaching

first in upstate New York and then upstate Louisiana. From there, he went to Mexico to study the art of the Aztec and the Maya, believing that the status of these cultures outside of the Occidental narrative made them analogs for the traditions of China. No mention survives of Chin's study of the work of the tribal peoples of Taiwan. Chin in fact steered clear of his homeland for nearly two decades. He detested the dictatorial control that Chiang exerted over the island, and only returned in 1978 for an exhibition held three years after the Generalissimo's death. Shortly thereafter, he returned to China itself, holding seminars on modern and contemporary art in Shanghai and Beijing.[54]

The worlds to which he returned were on the precipice of great transition as another pivot carefully architected by Nixon and Mao was bearing itself out in international agreements. Between 1979 and 1980, the US government moved its Chinese embassy from Taiwanese Taipei to Beijing and terminated its mutual defense treaty with Taiwan. Under the new diplomatic framework, ROC-controlled Taiwan was not a sovereign nation with whom the US would enter into such a pact. The US did not so much abandon their allies as endeavor to create a legal mechanism in which the liminal status quo could continue. The Taiwan Relations Act created the American Institute of Taiwan, a private non-profit corporation that could continue to act as a *de facto* American embassy in Taipei. The US agreed not to push the agenda of reunification from either side, as well as committed to the continued sale of military equipment to Taiwan, The trade in arms was counterbalanced by the export of consumer goods—mainly toys, clothing, and electronics—which created a comfortable trade surplus for the ROC.[55]

A twilight world in which tens of billions of dollars' worth of tennis shoes, VCRs, and missile defense systems flowed between allies that were not legally able to enter into a formal treaty. An abstraction more radical than the most adventurous canvas. And a backdrop for the export-based emergence of the still-stranger world of experimental visual art in mainland China (see "Our Own Arrows" in the present volume).

6

静音情况

Muted Situations

Co-authored by Alexander Rehding, Fanny Peabody Professor of Music, Harvard University.

Muted Situations #22, 2018. Image courtesy of the artist.

At a Glance

The following essay explores the work of Samson Young. A previous version of this text, authored by musicologist Alexander Rehding, accompanied an exhibition of Young's at the Guggenheim Museum (NYC) in 2018. Rehding has served as a guest author on this revised and expanded version, which extends from Young sound-based practice out to the contested history of Young's native Hong Kong.

Originally founded as a treaty port from which to quarantine British influence on Chinese affairs in the 19th century, the island of Hong Kong was ceded to Britain in the aftermath of the Opium Wars. Wishing to maintain the appearance of protecting the territorial integrity of the venerable Chinese Empire, the British constructed a lease agreement with the Qing that would permit them control of the island on a 99 year term. When that lease lapsed 1997, the erstwhile British zone was thrust back into a national polity with which it no longer fully belonged. While some Hong Kongers sought closer relations with the mainland, the Western habits of voting, of a free press, and relatively unregulated markets had made such integration unwieldy at best. And the Chinese state found that it enjoyed continued benefits of a liminal, Special Administrative Region in which aggregate benefits of foreign trade would outweigh the localized political risks. However, the foundational "One Country, Two Systems" framework that governs the relationship between Hong Kong and the mainland has recently begun to fray, with the result that the futures of nearly eight million people, and tens of trillions of dollars, are caught in largest gap remaining in the colonial history of the world.

It is enough, as Samson Young's *Muted Situations* (2018), might have put it, to cause a silent scream.

Samson Young's *Muted Situation #22: Muted Tchaikovsky's 5th* (2018) plunges us into a situation in which concert-goers have found themselves countless times. Viewers follow an orchestra busy at work performing Tchaikovsky's Symphony no. 5. The conductor lowers his baton. String players bow their instruments. Wind players blow into their horns. But this performance is like no other. While the instrumentalists play every note of Tchaikovsky's score exactly as written, the all-too-familiar sounds of the symphony are withheld. The strings have been taped down and cannot resonate, the reeds on the woodwinds are stopped or removed, air is blown through brass instruments from flaccid lips, the timpani are muffled.

A silent orchestra? Silence has been a trope of the avant-garde ever since Yves Klein's *Monotone-Silence Symphony* (1949) or John Cage's epochal *4"33"* (1952). But Young's *Muted Situation #22* is anything but silent: this muffled symphony is a precision mechanism that rattles, ticks, and hums. It is an organism that breathes, wafts, and billows. We hear the soft scratching of horsehair on the violins, the gentle clicking as the wind players press down the metal keys on their instruments, the dull thumps of the timpani mallets falling down on the dampened drumhead. We hear the musicians' breath, collectively and individually. We even hear the faint rustling of the fabric of the players' clothes.

Absent from this symphony are the pitches specified in Tchaikovsky's score, his orchestral palette, the pathos of his melodies, the gorgeous timbres that pull at the listener's heart strings. What remains are the clearly articulated rhythmic features of his symphony. The "fate theme" that opens the work and recurs throughout the symphony is instantly recognizable, even in its skeletal rhythms: "daaaaaaam dada daaaaaam dada daam daaaaam." The symphony is so well known, both loved and loathed, that it is easy to recall those moments from memory. But the eloquent silence of *Muted Situation #22* tears off the luxurious sonorous shroud of this romantic symphony (a composition that cultural critic Theodor Adorno held up as the epitome of kitsch)

and reveals what lies underneath it: the collective sound of musicians at work.¹ In this rendition the music is turned inside-out: the heart-wrenching melody from the slow movement, freed of its pitchiness, retains all of its tension and energy, but its warm glowing intensity turns menacing, the pulsating string carpet becomes threatening, each emphatic downbeat a gunshot. Other passages exude a new-found seductiveness, a whisper, a breath that caresses your ear and may elicit something close to ASMR. What the performance retains is the *espressivo* of the symphony; its purified expressiveness highlights what is not being said. This muted situation is the epitome of the uncanny: the familiar turned strange and unsettling.

A situation, a place, made not itself.

It is perhaps one of those marked coincidences that the first of these *Muted* symphonic works—a single channel video work muffling a chamber quartet—emerged in synchrony with the uprising that gripped Young's native Hong Kong in 2014. This upheaval, which was spurred by the Chinese Communist Party's attempt to exercise more direct control of the ostensibly independent election in Hong Kong, drove hundreds of thousands of protestors into the streets. The emblem that emerged from that tumultuous moment was the umbrella—typically cited as a tactical adaptation used to block onslaughts of tear gas. However, the umbrella has another meaning, or at least another resonance. In the earlier part of the decade, in its constant game of whack-a-mole against dissent, government censors in China were briefly lenient in allowing urban citizens to grouse over the visible air pollution problem. Made on publicly visible platforms such as Weibo, these protestations ran counter to Party statements on China's excellent air quality. As such, "smog" or "foul weather" became a metonym for the political corruption in China—a way of talking about a problem everyone can see but no one could name.² A toxic miasma hovering over a strictly enforced harmony.

The umbrella becomes a silent shield.

Indeed, in the subsequent wave of protests that have gripped Hong Kong since the summer of 2019, silence has been wielded as one of the demonstrators' most powerful weapons. Under the sweltering August sun, a cadre of the city's lawyers took to the streets in silence. They marched all in black, many of them carrying umbrellas, to express their solidarity with the so-called "youth revolts" that sprang up in response to another proposed move to link the governmental and judicial systems of Hong Kong more closely with the mainland.[3] Such silent protests have been undertaken by groups of medical workers, students, and other social cohorts. As Young himself noted, such self-imposed silence forms a counterpoint to the external imposition of *muting*—instead silence is a "relentless down beat" that "is so sure of itself that there's no room" for doubt or deviation.[4] The kind of implacable determination needed to face down an enemy with only deflection.

The more recent protests in Hong Kong continue to retread over the same territory—a rising tide of deep anxiety over what will happen as the formerly British Hong Kong is fully integrated into the Chinese political and economic system. At stake are the futures of nearly eight million people, and tens of trillions of dollars, caught in largest gap remaining in the colonial history of the world. The temporary regime of "One Country, Two Systems" is unraveling in real time, but what lays after no one can say for certain.

It is enough to cause a silent scream.

The Harbor in the Shadow of Empires

The seeds of the present conflict were sown during the height of European colonial expansion. Although the territory now known as Hong Kong has been inhabited continuously the Bronze Age, the importance of Hong Kong harbor to long distance sea trade was a

relatively recent development. As is discussed in greater depth in "Our Own Arrows" in the present volume, the Imperial dynasties of the Middle Kingdom had an uneven relationship with the Far Barbarians whose ships began to appear in the early sixteenth century. The Portuguese established a trading post in 1513 on an island somewhere on the Pearl River Delta, near the contemporary cities of Hong Kong and Shenzhen, but were forced to abandon their settlement after an engagement with the Ming Navy ended in disaster eight years later.

But, with strong foreshadowing of future events, the draw for Chinese porcelain was too great to resist. With an export ban limiting licit supply, adventurous Portuguese traders found themselves entangled in the strange world of the *wokou* pirates, outlaws made of an admixture of Chinese, Japanese, and Korean outlaws with roots dating back to the Mongol invasions of Japan in the thirteenth century. The pirates found that Portuguese inventions such as the matchlock musket were enormously helpful in holding off the Chinese navy, and the extra-legal export business boomed until the Ming crushed the port haven of Shuangyu in 1548. With peerless adaptability, the Portuguese used the opportunity to reboot their relationship with the victorious Chinese, and in 1554 signed an agreement with Provincial Admiral at Guangzhou to permit the permanent creation of a trading settlement on territory leased from the Middle Kingdom.[5]

Although the Portuguese were now allies of the Chinese empire, the deepening trade links exacerbated the scourge of piracy. The European colonial powers found themselves with a sudden glut of precious metals extracted from their possessions in the New World, and as these newly mined materials entered circulation in Asia, unpredictable effects began to pile on top of one another. While pirates were attracted to suddenly rich import/export targets, the net inflow caused runaway inflation among those least capable of dealing with it: ethnic minorities eking out an agrarian existence on

China's northern steppes. When the revolting Manchus overthrew the majority Han Ming Dynasty to establish the Qing, vestiges of Ming loyalists became intertwined with the *wokou* pirates, forming a political as well as security threat to the new Imperial order (See "Degrees of Separation") in the present volume.

Under increasing pressure, the third emperor of the Qing (known by the honorific Kangxi) reinstated the infamous *haijin* isolationist policies.[6] These bans on overseas trade have often been touted by Western apologists as a kind of circular explanation for China's ostensible retreat at a moment of counterpoint European expansion. As an inward-looking Empire, so the received logic goes, China would naturally seek to prohibit overseas commerce at moments of political crisis. However, the historical function of *haijin* bans on international commerce have been widely misunderstood. For many centuries, emperors had periodically interdicted trade with external kingdoms as a means of ensuring control over an enormous sphere of projected power. An expression of the Imperial impulse to "build that wall," a sentiment with which even the most expansionist Westerner could sympathize.

However, the reinstatement of the *haijin* in 1661 turned out to be a miscalculation with drastic consequences. The Chinese monetary system had become dependent upon European silver, and when the arrival of overseas specie came to a crashing halt, wild currency fluctuations led to panic.[7] Chinese traders fled their homeland in droves, and a decree threatening death for those who refused to return failed to produce results. The Qing *haijin* exacerbated the damage by instituting a Great Clearance, in which coastal cities and towns were required to move themselves at least 25km inland. The forced relocation of millions of people, and the untold damage to property and trading infrastructure proved to be fatal wound, although one that bled slowly. When the clearances were reversed, fewer than 10 percent ever came back, a paltry return that opened the door to newer, more dangerous global "partners."[8]

Although the Qing were to reopen trade in the late seventeenth century, a move Kangxi claimed would enable the world to see "the populous and affluent nature of our rule," problems remained. Pirate commerce, exacerbated by the outlawing of licit trade, remained difficult to extinguish. Moreover, the subsequent emperors discovered that Europeans could never seem to mind their own religious business; missionaries remained stubbornly interwoven into the fabric of industry. The missionary presence became an even greater insult after 1715, when Clement XI formally condemned traditional Confucian practices.[9] The emperor attempted to concentrate all foreign trade into the port of Guangzhou, 200km upriver from the island of Hong Kong. Specialized trading houses were established to limit the footprint of the meddling outsiders, and a system was created where local *hong* merchants would bear responsibility for the compliance of specific foreign trading partners.[10] These systems form the deep historical antecedents for the contemporary flash points in East/West trade: a network of legally enforced intermediaries operating in a territory that seems at once to be both inside and outside of the Chinese polity.

In reopening trade, the Qing court had assumed a continuity with the deeply ancient balance of power: the Middle Kingdom as the focus to which all peripheral nations and forces would of course pay obeisance. They were tragically both correct and incorrect. The Western consumers—particularly the British—had a voracious appetite for silks, teas, porcelains, and other objects of Chinese origin, but no counterpoint consumer market existed in China. This unidirectional flow of goods quickly created a vacuum that was deviously filled by the British East India Company, which began to quietly import the one British-colonial substance with genuine local demand, Indian-grown opium. The new opium created a rash of problems—not only drug addiction and the attendant social strain, but also an enormous outflow of currency. The Chinese made several attempts to crack down on the drug trade, first pleading with the

British for their assistance and then pursuing independent police action.

But the Chinese underestimated the consequences of entering into open conflict with the British merchants, who were reinforced by the might of the Royal Navy. Buoyed by the recent defeat of the Napoleonic forces in Europe and a coalescing sense of colonial destiny, the Brits were only too eager for an excuse to engage militarily with a waning empire weakened by self-enforced isolation. The so-called "Opium Wars" were brief, one-sided affairs that ended in disaster for the Qing government. They were forced to grant immunity from local laws to all British traders, to open additional treaty ports to unwanted commerce and, perhaps most shameful of all, to cede territorial control of Hong Kong.[11]

The Sun Never Sets ...

The ceding of Hong Kong Island occurred with the Treaty of Nanking in 1842, the first of the so-called "Unequal Treaties" forced on the weakened Qing empire. Beyond Hong Kong island, the treaty compelled China to cede several surrounding islands to the United Kingdom, establish numerous treaty ports for the British, pay millions in restitution and (in an addendum added the following year) grant Britain most favored nation status. However, even these terms failed to satisfy British expectations for remuneration, and the colonialists in Westminster were soon looking for new justifications for expansion. After a British ship was "wrongfully" detained in Hong Kong in 1856, a further round of lopsided violence kicked off, the unequal resolution of which saw the opening of additional trading ports, the legalization of the opium trade in China, and new ceded territory across the harbor from Hong Kong Island and on the mainland itself.[12]

What in China has since become known "Century of Humiliation" was fully underway. British soldiers razed Imperial palaces with impunity and inspired copycat European powers to demand territorial concessions carved into Chinese cities, complete with legal immunity granted to European interlopers. A moment of the projection of European colonial power and Romantic, world-remaking ambition that one still hears resonating in Tchaikovsky's 5th. At the end of the nineteenth century, China was defeated in the First Sino-Japanese War—a defeat made all the more stinging given Japanese emulation of German and British military-colonial strategy. This loss opened yet additional opportunities for the seizure of territorial control wrapped in the garb of paternalistic deference. While the mood had changed in the past decades—it was no longer considered acceptable to conquer Imperial territory outright—Britain seized the chance to enforce a Second Convention of Peking. It was intended as a gesture of deference to a formerly great power that the British delegation agreed not simply to expropriate Hong Kong from the Qing, but to lease it. Signed in 1898, the 99-year lease was envisaged to govern the peninsula essentially into perpetuity. The actual effect was to plant a time bomb scheduled to go off in 1997.

In the intervening almost-century, Hong Kong was alternately celebrated as a colonial achievement and ignored as a legislative priority. The British earnestly aimed at modernization, bringing in new infrastructure cutting across education, transportation, and healthcare that managed a burgeoning population. Its interstitial status as a British Crown Colony that was nevertheless deeply embedded in the trading fabric of the Chinese empire set the territory on a course of comparative prosperity. Banks such as the Hongkong and Shanghai Banking Corporation Limited and export merchants such Jardine Matheson enriched their mostly Anglo shareholders, but also raised the general standard of living. Local

challenges to British authority were co-opted by selective inclusion in the trappings of government ranging from impotent oversight committees to social clubs.[13]

And yet, its political status apart from the Middle Kingdom pushed the territory of Hong Kong into cultural separation from mainland China. During the tumultuous period that followed the collapse of the Qing in 1911, political refugees from across the ideological spectrum sought refuge in what was widely perceived to be neutral territory. While English served as the official language, Cantonese remained the local dialect of preference, further dividing the territory from China as revolutionary Sun Yat Sen declared Mandarin to be the official dialect of the fledgling Republic of China.

As the storm clouds of World War II darkened on the horizon, the British formalized an agreement with Sun Yat Sen's nationalist successor Chiang Kai Shek, collecting a pledge from the Generalissimo to attack Japanese forces in the North if British Hong Kong came under attack in the South. But unlike its synchronized lightning strike on Hawaii, Japan came to Hong Kong with the intent to conquer. British soldiers tried to hold the city's defenses, but when the Japanese successfully crossed Victoria Harbor onto Hong Kong Island, the leadership realized that the game was up. Colonial Governor Sir Mark Young surrendered Hong Kong to General Takashi Sakai on December 25, 1941, a date now known to Hong Kongers as "Black Christmas."

The Japanese occupation of Hong Kong was a notoriously brutal affair, and reduced the territory's population by more than half. Permanent martial law was declared, and the newly formed Kempeitai police force began to use the King's Park in Kowloon for beheading, shooting, and bayonet practice on Chinese civilians. An estimated 10,000 people were executed, with untold others tortured, raped, or mutilated. Allied bombardment, financial mismanagement by Japanese occupiers, and other miseries compounded one another, with the Japanese eventually hoping to extend their resources by

forcibly deporting hundreds of thousands of ethnic Chinese back to the mainland.

The brutality of the Japanese occupation was such that after Emperor Hirohito's own surrender most of the remaining local elites were glad to welcome the British back.[14] And while Sakai was executed as a war criminal in 1946, there was little discussion of returning the territory to China. The 99-year lease was less than half over, and as violence between Chiang's Nationalists and Mao's Communists was only just ramping up, it was unclear to whom the territory would even revert.

When former British governor Mark Young was reinstated in 1945, he attempted to launch what would have been a far-reaching set of democratic reforms in the Crown Colony. Believing that a broadening of political franchise would encourage Chinese loyalty to the British in the face of Communist attempts to retake Hong Kong, Young proposed a new parliamentary body, two thirds of which would represent native Chinese voting blocs. The plan, however languished under resistance from conservative British politicians and entrenched business interests, who feared that the increased democratic power would upset an inherently precarious balance of power. It was to be the last serious attempt at democratic reform for half a century.[15]

Meanwhile, British Hong Kong seemed an increasingly attractive destination for a broad assortment of Chinese society with the means to flee the tightening grip of the Communist Party. As many as 100,000 Chinese refuges arrived every month, often bringing with them significant capital and management experience in industries ranging from manufacturing and finance to organized crime. Although the CCP continued to maneuver in service of its long-term goal of territorial reunification, the Party was consumed with domestic issues. Reprising the *haijin*, Mao's hardline policies effectively forced the end of trade with the non-Communist West, while his ongoing feuding

with their erstwhile Russian allies severely limited any remaining options for international cooperation.

Split between claims by two distant rivals, Hong Kong was in some sense left to its own devices, and the city's business community grew adept at exploiting the liminal status afforded by its peculiar history. At the center of this expansion lay the banking sector, which enjoyed a unique combination of Western advantages and Asian relationships. Growth was uneven, but all told spectacular. A series of crises in the 1960s—which some scholars have attributed to *over-banking*—resulted in regulatory reform that set the territory on a trajectory to ascend into the position of global superpower. After the 1960s reform period, total bank assets had increased nearly 600 percent during the 1970s, with Hong Kong home to representatives from just under two thirds of the top 100 banks in the world.[16] These institutions found new customers in Asian multinationals and governments, as the share of overseas debt held by Hong Kong chartered institutions soared into the billions. Driven largely by its financial industry, the GDP of the tiny enclave grew by a factor of nearly 3,000 percent between 1960 and 1980.[17]

Few were publicly worried about what would become of this new financial nerve center at the termination of the 99-year lease, which by 1980 had less than two decades remaining.

Orientalism Comes Unwound

And while Hong Kong's elite drew power from their position at the confluence of East and West, experimental artists in the West began to draw unprecedented artistic conclusions from their study of Eastern material. Of course, Western artists have been engaged with ideas originating from Oriental cultures for centuries. However, post-World War II interaction with these Eastern sources, and the ways in which they were transformed to answer thoroughly Western

artistic questions, are particularly relevant for understanding Samson Young's practice both on its own terms and as a window onto the historical trajectory of Hong Kong. Most notably, visual artists, poets, and composers drew the precedent from the mystical East that works of art could be pushed asymptotically to the limit of nothingness. Kaballah, the I Ching. Olympic level Judo. Isou's empty books, Rauschenberg's empty drawings, Klein's empty symphonies. All of them—nothingness with a title.

These works, mostly minor *succès de scandale* upon the time of their debut, have been built into a major pivot point in the aesthetic and intellectual history of the West by a cascading series of critics and academic historians. The line, so it goes, is a final nail in the coffin kind of story. Per what we might term the "modernism in hindsight" school of thought (T.J. Clark, Rosalind Krauss), the medium of painting had been increasingly desperate as it sought to iterate through new disciplinary goals for itself in the wake of the advent of photography. Painting, it was thought, should have a destiny, should be *of* something. Daily life (Manet). Speed and modernity (Marinetti). Interior mentality (Ernst). The last in the series, painting as of "its own formal and gestural possibilities" (Pollock) is lavished with extra interpretative attention.

Music history did not quite follow the same patterns. No big surprise, since art music was already a cipher for nothingness—a pointed meaninglessness that came under the name of absolute music.[18] Pure form ruled supreme in this history of non-representation. It was this tradition that the eminent Victorian art critic Walter Pater had in mind when he declared that "all art constantly aspires to the condition of music."[19] But the *sound* of music was always exempt from this mandated nothingness. It was, after all, what made music music. It was not until Cage that music learned to listen to its own silence. In this regard, Samson's *Muted Situation* series shares more with aesthetics of a Helmut Lachenmann, whose

musique concrète instrumentale lets pitches fall by the wayside and wallows in an aesthetic of non-beautiful scratches, noises, and howls. Adorno would surely have approved. Back in the world of the visual arts, those that either rhymed with, or borrowed Cage's ideas used them to drive the prior teleology of form straight into a brick wall. Painting becomes of *nothing*. A final *reduction ad absurdum* of Modernism's last dying wish to set culture on a necessary pathway. An abandoning of all hope. A silent scream of both despair and destructive glee.

It is a moment that a younger generation of artists and scholars are beginning to articulate as an expression of reflexive cultural trauma. As Samson Young himself noted, "John Cage's project has failed Asia." Although "his philosophies are fully absorbed into the history of art," little changed in the institutional fabric of academic music, which has "continue to neglect and negate … composers outside of the West."[20] The failure of avant-garde work to alter or destroy the long-established relationship between canonicity and white European male is hardly surprising, especially given that the best recognized avant-gardists are European white men. And while Young's work has endeavored to shift these dynamics—both through his personal success as well as his attempts to complicate received understandings of colonial history—it is important to note the ways in which the ostensibly failed generation of Cage et al. can also be read symptomatically. Indeed, guilt over the project of European colonial expansion hovers like a mist over this work.

As the task of modernist painting had been to unify the direction of visual artistic activity, the aim of political modernity had been, after all, to remake the whole world into part of the West. This guilt is legible in both positive and negative forms: the political alignment of Lettrist agitators with the Algerian revolutionaries on the one hand, and the stark Orientalism of Burroughs etc. on the other. Charges and countercharges of complicity to what composer Henry Flynt would call

"Cultural Imperialism."[21] It was a moment of self-realization the West would have to relinquish its claims to international moral authority—a dawning realization that manifested itself both in the bohemian quest to reground aesthetics outside of the received Occidental tradition as well as in larger political and economics shift. As John Cage silenced the symphony—and by extension, the Classical tradition—in favor of listening to the World as such, the World was stirring itself to unwind the very real systems of European colonial domination.

Easy Listening in the SAR, Or a Jasmine Flower By Any Other Name

As discussed in "Our Own Arrows" in the present volume, the Chinese Communist Party began in the 1970s to reconsider its relationship with West. While Nixon and Mao had made a furtive alliance, it fell to Mao's successor Deng Xiaoping to implement what would be termed "Socialism with Chinese Characteristics"—a tactical hybrid of planned economy, free marketeerism, and endogenous cultural arrangements. With the expiration of the 99-year lease looming in the foreseeable future, the fate of the British Crown Colony of Hong Kong quickly emerged as a post-Mao diplomatic priority. Negotiations between Deng and British Prime Minister Margaret Thatcher began in earnest in 1982, and culminated in the 1984 British-Sino joint declaration.

The declaration is remarkably short, eight bullet points supplemented by a few indexes. In essence, the two parties agreed that Hong Kong would be restored "to the People's Republic of China with effect from 1 July 1997."[22] But this restoration would be unique. Taking into account the singular history and position of the territory, the CCP agreed to establish a Hong Kong Special Administrative Region which would "enjoy a high degree of autonomy." Most importantly, the text specifies that "the current social and economic systems in

Hong Kong will remain unchanged ... rights and freedoms, including those of the person, of speech, of the press, of assembly ... will be ensured by law."[23] Enforcement mechanisms, appeal processes and amendment procedures were left unspecified. It was to be, as Deng put it, "One Country, Two Systems," an updated version of the prior *hong* framework for operating inside and outside of national boundary.

The subsequent fifteen years were rocky, but defined by remarkable gains in the mainland Chinese standard of living. In real terms, GDP tripled, but adjusted for the parity of local purchasing power, the increase was more like 500 percent. National consumer savings quadrupled. As is discussed in "One Way Glass," generations of Chinese consumers were introduced, in remarkably quick succession, to broadcast television, the internet, and mobile phones. Mainland China got its first exposure to the bleeding edge of the Western avant-garde, ranging from erudite conceptual art to New Wave rock music, and local creators were quick to adapt and repurpose the imported foreign styles.

The burning question of the period—the extent to which Party leadership would allow political evolution to accompany the sweeping cultural and technological change—was answered with bloodshed in June 1989. And while China suffered intensive international blowback in the immediate aftermath of the Tiananmen Square incident, the opprobrium was short-lived. The US never once failed to renew China's Most Favored Nation, status. At the start of the new millennium, China would be admitted to the WTO. It was a period frequently theorized as one in which difference disappeared. Frederic Jameson called it the perpetual present.[24] Francis Fukuyama called it *The End of History*.

The wash of Western consumer culture into the erstwhile Communist nation was unmistakable. Critic Li Xianting penned a scathing critique of these developments, nothing that "singers and movie stars replaced revolutionary heroes," while "western

Figure 6.1 *Possible Music #2*, 2019. Image courtesy of the artist.

consumer culture ... penetrated almost comprehensively from daily necessities, food, vision and hearing."[25] Importantly, his observation of the changing soundtrack of daily life was also observed by Samson Young, an artist nearly forty years younger than the pioneering critic and coming of age amidst these transformations. For Young, the reverberations of international finance capitalism could now be heard everywhere in his native Hong Kong, pitter-pattering with the most anodyne of echoes.

Young in fact addressed this intersection of the economic and the acoustic in a statement extracted from a 2019 video work. As Young put it,

> In Hong Kong (and in many parts of post-open-door-policy China), the ridiculously romantic and easy-listening world of Kenny G-que pop, which in North America is officially known as 'Adult Contemporary (AC),' have become associated with commerce, which is not all that surprising given that its rise coincided with the expansion of the multinational music industry into Asia. And

in the same way that commerce cannot be contained, this mutated strain of localized AC also cannot be contained—since 1989, Kenny G's *Going Home* has occupied a special status of being the unofficial closing songs for malls, department stores, health clubs, and other commercial premises all over China. AC is also the musical genre of choice for the depiction of sexually suggestive scenes, and the liberal lifestyle of the Western-educated upper middle-class on TV and in films.[26]

While the fraught possibilities of "Going Home" in the Hong Kong context are rich enough with possibilities, it is another popular cover of Kenny's where the real interpretive meat can be found. As Young notes, one of the most popular songs by Kenny G in China was his adaptation of *Molihua* (Jasmine Flower), a traditional folk song that had been adapted by opera composers and Hollywood directors looking to infuse their musical strains with the exoticizing flavor of the East.

Not surprisingly, Young is specifically interested in the Sino-British history of the tune. Already present in China during Qianlong Emperor's reign (1735–96), *Molihua* was first heard in the West at the turn of the 1800s. This can be dated with musicological precision. Britain was in the processing of opening diplomatic relations with the Middle Kingdom to expand trade, and King George III sent a mission in 1793, led by George Macartney, create an embassy in Beijing. The negotiations with Qianlong Emperor ended in failure, largely due to cultural misconceptions and mutually incompatible worldviews. (Or perhaps it really was the lack of a kowtow before the emperor, as popular legend has it.) Macartney and his deputy George Staunton returned to Britain without an agreement. But they brought with them a number of cultural items from China, among them a transcription of *Molihua*, which was published a few years later in London under the title *Moo-Lee-Chwa*, along with one other song. The introduction underlined the authenticity of the music:

The following songs were brought to England by a Gentleman of the late Embassy to China, who took them down on the Spot. Their Originality, therefore, may be depended upon, and Mr Kambra is offering them to the Public, with the Addition of a Bass, flatters himself to have made them more agreeable to the English Ear.[27]

Furnished with English lyrics and a keyboard accompaniment with Western harmonies, *Molihua* became *Hail matchless flow'r*, a parlour song with exotic frisson suitable for domestic consumption in the drawing rooms of the British upper middle classes, a fashionable *chinoiserie* made agreeable to the "English Ear."

Young points out in his writings that transcription—a fundamental skill in the musicologist's skill set—is also a political tool for colonization: "The system of musical notation includes and excludes, sets boundaries, makes judgements."[28] The transformation from 茉莉花 into *Hail matchless flow'r* reveals how this transplanted cultural object must jettison one system of signification and adopt another, all the while upholding—Young cites literary theorist Terry Eagleton here—a set of "universalizing beliefs so as to render them self-evident and apparently inevitable."[29] Kambra's reassurances that his Westernized domesticated version represents the original, authentic song underlines this ideology, but the situation becomes more complicated in recent political and military history.

In the past decades, *Molihua* has been featured in the epochal Beijing Olympic games 2008, and was highlighted at the Party's 2013 New Year Gala, a grand cross-cultural extravaganza involving Céline Dion and Song Zuying, a Chinese classical singer and putative lover of General Secretary Jiang Zemin. The piece becomes a kind of obverse demonstration of what theorist Fredric Jameson defines as the cultural conditions of late capitalism (though in the nearly thirty years since its publication, capital has been getting later and later). In describing the de-territorializing effects of an international, "always on" circuit of exchange, Jameson insists that "the producers

of culture have nowhere to turn but to the past." The result becomes a kind of meaningless cacophony defined by "the citation of dead styles … stored up in the imaginary museum of a now global culture."[30] A folk song appropriated by the colonial powers, re-appropriated by the Chinese state and diffused safely out in the world of Céline Dion.

There could, of course, have been no better soundtrack to the 1997 ceremony in which the British government formally returned Hong Kong to Chinese sovereignty. After the fading of the strains of *Molihua*, Chinese Premier Deng Xiaoping assured his esteemed audience that "the Chinese and British Governments have provided the international community with an example of peaceful settlement of historical issues between states." It would be a "a long-term basic principle" to respect the "high degree of autonomy" guaranteed by the Joint Statement and the newly signed Hong Kong Basic Law. At least for the agreed-upon 50-year window.

Coda: Slouching Towards Expiration

The writing of these pages in 2022 marks precisely the halfway point of the expiration of the so-called "Basic Law," and the anxiety over what will replace it has manifested itself on the front pages of newspapers worldwide. Party leaders promise independent legal processes, while simultaneously setting carefully constructed guardrails for the "independence." When the term of Tung Chee Hwa, the first premier of Chinese Hong Kong, was approaching its end, few citizens understood what the future would hold. Increasingly bold political reporters began to pester the Chinese premier Jiang Zemin about the fate of the suzerain colony. "The Hong Kong SAR belongs to the Central Government of the People's Republic of China … we'll let you know our decision." Tung returned to serve most of another term, his abrupt resignation

catalyzed by a one-sided confrontation with Chinese premier Hu Jintao in 2005.[31]

Negotiating this boundary—between Hong Kong and China, as well as Hong Kong and the West—has become a central *leitmotif* in Young's work. In his 2012–14 work *Liquid Borders*, he created an audio-visual map of the Frontier Closed Area that sits between Hong Kong and mainland China. Erected as relations between Mao and the West collapsed in the early 1950s, the border between mainland Hong Kong and China—an area with some of the most valuable real estate in the world—was turned inadvertently into a small nature sanctuary of more than ten square miles. With microphones attached to wires, and hydrophones in the Shenzhen river, Young creates an eerie soundscape where much can happen but little can be said.[32]

The sense of waiting with baited breath, or withheld speech, caused many in Hong Kong to agitate for meaningful political autonomy from the Mainland. The strains of *Molihua* returned again around 2011, this time as an oblique anthem of purpose. Beijing worried about the possibility of a "jasmine revolution" analogous to the colored revolutions sweeping through the Middle East and the former Soviet republics. Government censors quickly moved to block virtual references to "jasmine," a precarious position given the song's popularity not only as a folk tune but as a semi-official national anthem. An extraordinarily strange dynamic; a musical contranym in which expression is made to mean its opposite. Separating the patriotic *Molihua* and the protest *Molihua* is nothing, or perhaps the protest version differs only by the addition of silence. Thus, for every act of resistance, Jasmine Flower is at risk of being turned back into an act of affirmation, a Jasmine Flower by another name.

Of course Young created his own rendition, which appears in the 2019 video work *The World Falls Apart Into Facts*. The installation exists in two parallel video screens, one showing an extended lecture, given by a white horse, that includes a lengthy excursion on the history

Figure 6.2 *The World Falls Apart Into Facts* by Samson Young, 2019/2020. Image courtesy of the artist.

of *Molihua*. On the other, a performance draws out an overwrought staging of the musical narrative. The scholarly lecture skirts the overt political overtones of the song and zooms in on the various means of global transmission of the song, as a politics that is both more profound and more insidious: two notated versions made it into the West, while three other versions from the time were preserved in notation that circulated in East Asia. Those three sources resemble each other. But it is one of the European transcriptions, by John Barrow (1804), which takes far greater liberties with the song, that has become the prototype of what is now universally recognized as *Molihua*. This adoption of the changed European version, a caricature of itself, is precisely the "echoic mimicry" that the title of the installation references. Western global capitalism emerges triumphant, even in the early nineteenth century. "This shit is real. You can't win," murmurs the scholarly equine narrator in Young's lecture.

Meanwhile, the performance of *Molihua* takes up elements of absurdist theater. Musicians dressed up as fruits and vegetables perform the song in a "counterfactual tōgaku"—the Japanese court version of music from the Chinese Tang dynasty. Occasionally harpsichord phrases waft over the thick musical texture, in which the song becomes all but unrecognizable. Two bananas film the performance, moving back and forth on a dolly. The white horse that gave the learned lecture on the other screen is led around the stage. A mounted cardboard grey moon in the background has the Lunar New Year prediction "All fortune[s] relies on [the] heaven" scribbled across it, with the bracketed letters crossed out. Echoic mimicry everywhere in an aural hall of mirrors. A Japanese (mis)pronunciation of a Chinese song. A European (mis)transliteration of the same song. Musical fruits playing tourist instruments. Everything is a game of Telephone (which is called "Chinese Whispers" in the British world). There is no pure origin, no authenticity, no stable point of repose, only translation and retranslation. Why should we not take the naked truth from the horse's mouth?

These kinds of negations and dislocations have become central to the experience of Hong Kongers of Young's generation. Educated under a Western colonial regime (and often possessed of substantial exposure abroad), they return to the island to find a strangely different mode of political suzerainty. And with a younger generation raised with Western expectations (mediated in part through social media) but denied the autonomy of the prior British-colonial period, a break was almost inevitable. Another wave of protests boiled up in 2019, with agitators ditching *Molihua* in favor of the overtly confrontational *Glory to Hong Kong*. The key line: "we shall never surrender. With blood, tears, and sweat, we shall stride ahead for this glorious liberal land."[33] The protest movement, by far largest in the modern history of the territory, drew in hundreds of thousands of everyday citizens and seemed briefly capable of toppling the government.

But the wild disruption of COVID-19, which in most other sectors has served to accelerate social and technological change, enervated the protests just as they were perceived to be building staying power. As the medical emergency began to mount in 2020 (and, as of this writing, has not subsided as sharply as in the West), the local government began to rely more extensively for medical and logistical support from the mainland.[34] Whether the support given was a genuine expression of governmental responsibility or a cynical power grab may be debated, but the effective strangling of the protest movement became a *fait accompli*. One thing is for certain. Hong Kong mayor Carrie Lam's 2019 *ban* on the wearing of masks in public crowds got turned on its head extremely abruptly.

The extent to which the mainland had effectively tightened control was clarified coincident with the writing of these pages in March 2022. Just last week, a Hong Kong judge issued an 11-count guilty verdict in the territory's first sedition trial since the reversion to China in 1997. The guilty verdict reaffirmed the constitutionality of Hong Kong's anti-sedition laws, holdovers from the days of British colonial control. For the crime of leading a chant of "Liberate Hong Kong, Revolution of Our Times" and "Down with the Communist Party" at a public rally, radio DJ and activist Tam Tak-chi is likely facing a stiff prison sentence, and has been held without bail since his arrest in September 2020. The judge emphasized that verbally assaulting the government of Hong Kong constituted a credible threat to challenge the government in Beijing. A mirror image reversal of the synchronous congressional hearings into January 6th. What constitutes the crime, and the punishment, look quite different depending on which end of the telescope one uses.

Samson Young's ideas here point the way forward. In an artist statement, Young emphasized that "there is no time between the certainty of *Burmese Days* and the certainty of *1984*." The former was also George Orwell, and contained a scathing critique of the British

colonial administration in that country. The control of the overlord, techno-fascistic or just plain old racist. The only way around these regimes, the only way there can be, is silence loaded with double and triple meanings. To leave the last words to Young: "Speechlessness is writing in codes so you don't send yourself or a friend to jail."

7

生存机器人

Survival Robot

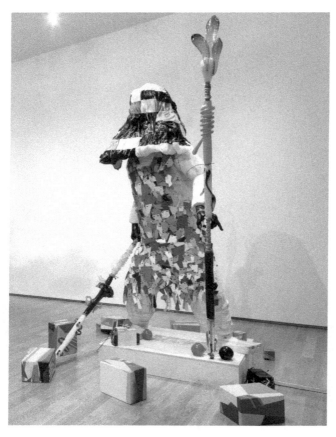

Survival Robot, David Teng Olsen, 2019. Image Courtesy of the artist.

At a Glance

The following essay explores the concept of "publicness" across East and West, with an eye towards the potential adoption of public ledger blockchain technology. Different from the other essays, the following piece was commissioned for *Survival Robot*, a large-scale Bitcoin mining sculpture created by Chinese-American artist David Teng Olsen.

The essays return to origins of the "Public Sphere" in the European Enlightenment as a point of contrast with the ancient as well as modern uses of 公 (*gong*)—the rough equivalent of "public" in English. By contrast with the consented assembly of atomistic individuals in the European construct, *gong* has been collective to its core—emphasizing the expansive remit of the state to managed share affairs on behalf of all. This differing construct of public-ness tracks through the conflicted relationship with cryptocurrency borne out by the Chinese state. China remains the world leader in the export of cryptocurrency mining equipment, but recently banned the practice within its own borders. The CCP Is actively pushing towards a digital Yuan, but forbids the ownership of existing cryptocurrencies. The State—constitutive of the Public in a much different way than in the West—anxiously seeks advantage but is reticent to part with control.

The object rises, towering over the viewer at the size of a small building. Later, it will spread, dozens or even hundreds of them, arrayed in formation through the desolate landscape. The units form a stationary hive, buzzing with the whir of GPU clusters churning through cascades of many digit calculations. The heat, and the vaguely technological smell, give off a subtle haze. Robot BO. A server farm's answer to the coal dust of a Dickensian boiler room.

Survival Robot is many things—a waking Golem, a paranoid Ark, a sculptural folly conjured out of a fever dream. It is a meditation on public belonging and private agency, transparency and autonomy, collectivity and innovation. It is a (as yet symbolic) defense mechanism against the many techno-dystopian nightmares that seem to lurk behind every data breach and privacy update.

It draws its features from statuary defenders both new and ancient. Its stitching derives from recently unearthed Han dynasty funerary armor. Its dense tangle of dreadlocks shields its face from the prying eyes of scanning cameras. Its lumbering size harks back to the Golem of Prague and forward to the imagined futures of Robocop and Tony Stark. Its endless cascade of self-replicas positions it as a 3D printed reply to the Terracotta Warriors. And like Qin Shi's grave soldiers, it yearns to secure a kind of life after death. Embedded in armatures—built into wooden and metal bones—are the machines necessary for it to protect its master in a radically unknowable future. While other artists and scientists have envisioned automata that could repair themselves, we have something different before us.

Survival Robot makes its own money.

Publics and Ledgers in Deep Context

But before delving into the recent crypto-developments that enable the *Robot*, we need set the historical stage onto which our mechanical min(t)er now walks. Indeed, the work hinges on the ways in which its

core concepts—autonomy and collectivity, privacy and transparency—have been figured differently along the East/West cultural axis. It is thus imperative to attend to the ways that "the individual" and (his) relationship with the collective have been differently produced by vectors of both soft and hard power.

On the one hand, running through virtually all of the disparate theorizations of European modernity, one finds that the rise of "the individual" in Enlightenment discourse serves as a kind of bellwether. One side, the feudal past. On the other, the dawning of the modern present. On the European continent, the individual is suddenly thrust into the center of far-flung intellectual systems. He, and it is always a he, becomes the ultimate object of metaphysical speculation (Descartes). He overthrows the tyranny of doctrine to assert the right of exegetical self-determination (Luther). He eventually becomes an axiomatic political entity (Locke), an ethical paradigm (Kant), an expressive subject (Schopenhauer), and a sociocultural product (Levi-Strauss).[1]

The rise of the individual in Enlightenment discourse of course necessitated a rethinking of the political entity into which all of these ostensibly free agents were bound up. The notion of "the nation"—a collective belonging of free persons rather than subjects duty bound to a king—becomes a hallmark of Enlightenment political theory. Pace the well-known ideas of Habermas and Foucault, nationhood created the possibility of a highly orchestrated "public sphere." And in turn, this arena came to both embody and produce the pivotal changes in the colonial-era West, including the industrial revolution, speculative finance, and the Great Game.[2]

On the European continent, the "public sphere" was more typically imagined as a *gesellschaft*, a united front defending that which is held in common.[3] But in the Anglophone world, public economy played a different role in the nation's collective imaginary. The role of the public as a vehicle to maximize *individual* freedom becomes a line connecting the ideas of Adam Smith and Thomas

Jefferson to more recent figures such as John Dewey and Milton Friedman.⁴ Indeed, this kernel of freedom as fundamentally a private enterprise is intimately threaded into the interdependent rise of liberal democracy and international finance capitalism. As David Harvey has recently observed, this latent identification has been given a new, explicit articulation in the late twentieth-century doctrines of Friedman's neoliberalism. Under this formulation, freedom is understood only to mean, and to in fact be synonymous with, private wealth.⁵

Going, Going, *Gōng*

The Middle Kingdom, of course, took a different road. Jürgen Habermas himself insisted that his notion of the public sphere was a culturally specific development. The concept, he wrote, was one "originating in the European High Middle Ages," and therefore could not be generalized to "formally similar constellations" outside of the Occident.⁶ Nevertheless, these constellations occur and recur in China. Perhaps the mostly closely analogous concept is 公 (*gōng*), which in contemporary usage tracks closely with "public"— 公共汽车 (*Gōnggòng qìchē*) is the public bus, with the term redoubled for emphasis. But unlike its Anglo analog, the term has been in written usage for millennia. The seventh-century BCE *Book of Rites* contains the portentous aphorism 天下为公 (*tiānxià wèi gōng*), that which is under heaven belongs to all.⁷

While we will see this particular phrase mobilized in the twentieth century for specific political ends, historians have noted that the meanings of *gōng* have been subject to ongoing contestation. As an extraordinarily broad generalization, the term's most ancient meaning aligns with something like the English understanding of the "commons"—resources owned by no one and therefore belonging to

the community as a whole. In moments of waxing Imperial power, the meaning of *gōng* shifted to encompass the managerial apparatus and remit of the governing authority. During Habermas' cherished Middle Ages, the Song dynasty ruled over a united population larger than that of every contemporary European kingdom combined.[8] It was a moment in which, as Sinologist Thomas Rowe put it, the "business, property, and personnel of the Imperial-bureaucratic state" congealed under the sign of "*gōng*."[9]

This ever-closer alignment between the state apparatus and its managed population brought a sharpened sense of what *gōng* was, and what it emphatically was not. In the late eleventh century, the Imperial reformer Wang An Shi instituted a set of policies aimed at clarifying the role of the central government as the protector of the disenfranchised. In order to prevent the nation's peasants from "being ground into the dust by the rich," Wang argued, "the state should take the entire management of commerce, industry, and agriculture into its own hands."[10] Sounds good on paper. But when a government rules over more than a million square miles and communication proceeds at horse-speed, serving as the embodiment and protector of the "public" presents challenges. Wang's New Policies were designed to resolve this issue of sheer size by granting increased autonomy to local governments, which were reorganized into small independent fiefdoms. These "*baos*" were then given the autonomy to manage issues such as taxation, civil infrastructure, courts, and even military self-defense. At a pivotal moment in China's political imaginary, autonomy, the savior of the common people, was constructed as a collective rather than an individual exercise.[11]

Although this particular gambit in governmental self-determination was disrupted by the great Mongol invasions of the thirteenth century, the subsequent Ming Dynasty brought further elaborations on the notion of autonomy-en-masse. In re-establishing Han-Chinese Imperial sovereignty, dynasty founder Zhu Yuanzhang, also known

by the honorific Hongwu, recognized the value of the *bao* as a unit of delegated authority. Nevertheless, he must have been acutely aware of its shortcomings. The fragmented *baojia* system had prevented China's provincial armies from uniting with sufficient coordination to halt the invading barbarians. Thus, Zhu's legendary army was founded on different principles. Building on military adaptations undertaken during Mongol rule, Zhu created a military force that was, in a much different way, autonomous. The Imperial army morphed into a hereditary class within society—settling its disputes internally, refilling its own ranks, and even growing its own food.[12]

The soldiery, in a way, paid for themselves.

It would be a mistake to read these dynastic formulations as bearing out a direct impact on contemporary China. While the through-lines will be clarified below, the chasm of history remains. One cannot unfurl a Confucian precept about harmony as the underlying cause of current Chinese cultural attitudes any more than one could dredge up a dictum from Montesquieu to explain contemporary disputes over the separation of powers. Rather, the above discussion traces irreducible differences between axiomatic political concepts—what constitutes an authentic choice, or one forced by false consciousness? What defines freedom, or belonging? What constitutes the public?

We are making progress. But in order to understand the promise of cryptocurrency, and the "public ledger" on which it depends, we need our other term.

Double Entry Bookkeeping and Other Developments

Back in the fourteenth century, the question of who would the foot the bill for seemingly unending military campaigns pressed upon

potentates both Eastern and Western. We just saw Zhu Yuanzhang reorganize the Imperial army into a standalone social unit. But in the first part of the same century, France's "iron king" Philip had already hit upon an easier solution: expropriating the wealth of those he found politically inconvenient. He arrested Lombard merchants and then exiled the Jews, but the most infamous target of his pilferage has to be the Knights Templar, a medieval religious fraternity that, inadvertently, had created the world's first international banking organization.[13]

The Knights were founded as a Crusading order, but after their humiliating defeats at the hands of King Saladin, the organization was forced to pivot. Instead of reconquering the Holy Lands for Christ, the Templars had to content themselves with making the journey to the lands safer for Christians. Religious pilgrims made easy prey for highway bandits; they were often laden with riches and ill prepared to defend themselves. The Templars, who maintained estates in both the Mediterranean and the European mainland, hit on a brilliant stroke of deterrence. Rather than bringing their gold and silver with them, the pilgrims could simply deposit their money locally, and then redeem it upon safe arrival in Jerusalem. The trusted third party to the rescue.

While strategic accusations of witchcraft and sodomy proved sufficient justification for an autocrat to crush what was effectively a proto-central bank, the financial institutions that rose in the wake of the Templars were not so easily cast aside. Money that could change owners without changing (deposit) location was too good an idea to ignore. Of course, any innovation introduces complications. How could anyone confirm that deposit slips, which began to circulate as a kind of unofficial currency, were unadulterated?

Another solution, another presage of the present. The issue, at its core, was to prevent counterfeiters from "inventing" money. Simple enough—make sure that every movement of lucre has two

entries—one for its destination (credit) and one for its origin (debit). This "double entry ledger," which had been discovered many times in history, finally gained widespread adoption during the Italian Renaissance.[14] Indubitably, the ideas of Renaissance art and finance interpenetrate one another—both proposed a new rule-governed system of exchange that, in its systematicity, would be made infinitely transposable.[15] Visual (or economic) inputs generate necessary outputs, these outputs function at the level of the individual, and all outputting individuals are fundamentally the same.

The next set of ripples brings us across the divide between Habermas's Sphere and Imperial *gōng*. The innovations of Italian banking families became the basis for the sovereign banks chartered, one after another, by the crowned heads of Europe. But these institutions added one new concept particularly relevant for our story: the joint stock company.[16] These speculative investment vehicles—entities with clear parallels to today's venture capital plays—helped to remake the world to European advantage. The most famous of these, Britain's East India Company, helped to violently rebalance Britain's trade by, among other things, forcing opium imports into the Qing empire (See "Muted Situations" in the present volume).[17] The national humiliation and resulting addiction epidemic tore at the country's social fabric. As early as 1850, Karl Marx confidently declared that the Empire was "already threatened with a mighty revolution … which will certainly have the most important results for civilization."[18] The predicted revolution was not long in coming.

Beleaguered by both accelerating encroachment from European colonial powers and an unending series of internal revolts, the last of China's Imperial dynasties, the Qing, finally collapsed in 1912. With the demise of millennia of continuous Imperial rule, Chinese society was thrust into a paroxysm of modernization—a process historian T.J. Clark has described as a turning "from the worship of ancestors and past authorities to the pursuit of a projected future."[19] It was over

the terms of this future that Chinese activists and revolutionaries struggled in the first half of the twentieth century. Revolutionaries such as Sun Yat Sen revived an ancient communitarian ethos—encapsulated by their motto "*tiānxià wèi gōng*"—combining these deeply Chinese ideas with the doctrines of contemporary European revolution.[20]

Conflicting camps lay claim to the standard raised by Sun's Revive China Society. And while the antagonists forged a temporary alliance to resist the invading Japanese, the end of World War II saw hostility between Chiang Kai Shek's Nationalists and Mao Tse Tung's Communists intensify into a fight to the ideological death. After a protracted struggle, the Communists eventually gained the upper hand and the vanquished Nationalists were forced to retreat to Taiwan (see "Degrees of Separation" in the present volume).[21] On October 1st, 1949, Mao stood under the Imperial Gate of Heavenly Peace in Tiananmen Square and declared that the Communist Party, "representing the will of the whole nation," would create a new kind of governmental entity.

First among equals, Mao and his cadre would administer the nation as a "*Gònghéguó*."[22]

Publics in Modern Redux

On two differing post-World War II trajectories, two opposing images congealed within their respective political imaginaries.

In the West, the construct of the visionary artist—a limit-case of the more generalizable Enlightenment "individual"—was reaching an apotheosis in the mythos surrounding the New York School painters. Critics worked to reify them as heroes, each undertaking a solitary struggle with the burdens of history and the emptiness of the canvas.[23] Back across the Pacific, the single personality of Mao was attempting to force an entire national culture to move in the opposite direction.

As T.J. Clark would put it, two totalizing systems each bent on making their world non-contingent again.[24]

The destructiveness, and recent-ness, of Mao's "continuous revolution" (the intellectual doctrine underpinning the Great Proletarian Cultural Revolution) often defies Western comprehension. At a moment in which Pop artists such as Andy Warhol were experimenting with reproducible images of recognizable figures (among them Chairman Mao), defacing a portrait of the Party's Chairman could be a capital offence.[25] This taboo only unraveled during the neoliberal 1990s. In the West, critics were agreeing that the animal carcasses and coital detritus of the YBAs proved that art had lost its ability to shock. In China, artists such as Li Shan and Yu Youhan were being hailed for their bravery in simply depicting Mao's likeness.[26]

Indeed, it is striking to use the visual arts as a lens through which to see Chinese and Western cultural ideologies accelerating into the present. The boomerang return of Western-style contemporary art from China (see "Our Own Arrows" in the present volume) has created an uneasy alliance between a hegemonic polity and a burgeoning cultural sector.[27] On the one hand, as art historian Bo Zheng has argued, the European traditions of modern and contemporary art have given Chinese artists a set of tools with which to instantiate, however symbolically or temporarily, a Habermas-ean public. Under this construct, collective identity can be composed of voluntary association and conflicting values (manifested in the open-ended and sometimes disputatious reception of artworks) rather than figured as a static, officially enforced "harmony."[28] On the other hand, skyrocketing auction prices and a deluge of international attention for Chinese artists have proven useful assets to the Party. After all, one must evolve to keep up with the times, and contemporary art provides a convenient shorthand in which to demonstrate China's growth in both cultural and economic capital. A blizzard of major new cultural assets ranging from museums and fairs

to art-based luxury property developments are both symptom and cause of the changes within China's sociocultural landscape. And these changes are moving in ever shortening cycles.

Even in Marx's lifetime, the relentless direction of all of this was already visible. In his writings, he repeatedly pointed to the ways in which capital was, to borrow a term from one of his later Apostles, de-territorializing. Like a mist, it had the potential to permeate ancient, inveterate structures and dissolve them to nothing: class hierarchy, distance between places, gender roles, all of these had been loosed from their traditional moorings and set adrift on the sea of modernity. "All that is solid," he wrote in 1848, "melts into air."[29] This glacial melt, he prophesied, was going to tear the social order down to its studs.

But what subsequent theorists failed to grapple with was that these changes would not be a steady, implacable march into the future, but an increasingly headlong dash into radically unknown territory. The affordances of machines and the techniques of capital began reverberating with an ever-increasing feed-forward cycle, with creation and destruction cascading into a generalized version of Moore's law. Instead of doubling transistor density every two years, we seem to double everything. Powered by the twin rockets of information technology and speculative financing, the fundamental property of capital might be that it always accelerates.[30]

The Continuous Revolution indeed.[31]

No one, of course, can know what shape all of this will take in the collapsing time to come. Increasingly, a sense has been growing that this acceleration cannot continue indefinitely; some critical mass will be reached and the implicit *telos* governing all of this will make itself manifest. The so-called Singularity, as it has been dubbed by future speculators of a certain millenarian outlook, hinges on the premise that networked capital will eventually gain a kind of self-awareness; if the human brain is composed of a staggering but finite number of neural interconnections, it only makes sense that the IoT might

eventually wake up to its own tenebrous reflection. Recent advances in deep learning, facial recognition, autonomous transport, network mapping, and a host of other disciplines seem poised to tighten the screws. The COVID pandemic has added fuel to the roaring fire. The invasion of Ukraine promises to turn the heat up yet higher.

And while so-called accelerationist thinkers yearn for this forthcoming anti-messiah of technocapitalism, its potential to lay waste to the collective efforts of mankind haunts nightmares the world over.[32] The control will be total. We will become the victims of our own success. Unless we develop the means to defend ourselves.

Blockchains and the Next Public

The machine—the state, the market, the Party, whatever other names it goes by—is seen to be forever accelerating. Given that, how can one construct mechanisms so that the machine remains responsible to the public, whether this understood as a temporary gathering of independent actors or a collective bound together by shared purpose?

The core conceptual issue lays with the "trusted third party." Centuries ago, the Templars discovered a way for distant parties to transact business: pilgrims could harvest crops in northern France but spend their earnings at market in Palestine. As the world's financial infrastructure grew, it grew more institutionally centralized. Dye merchants in Calcutta, slavers in west Africa, porcelain exporters in Guangzhou, and poppy growers in Bengal were only able to conduct business because of an intermediary based in London. Though they made the system possible, the trusted third parties of central banks had pernicious side effects. They could engineer wars to profit from and distort monetary policy to their own advantage. Their executives created credit bubbles, destroyed social institutions, paid themselves exorbitantly and capriciously, and had the temerity to collect despicable art.

In a way, the trusted third party has become a glitch in its own system. It is now seen an epitome of friction, a lumbering monument to transaction costs. Indeed, because exchanges now occur with global synchrony, all that would be needed to obviate the third party would be a public double entry bookkeeping system, one that would be broadly accessible to use but difficult to manipulate. And this, we recently learned, was a technical rather than conceptual problem.

In 2008, a person or persons known by the name Satoshi Nakamoto showed precisely how this could be done. Buyers and sellers would simply create "blocks," entries on a shared digital record. Goods are placed on order, and money is placed into an escrow account. The record of these transactions is then permanently etched into the system by use of "chains," or links of blocks that for the present purposes, allow only downstream modification. No retrospective substitute products, no ex post facto price changes. A cryptographic, one-way membrane that enables transactions to move only forward in time. The resulting system, Nakamoto wrote, would allow "any two willing parties to transact directly with each other without the need for a trusted third party."[33] A public that would make itself autonomous.

But in true accelerationist fashion, there are even bigger stakes here. Blockchain's true believers promise that the technology will revolutionize not only the world's transactional infrastructure, but also the medium of its transactions. Namely, blockchain creates the possibility of purely digital money. This is not perhaps as strange as it first sounds. One click purchasing and almost frictionless card swiping is obviating paper money, which is itself a pure fiat currency, an arbitrary thing issued in arbitrary amounts by a third-party bank. Seeming eons ago, such paper slips tracked back to a physical reserve of an arbitrary commodity, gold, which many, many millennia before that tracked back in arbitrary fashion to certain essential commodities. Money has itself become a copy of a copy of a copy, a melted vapor.

But always in limited supply.

And it is in this limitation that blockchains do not so much create the possibility of digital currencies, but rather depend on them in order to function.[34] Though blockchain technology promises to cut out the financial middleman, its buyers and sellers still need to be able to find each other in order to transact. Within a given network, users can send and receive funds using two sets of keys: a public key analogous to a physical address, and a private key similar to a password. The time, amount, and public addresses involved in every transaction are permanently recorded into the publicly-viewable blockchain. The funds actually move between parties via the private key and into an individual wallet.

All of this requires enormous computing power—recording transactions and confirming key matches moves via a series of cryptography puzzles that are solved by increasingly massive brute computational force. As of 2021, more than 300 million–billion puzzle answers are proposed every second by computers on the Bitcoin network.[35] Bitcoin's original architects solved the problem of sourcing this Herculean computational burden in a clever way. When users lend spare processing power to the network (so that its business of cryptographically secured transactions can take place), they are rewarded with a small amount of new currency issued directly to them. In this way, as they provide the infrastructure, users are said to be "mining" a digital equivalent of gold. As the network is used, the market grows not only in the value of its total transactions but also in the amount of money available to make transactions with. In theory, this mechanism creates a self-regulating monetary supply that grows in proportion to the expanding economy.

Scenarios in which this platform enjoys widespread adoption are almost fantastical in their consequences. By ensuring public scrutiny, blockchain-based smart contracts could serve to thwart all kinds of middleman-based corruption. The more recent explosion

of interest in the NFT sector demonstrates the power of digital uniqueness—not merely pictures of cartoon apes, but deeds to property and other records can be secured and transacted on the blockchain. Closing time was cut from weeks to minutes—an order of magnitude improvement made possible by removing encrustations of "trusted third parties."[36] Key to all such possibilities are peer-to-peer "digital cash" transactions, which have the potential to disrupt the world's banking infrastructure in favor of those on the margins, while also providing a safe haven for bad actors the world over.

One of the most devastating effects of Bitcoin comes from one of its most seemingly benign features. Its original code was designed to run on spare processing power—to pay users for computer power that was essentially going to waste. But the terrifying, upside-down effect of a system that pays for garbage is that it creates a financial incentive to *generate* garbage. Worldwide, there are now tens of millions of such machines in operation, a worldwide armada of cars purpose built to run on idle. By some estimates, Bitcoin mining alone consumes more electricity than the nation of Switzerland.[37]

Strikingly, independent aspects of China's economy are now coalescing around dominance of the entire cryptocurrency lifecycle. Longstanding prowess in hardware manufacture has positioned Shenzhen to lead the world's production of crypto-miners. And because of its surpluses of power, land, and labor, the Party was able to set up mining operations of Imperial proportions: one mega-mine in Inner Mongolia supports nearly 30,000 units that collectively consume $40,000 worth of electricity *per day*.[38] Lastly, because of the centralized nature of its government, the PRC can move ahead with consumer-level adaptation at gargantuan scale. In 2017, the People's Bank of China announced its own digital currency, which is currently winding its way through an internal government approval process for widespread rollout.[39]

In less than a decade, we have moved from a theoretical white paper about digital money to its planned adoption by the largest planned economy in the history of the world.

As Marx saw, the status quo never lasts.

Survival Robot

For most of human history, there was a straightforward way to deal with the need for self-defense in the face of engulfing change. One could raise an army, or conjure a monster. In preparing for the afterlife, emperors and pharaohs the world over were buried with military tomb attendants. Other cultures, possessed of a less hegemonic disposition, imagined supernatural creatures summoned to defend against violent incursion. The Gargoyles warned evil spirits away from medieval monks, while the Golem of Prague defended the beleaguered Jews of his namesake town. Tony Stark's Ironman exoskeleton helped keep America safe from Communism.

This seemingly basic societal instinct depends, however, on a sharp division between the inside and the outside. Us and Them. The present life and the afterlife. But somewhere right around when Nixon arranged a meeting with Mao, the world seems to have slipped over some critical threshold past in which such differences lose their meaning. Paraphrasing theorists including Fredric Jameson, Jean Baudrillard, and Mike Davis, the "always on" nature of multinational capitalism has erased differences not just between places, but times. We live, as Jameson has it, in a "perpetual present." A temporal version of Marx's vapor. As change accelerates, the future grows more unpredictable while the present becomes ever more unlike the past. A now losing its yesterday and careening headlong into an all-black tomorrow.

Under these circumstances, we must wake up to our ancient techniques.

We must build Survival Robot.

Coda: Crackdowns and the Fault Lines of Future History

This preceding essay accompanied a presentation of Olsen's *Survival Robot* at the Davis Museum (MA) in 2020, and was hidden inside the work on a thumb drive. This sculpture was conceived as a prototype for a large installation of many such sculptures, which was to have taken place in the Dabashan, a mountain range above the site of what was China's most prolific Bitcoin mining center. The sculptural group was to include a solar mesh network (to provide autonomous internet) as well a DNA-backed crypto-wallet (to ensure the continued availability of the mined cryptocurrency by generations of the artist's descendants). The installation was put on indefinite hold due to geopolitical concerns as well as the unfolding coronavirus pandemic.

In the West, the cryptocurrency sector exploded and then crashed between the years of 2021–3. But within China, the Party has been attempting to manage these unprecedented developments by recourse to the broad themes identified in the preceding chapters: harnessing the best of foreign technological tools while retaining maximal control of the political and cultural activity within its own borders. Unsurprisingly, the CCP has smiled upon private blockchains— versions of the Bitcoin or Ethereum network that are accessible only to predetermined parties. These networks may lower transaction costs, improve trust, and promote data transparency. Significantly, China has the largest number of active blockchain projects in the world, and filed more than half of the world's patents in the technology space last year.[40] The Party maintains an active industry consortium on blockchain technologies with Chinese firms including JD.com, Huawei, Baidu, Ant Financial, and Tencent, firms with a cumulative market capitalization of just under $1 trillion.

But the boundaryless world of cryptocurrencies has been a continued source of consternation for the Party. Firms such as Ant

Financial rose to global prominence manufacturing the equipment for Bitcoin mining, and China was for many years the worldwide leader in hashrate, the measure of active mining activity. Beyond the local manufacture of the hardware, China's command and control economy lent itself well to Bitcoin mining. Energy generation projects in the remote corners of the country might be turned but languish without adequate connections to a national grid. As such, spare power and land were relatively easy to convert to globally accepted currency.

Nevertheless, Party leadership looked with increasing skepticism on the use of Bitcoin by its own citizens. After repeated crackdowns, China banned financial institutions settling crypto transactions in May 2021, outlawed mining in June, and ultimately banned all forms of cryptocurrency exchange in September. While as much as 10 percent of world's Bitcoin transactions may still be taking place within the Middle Kingdom, China's role as a leading producer of both currency and currency mining equipment has been effectively curtailed.[41]

Given the increasing global reliance on the Bitcoin network, this huge swath of extractive, low value-adding work all had to go somewhere. In fitting reversal to the preceding pages, the majority of it wound up in the United States, as rural areas with spare power generating capabilities including upstate New York (hydroelectric), Nebraska (nuclear, solar), and Texas (wind, gas) readily reap the windfall of the ready cash flow generation. It is a particular irony that many of these conservative areas are associated with a hawkish politics towards China, but find themselves benefiting from an influx of Chinese equipment and capability from an industry that regulation pushed to overseas production.[42]

The future at this scale is of course unknowable, but the fault lines resonate deeply into the past. With the posited explosive growth of blockchain-based Web3, numerous commentators have speculated that China's Bitcoin expulsion will turn out to be a colossal mistake. All while the historical analogy is far from the front pages of today's crypto news, shades of Ming-era *haijin* bans on overseas trade lurk in

the backdrop. Overweening foreign influence, when it will not submit to centralized control, can be uprooted by fiat. China is of course a fundamentally different entity than it was during the Ming Dynasty, but it is nevertheless significant that numerous intervening regimes have defined their governmental mandate by reference to their power (or lack thereof) to clamp down on the artifacts of foreign interference. Opium, bourgeois literature, open search engines, and other forms of "spiritual pollution" have tested the mettle of the Chinese state over decades and centuries.

The testing will no doubt continue, but can no longer be described as a unidirectional phenomenon. Increasingly, Chinese products, Chinese technologies, and Chinese contemporary art have become a norm against which the West must now adjust itself. The question may ultimately be how the Occident choses to engage with "arrows"—from aesthetic experiments to massively-scaled economic innovations—which may have once been borrowed but now return no longer fully our own. Or perhaps, the return puts the lie to our mythos that they were ever fully ours in the first instance.

Notes

Chapter 1

1. Andrew Solomon, "Their Irony, Humor (and Art) Can Save China," *New York Times*, December 19, 1993. Accessible online at https://www.nytimes.com/1993/12/19/magazine/their-irony-humor-and-art-can-save-china.html (Last accessed 5/22/2019).
2. Holland Cotter, "Art That's a Dragon With Two Heads," *New York Times*, December 13, 1998. Accessible online at https://www.nytimes.com/1998/12/13/arts/art-that-s-a-dragon-with-two-heads.html (Last accessed 5/22/2019).
3. Ibid.
4. See discussion of international reception of Political Pop in Hsiao-peng Lu and Sheldon H. Lu, *China, Transnational Visuality, Global Postmodernity* (Palo Alto, CA: Stanford University Press, 2001), 144–6.
5. Peggy Wang, "New Audiences, New Energy: Producing and Exhibiting Contemporary Chinese Art in 1993," *MoMA Posts*, August 19, 2015. Accessible online at https://post.at.moma.org/content_items/612-new-audiences-new-energy-producing-and-exhibiting-contemporary-chinese-art-in-1993 (Last accessed 5/22/2019).
6. G.F.W. Hegel, "Part I: The Oriental World," *Philosophy of History*. Translator unknown. Accessible online https://www.marxists.org/reference/archive/hegel/works/hi/lectures1.htm (Last accessed 5/22/2019).
7. Solomon, "Their Irony …".
8. For a thorough history of this loaded term, see Immanuel Chung-yueh Hsü, *China without Mao* (Oxford: Oxford University Press, 1998), 168–205. For an overview of this term in contemporary debates over international trade, see Chris Buckley, "Xi Jinping Thought Explained: A New Ideology for a New Era," *New York Times*, February 26,

2018. https://www.nytimes.com/2018/02/26/world/asia/xi-jinping-thought-explained-a-new-ideology-for-a-new-era.html (Last accessed 5/22/2019).

9 *The Guardian*, "China GDP: How it Has Changed Since 1980," *Datablog*, March 23, 2012. Accessible online at https://www.theguardian.com/news/datablog/2012/mar/23/china-gdp-since-1980 (Last accessed 5/22/2019).

10 Li Xianting, "Apathy and Deconstruction in Post-'89 Art," in *Contemporary Chinese Art: Primary Documents*, ed. Wu Hung (New York: Museum of Modern Art, 2010), 164.

11 Javier Silva-Ruete, "The Development of China's Export Performance." Speech given to Central Reserve Bank of Peru. Accessible on IMF website at https://www.imf.org/en/News/Articles/2015/09/28/04/53/sp030706 (Last accessed 5/22/2019).

12 "China: monthly value of exports from March 2018 to March 2019 (in billion U.S. dollars," *Statista* https://www.statista.com/statistics/271616/monthly-value-of-exports-from-china/ (Last accessed 5/22/2019).

13 For an excellent overview of the topic from the period under consideration, see Ann Fenwick, "Equity Joint Ventures in the People's Republic of China: An Assessment of the First Five Years," *The Business Lawyer* 40.3 (May 1985), 839–78.

14 Yiling Pan, "China's Luxury Copycats Say They're Fans," *Jing Daily*, March 6, 2018. https://jingdaily.com/fake-manufacturers-luxury/ (Last accessed 5/22/2019). Marc Bain, "'Unbranded' Luxury Items in China Are Like Knockoffs, with One Vital Difference," *Quartz*, May 15, 2018. https://qz.com/1278501/unbranded-luxury-items-in-china-are-like-knockoffs-with-one-vital-difference/ (Last accessed 5/22/2019).

15 Uri Freedman, "Welcome to China's Fake Apple Store," *The Atlantic*, July 2011.

16 For a thorough theoretical history of *shanzhai* in relation to the Western intellectual tradition see Byung-Chul Han, *Shanzhai: Deconstruction in Chinese*, trans. Philippa Hurd (Cambridge, MA: MIT Press, 2017), 71–81. An enormous missed opportunity to analyze the idiom of "fakeness" and appropriation in Chinese contemporary art can be found in Caroline Jones' "Fake | Factory" in which she jointly

analyzes the studio practices of Ai Weiwei and Andy Warhol, noting the irony of Weiwei's appropriation of Warholian tropes of delegated labor while privileging traditional handcraft.

17 Thomas Crow, *Modern Art in the Common Culture* (New Haven, CT: Yale University Press, 1996), 35.

18 One oft-quoted report from McKinsey referred to China as an "innovation sponge," simply absorbing ideas from elsewhere, while the *Harvard Business Review* pointedly wondered, as its article headline put it, "Why China Can't Innovate." See McKinsey and Company, "The China Effect on Global Innovation," McKinsey Global Institute 2015, 4; Regina M. Abrami, William C. Kirby, and F. Warren McFarlan, "Why China Can't Innovate," *Harvard Business Review*, March 2014.

19 *The Economist*, "China: Mad About Museums," August 2018. (Last accessed 5/22/2019). Oliver Giles, "The New Generation of Chinese Collectors Shaking up the Art World," *CNN*, October 6, 2017. https://www.cnn.com/style/article/chinas-young-art-collectors/index.html (Last accessed 5/22/2019).

20 For an excellent overview of the tactic of imitation as a rehearsal for competition in the Chinese technology sector see Kai-Fu Lee, *AI Superpowers: China, Silicon Valley, and the New World Order* (New York: Houghton Mifflin Harcourt, 2018). The present essay was inspired by, and written in response to, Lee's book.

21 This oft-repeated quote is the subject of a frequent mistranslation. Zhou was speaking about the 1968 protests rather than the 1789 Revolution. See Richard McGregor, *"Zhou's Cryptic Caution Lost in Translation," Financial Times, June 10, 2011.*

22 For more, see, Warwick Ball, *Rome in the East: The Transformation of an Empire* (New York: Routledge, 2001).

23 Margaret Miller, "Persians in the Greek Imagination," *Mediterranean Archaeology* 19/20 (October 2005), 109–23. Irina Metzler, "Perceptions of Hot Climate in Medieval Cosmography and Travel Literature," *Reading Medieval Studies* 23 (1997), 69–105. For a broader overview of the topic see Kim M. Phillips, *Before Orientalism: Asian Peoples and Cultures in European Travel Writing, 1245–1510* (Philadelphia: University of Pennsylvania Press, 2014).

24 Ibid., 181.
25 For an overview of Portuguese exploration of Asia, see Ronald S. Love, *Maritime Exploration in the Age of Discovery, 1415–1800* (Westport, CT: Greenwood Publishing), 9–32.
26 Philip Jenkins, *The Lost History of Christianity* (New York: Harper Collins, 2008), 64–68.
27 Bruce A. Elleman and S. C. M. Paine, *Modern China: Continuity and Change* (Lanham, MD: Rowman and Littlefield, 2019), 9.
28 "Emperor Qian Long's Letter to King George III," (1793). Reprinted in E. Backhouse and J.O.P. Bland, *Annals and Memoirs of the Court of Peking* (Boston: Houghton Mifflin, 1914), 322–31. More easily accessed online at http://academics.wellesley.edu/Polisci/wj/China/208/READINGS/qianlong.html (Last accessed 5/22/2019).
29 For an excellent overview of trade and monetary policy in the Ming era, see Richard von Glahn, *Fountain of Fortune: Money and Monetary Policy in China, 1000–1700* (Berkeley, CA: University of California, 1996), 113–45, 187–206.
30 Aditya Das, *Defending British India Against Napoleon* (Woodbridge: Boydell & Brewer, 2016), 243; for an authoritative overview of the larger conflict, see Stephen R. Platt, *Imperial Twilight: The Opium War and the End of China's Last Golden Age* (New York: Knopf Doubleday Publishing Group, 2018). The widely reported largest bust of Colombian cocaine was 13.8 metric tons, or just over 22,000lbs, seized from Pablo Escobar in 1984.
31 For more on the "Century of Humiliation" as a backdrop for modern Chinese political consciousness, see David Scott, *China and the International System, 1840–1949: Power, Presence, and Perceptions in a Century of Humiliation* (Albany, NY: SUNY Press, 2008).
32 Chang-tai Hung, *Mao's New World: Political Culture in the Early People's Republic* (Ithaca, NY: Cornell University Press, 2011), 33.
33 This analysis was synthesized from Liang-Shing Fan, "The Economy and Foreign Trade of China," *Law and Contemporary Problems* 38.2 (Summer–Autumn, 1973), 249–59.
34 Ibid., 249–51. See also Chris Tudda, *A Cold War Turning Point: Nixon and China, 1969–1972* (Shreveport, LA: LSU Press, May 7, 2012).

35 John and Wendy Cornwall, "Globalization, the Distribution of Power, and Full Employment," in *What Global Economic Crisis?*, ed. Philip Arestis, Michelle Baddeley, and John McCombie (New York: Springer, 2001), 112–17.

36 Song Mei Lee-Wong, "Discourse as Communicative Action: Validation of China's New Socio-Cultural Paradigm 'Qiye Wenhua'/'Enterprise Culture'," *Pragmatics* 19.2 (January 2010), 223.

37 For more on Carter and Deng see, Brian Hilton, "'Maximum Flexibility for Peaceful Change:' Jimmy Carter, Taiwan, and the Recognition of the People's Republic of China," *Diplomatic History* 33.4 (September 2009), 595–613.

38 Julian Gewirtz, "The Little-Known Story of Milton Friedman in China," *The Cato Policy Report* (September/October 2017). Accessible online at https://www.cato.org/policy-report/septemberoctober-2017/little-known-story-milton-friedman-china (Last accessed 5/22/2019).

39 Julian Gewirtz, "The Futurists of Beijing: Alvin Toffler, Zhao Ziyang, and China's 'New Technological Revolution,' 1979–1991," *The Journal of Asian Studies* 78.1 (February 2019), 115–40.

40 Scott Cendrowski, "Opening Happiness: An Oral History of Coca-Cola in China," *Fortune* September 12, 2014. Accessible online at fortune.com/2014/09/11/opening-happiness-an-oral-history-of-coca-cola-in-china/ (Last accessed 5/22/2019).

41 Gerwitz, "The Little Known …".

42 Bill Chou and Ding Xuejie, "A Comparative Analysis of Shenzhen and Kashgar in Development as Special Economic Zones," *East Asia* 32.2 (June 2015), 117–36. See reference table 6.

43 Li Xianting, "Xiànshí zhǔyì bùshì wéiyī zhèngquè de tújìng," ("Realism is not the Only Right Path") Originally published in *Meishu* no. 2 (1981), 46–7. More easily accessible through the Asia Art Society Archive at https://bit.ly/3fUlbRj (Last accessed 1/22/22). Thank you to Adam Au for assistance with translation. For more on the topic see Wang Chunchen, "Realism is a Kind of Ideology in China," in *A New Thoughtfulness in Contemporary China: Critical Voices in Art and Aesthetic*s, ed. Jörg Huber and Zhao Chuan (Berlin: Verlag, 2014), 71–9.

44 Bo Zheng, "The Pursuit of Publicness: A Study of Four Chinese Contemporary Art Projects" (PhD Dissertation, University of Rochester, 2012), 114.
45 Julia Lovell, *The Opium War: Drugs, Dreams, and the Making of Modern China* (New York: Abrams Press, 2014), 78.
46 Ibid., 3. See also Daniel Weaver, "'Stars 1979': The Moment Chinese Art Changed Forever," *Sup China* (May 5, 2020). Accessible online at https://supchina.com/2020/05/05/stars-1979-the-moment-chinese-art-changed-forever/ (Last accessed 1/22/22).
47 Quoted in Wu, *Contemporary Chinese Art: Primary Documents*, 11. See also Han, *Shanzhai*, 67–9.
48 Li Jiatun (pseudonym for Li Xianting), "The Significance is not the Art," *Fine Arts in China*, Issue 28 (1986). Most easily accessible online at Asia Art Society archive. This essay is widely considered to be a landmark in the primary critical record of the period.
49 For a thorough accounting of this period see Yong Guo, "Corruption in Transitional China: An Empirical Analysis," *The China Quarterly* 194 (June, 2008), 349–64.
50 Gerwitz, "The Little Known …".
51 For an excellent analysis of the work see Jane DeBevoise, "Big Business, Selling Shrimps: The Market as Imaginary in Post-Mao China," *e-Flux* (March 2016). Accessible online at https://www.e-flux.com/journal/71/60526/big-business-selling-shrimps-the-market-as-imaginary-in-post-mao-china/ (Last accessed 1/25/22).
52 Alex Colville, "An Artist and her Gun," *Sup China* (March 16, 2021) https://supchina.com/2021/03/16/an-artist-and-her-gun-in-1989-xiaolus-accidental-revolt/ (Last accessed 3/2/22).
53 For an important, fictionalized account of the connection between the *China/Avant Garde* 1989 exhibition and the ensuing massacre from the perspective of one of its central participants, see Lu Xiao, *Dialogue* (Hong Kong: Hong Kong University Press, 2010).
54 For an in-depth, behind the scenes accounting of the lead up to the June 4th Massacre, see *The Tiananmen Papers*, compiled by Liang Zhang, ed. Andrew J. Nathan and Perry Link (New York: Public Affairs, 2008).

55 For more, David Skidmore and William Gates, "After Tiananmen: The Struggle over U.S. Policy toward China in the Bush Administration," *Presidential Studies Quarterly* 27.3, (Summer 1997), 514–39.

56 Ted Osius, "Legacy of the Clinton-Gore Administration's China Policy," *Asian Affairs: An American Review* 28.3 (Fall 2001), 125–34. See also David Harvey, "Neoliberalism with Chinese Characteristics," in David Harvey, *A Brief History of Neoliberalism* (Oxford: Oxford University Press, 2005), 120–51.

57 Julia F. Andrews and Kuiyi Shen, *The Art of Modern China* (Berkeley, CA: University of California Press, 2012), 257–78.

58 Meiqin Wang, "Officializing the Unofficial: Presenting New Chinese Art to the World," *Modern Chinese Literature and Culture* 21.1 (Spring 2009), 102–40.

59 Achille Bonito Oliva, "The Italian Trans-Avantgarde" *Flash Art* (1979). More easily accessed online at https://flash---art.com/article/the-italian-trans-avantgarde/ (Last accessed 5/22/2019).

60 Quoted in Wu, *Contemporary Chinese Art: Primary Documents*, 159.

61 Li Jiatun, "The Significance is Not the Art."

62 Ibid., 165.

63 For more see Sasha Su-Ling Welland, *Experimental Beijing: Gender and Globalization in Chinese Contemporary Art* (Raleigh-Durham, NC: Duke University Press, 2018), 1–15.

64 For more see Yasheng Huang, *Capitalism with Chinese Characteristics: Entrepreneurship and the State* (Cambridge: Cambridge University Press, 2008) and Jane DeBevoise, *Between State and Market: Chinese Contemporary Art in the Post-Mao Era* (Leiden: Brill, 2014).

65 Michael Pillsbury, *The Hundred-Year Marathon: China's Secret Strategy to Replace America as the Global Superpower* (New York: Henry Holt and Company, 2015), 1–5.

66 Smithsonian Institutional Archives, "An Explosive Event with Cai Guo-Qiang," https://siarchives.si.edu/collections/siris_sic_13660 (Last accessed 11/1/4/2022).

67 Sheldon H. Lu, *Chinese Modernity and Global Biopolitics: Studies in Literature and Visual Culture* (Honolulu, HI: University of Hawaii Press, 2007), 102.

Chapter 2

1. Author interview with artist, March 2019.
2. Li Xianting, "Apathy and Deconstruction in Post-89 Art: Analyzing the Trends of 'Cynical Realism' and 'Political Pop,'" (1992) reproduced in Wu Hung (ed.), *Contemporary Chinese Art: Primary Documents* (New York: Museum of Modern Art, 2010), 157.
3. Theodore Caplow and Howard M. Bahr, *Recent Social Trends in the United States, 1960–1990* (Montreal, CN: McGill-Queen's Press, 1994), 310; Todd Hazelbarth, "The Chinese Media: More Autonomous and Diverse—within Limits" (Central Intelligence Agency: Center for the Study of Intelligence, 1997), 1.
4. When considered as population within the city proper rather than the greater metropolitan area, a methodology that does favor Chinese central planning. See Wikipedia, "List of Largest Cities," https://en.wikipedia.org/wiki/List_of_largest_cities (Last accessed 10/13/2019). For an excellent overview of China's urbanization see Ding Lu, *The Great Urbanization of China* (Singapore: World Scientific Publishing, 2012).
5. James Hoge, *The Rise of China* (New York: Foreign Affairs/Council on Foreign Relations), 76.
6. Geremie R. Barme and Sang Ye, "The Great Firewall of China," *Wired*, June 1997. More easily accessed online at https://www.wired.com/1997/06/china-3/ (Last accessed 10/13/2019).
7. Victoria Tin-bor Hui, *War and State Formation in Ancient China and Early Modern Europe* (Cambridge: Cambridge University Press, 2005), 82.
8. Shang Yang, *The Book of Lord Shang: Apologetics of State Power in Early China*, trans. Yuri Pines (New York: Columbia University Press, 2017), 152.
9. Zhengyuan Fu, *Autocratic Tradition and Chinese Politics* (New York: Columbia University Press, 1993), 90–2.
10. Shang, *The Book*, 86.

11 Charles Sanft, *Communication and Cooperation in Early Imperial China Publicizing the Qin Dynasty*, 2nd edition (Albany, NY: State University of New York Press, 2015), 47, 71.
12 David George Johnson, Andrew James Nathan, and Evelyn Sakakida Rawski (eds.), *Popular Culture in Late Imperial China* (Berkeley: University of California Press, 1985), 356.
13 Lee Ou-fan Lee and Andrew Nathan, "The Beginnings of Mass Culture: Journalism and Fiction in the Late Ch'ing and Beyond," in *Popular Culture in Late Imperial China*, ed. Johnson et al. (Berkeley: University of California Press, 1985), 361.
14 Ibid., 369.
15 Li Xiaoping, "The Chinese Television System and Television News," *The China Quarterly* 126 (June 1991), 340.
16 Deli Davin, *Internal Migration in Contemporary China* (New York: Springer, 1998), 4–6.
17 Tiejun Cheng and Mark Selden, "The Origins and Social Consequences of China's Hukou System," *The China Quarterly* 139 (September 1994), 655–60.
18 Wei Li and Dennis Tao Yang, "The Great Leap Forward: Anatomy of a Central Planning Disaster," *Journal of Political Economy* 113.4 (August 2005), 844–8.
19 Judy Helfin, "The Single Greatest Educational Effort in Human History," *Language Magazine*, May 9, 2015. Accessible online at https://www.languagemagazine.com/the-single-greatest-educational-effort-in-human-history/ (Last accessed 10/ 14/2019). See also Eric Li and Lijia Zhang "Debunking the Myths of Mao Zedong," *South China Morning Post*, December 26, 2013. Accessible online at https://www.scmp.com/comment/insight-opinion/article/1390108/debunking-myths-mao-zedong (Last accessed 10/14/2019).
20 See Isaac Stone Fish, "Why the Bestselling Chinese Book of All Time Is Out of Print," *Foreign Policy*, October 9, 2013. Accessible online at https://foreignpolicy.com/2013/10/09/why-the-bestselling-chinese-book-of-all-time-is-out-of-print/ (Last accessed 10/14/2019).

21 The cited quotations are collaged from different essays. For the first two, see Mao Tse-Tung, *Selected Works of Mao Tse-Tung*, Volume 2 Reprint Edition (Amsterdam: Elsevier, 2014), 31–2; third quote reproduced in Xuan Jiwen, "In Criticism of 'On Socialist Democracy and the Legal System," in *On Socialist Democracy and the Chinese Legal System: The Li Yizhe Debates*, ed. Anita Chan, Stanley Rosen, and Jonathan Unger (New York: Routledge, 2015), 117.
22 Lin Biao, "Foreword to the Second Edition of Quotations of Chairman Mao Tse-tung." Reproduced online at https://www.marxists.org/reference/archive/lin-biao/1966/12/16.htm (Last accessed 10/14/2019).
23 For more see Qiu Jin, *The Culture of Power: The Lin Biao Incident in the Cultural Revolution* (Palo Alto, CA: Stanford University Press, 1999).
24 Gary D. Rawnsley and Ming-yeh T. Rawnsley, *Routledge Handbook of Chinese Media* (New York: Routledge, 2015), 431.
25 Xiaoping, "The Chinese Television System," 346.
26 Ibid., 342.
27 Yu Huang, "Peaceful Evolution: The Case of Television Reform in Post-Mao China," *Media, Culture, and Society* 16 (1994), 217.
28 Xiaoping, "The Chinese Television System," 342.
29 Quoted in ibid., 355.
30 Author interview with Gan Yu, high school classmate of Hu Jieming and established artist in his own right. Interview conducted January 2022.
31 If not otherwise cited, information regarding the biography and practice of Hu Jieming comes from an extended interview conducted with the author in April 2019.
32 See "Hu Jieming" on *ArtlinkArt* http://www.artlinkart.com/en/artist/wrk_yr/8acarA/b5aa/1994 (Last accessed 10/14/2019).
33 Wolfgang Konen, Ekkehard Schulze-kruger, and Joerg Kopecz, "ZN-Face: A System for Access Control Using Automated Face Recognition." Reprinted in *Neural Networks: Artificial Intelligence and Industrial Applications*, ed. Bert Kappen and Stan Gielen (Berlin: Springer Science and Business Media, 2012). For a more general introduction to the topic see Kelly A. Gates, *Our Biometric*

Future: Facial Recognition Technology and the Culture of Surveillance (New York: NYU Press, 2011).

34 Konen, Schulze-kruger and Kopecz, "ZN-Face."
35 Tristan G. Brown, Alexander Statman, and Celine Sui, "Public Debate on Facial Recognition Technologies in China," *MIT Case Studies in Social and Ethical Responsibilities of Computing* (Summer 2021). https://doi.org/10.21428/2c646de5.37712c5c
36 Author interview with unnamed activist, April 2019.
37 For more see Ma Jue, "Imagined Reality: A Conversation with Hu Jieming and Hu Weiyi," *Afterimage: The Journal of Media Arts and Cultural Criticism* 45.6 (November/December 2018), 4–12.
38 Zhou Yixing and Laurence J. C. Ma, "Research Report China's Urbanization Levels: Reconstructing a Baseline from the Fifth Population Census," *The China Quarterly* 173 (March, 2003), 176.
39 Zai Liang and Zhongdong Ma, "China's Floating Population: New Evidence from the 2000 Census," *Population and Development Review* 30.3 (September, 2004), 471.
40 *China's Economic Dilemmas in the 1990s: The Problems of Reforms, Modernization, and Interdependence*, Study Papers Submitted to the Joint Economic Committee, Congress of the United States (Washington, DC: US Government Printing Office, 1991), 592.
41 Staff, "Murdoch and China," *The Guardian*, August 24, 2003. More easily accessible online at https://www.theguardian.com/media/2003/aug/24/chinathemedia.rupertmurdoch (Last accessed 10/ 14/2019).
42 Ibid.
43 Xianting, "The Chinese Television System," 157. NB Chinese television art been the subject of limited investigation in the West, with the vast preponderance focusing on the well-known work of Zhang Peili. An good introductory overview of the space was published in 2010 by media studies scholar Paola Voci, *China on Video Smaller-Screen Realities* (New York: Taylor-Francis, 2010). Peili's place as the "founding father" of Chinese video art was reinforced by his 2017 monographic exhibition and the accompanying catalog. See Orianna Cacchione et al., *Zhang Peili: Record. Repeat* (New Haven: Yale University Press, 2017). Zhang

Peili was also the subject of a dedicated chapter in Peggy Wang's recent book *The Future History of Contemporary Chinese Art* (Minneapolis: University of Minnesota Press, 2021). Importantly, the Asia Art Archive recently sponsored an in-depth report on the emergence of TV and video art, which does much to delineate the consumer-technology adoption as well as Zhang Peili's practice, but does not address the work of Hu Jieming. Katherine Grube, "Image and Phenomena: The Development of Video Art in China, 1988 to 1998," *Asia Art Archive* reports. Accessible online at https://aaa.org.hk/en/resources/papers-presentations/image-and-phenomena-the-development-of-video-art-in-china-1988-to-1998 (Last accessed February 2, 2022).

44 Quoted in Jean-Paul Sartre, *Being and Nothingness*, trans. Hazel E. Barnes (New York: Simon and Schuster, 1991), 311.

45 Jeremy Goldkorn, "The Internet," in *The China Story* online research compendium sponsored by the Australian Centre for China in the World. https://www.thechinastory.org/keyword/the-internet/ (Last accessed 10/14/2019). Strikingly, no English language accounts of this event mention that this date falls on the Chinese luni-solar date of the 5th day of the 5th, which is considered to be a doubly unlucky date.

46 Barme and Ye, "The Great Firewall of China."

47 Ma Si, "Penetration Rate of 5G in China to Top 30 Percent by Year End," *China Daily* (November 11, 2024) https://global.chinadaily.com.cn/a/202111/24/WS619e0e0fa310cdd39bc77516.html (Last accessed 2/8/2022).

48 This analogy was borrowed from media studies scholar Guobin Yang. See Guobin Yang, "A Chinese Internet? History, Practice, and Globalization," *Chinese Journal of Communication* 5.1 (2012), 49–54.

49 Alice Shen, "China pulls further ahead of US in mobile payments ...," *South China Morning Post*, February 20, 2018.

50 Kai-Fu Lee, *AI Superpowers: China, Silicon Valley, and the New World Order* (New York: Houghton Mifflin Harcourt, 2018), 13.

51 For details see Brian Liu and Raquel Leslie, "China's Tech Crackdown: A Year-in-Review" *Lawfare* (January 7, 2022) https://www.lawfareblog.com/chinas-tech-crackdown-year-review (Last accessed Feburary 9, 2022).

52 David Bray, *Social Space and Governance in Urban China: The Danwei System from Origins to Reform* (Palo Alto, CA: Stanford University Press, 2005), 75.

Chapter 3

1 Fan Hong, *Footbinding, Feminism and Freedom: The Liberation of Women's Bodies in Modern China* (New York: Routledge, 2013), 88–101.
2 This quotation is a frequent touchstone in the historiography of Chinese feminism. Shirley Mow, Tao Jie, and Zheng Bijun (eds.), *Holding up Half the Sky: Chinese Women Past, Present, and Future* (New York: The Feminist Press at CUNY, 2004).
3 Li Liu and Xingcan Chen, *The Archaeology of China: From the Late Paleolithic to the Early Bronze Age* (Cambridge: Cambridge University Press, 2012), 10, 184. Historically, the Chinese character 他 (pronounced as *tā*) served as a gender neutral term—combining the equivalent of "he," "she," and "it." In more modern usage, three separate characters denote male, female, and neutral genders, but all are still pronounced as *tā*.
4 Tantalizing evidence suggests that women were sometimes able to wield extraordinary power. Modern scholars have been able to piece together considerable detail of the remarkable life of Fu Hao, one of the consorts of emperor Wu Ding (c. 1200 BCE). Fu Hao was responsible for leading an army of thousands of men in decisive victories over frontier threats. Her singular tomb attests to her near mythical status—with more than seven hundred jade objects and sixteen sacrificial captives buried alongside her. See Li and Chen, *Archaeology of China*, 358.
5 Bret Hinsch, *Masculinities in Chinese History* (Lanham, MD: Rowman & Littlefield Publishers, 2013), 15. see also Hinsch, "The Origins of Separation of the Sexes in China," *Journal of the American Oriental Society* 123.3 (July–September 2003), 599.

6 Keith McMahon, *Women Shall Not Rule: Imperial Wives and Concubines in China from Han to Liao* (Lanham, MD: Rowman & Littlefield Publishers, 2013), 71–4.
7 Hinsch, *Masculinities*, 80.
8 Ibid., 84.
9 Ibid., 81.
10 For an authoritative treatment on the life of Wu Zetian, see N. Harry Rothschild, *Emperor Wu Zhao and Her Pantheon of Devis, Divinities, and Dynastic Mothers* (New York: Columbia University Press, 2015).
11 For more on Jiang and Wu, see Jiaqi Yan and Gao Gao, *Turbulent Decade: A History of the Cultural Revolution* (Honolulu: University of Hawaii Press, 1996), 443–4.
12 Anders Hansson, *Chinese Outcasts: Discrimination and Emancipation in Late Imperial China* (Leiden: Brill Publishing, 1996), 46.
13 Ping Wang, *Aching for Beauty: Footbinding in China* (Minneapolis: University of Minnesota Press, 2002), 48.
14 Ibid., 32.
15 Bettine Birge, "Levirate Marriage and the Revival of Widow Chastity in Yüan China," *Asia Major* 8.2 (1995), 109, 120–31.
16 Wang, *Aching for Beauty*, 33.
17 Paul Stanley Ropp, Paola Zamperini, and Harriet Thelma Zurndorfer (eds.), *Passionate Women: Female Suicide in Late Imperial China* (Leiden: Brill Publishing, 2001), 13.
18 Kim Thoa Doan, "The True-False Pattern in the Jin Ping Mei," *Ming Studies* 1 (1981), 35.
19 Alison R. Drucker, "The Influence of Western Women on the Anti-Footbinding Movement 1840–1911," *Historical Reflections / Réflexions Historiques* 8.3 (Fall 1981), 182–90.
20 Margaret Hillenbrand and Chloe Starr (eds.), *Documenting China: A Reader in Seminal Twentieth-Century Texts* (Seattle: University of Washington Press, 2014), 15.
21 See Guo Yanli and Guo Zhen (eds.), *Selected Works of Qiu Jin* (Beijing: Beijing Book Company, 2020), 11–14. For more on the contribution of Christian figures to Chinese women's liberation see Fredrik Fällman,

"'Two Small Copper Coins' and Much More: Chinese Protestant Women and Their Contributions to the Church," *Religions & Christianity in Today's China* 8.3 (2018), 39–55.
22 Quoted in Kazuko Ono, *Chinese Women in a Century of Revolution, 1850–1950* (Palo Alto: Stanford University Press, 1989), 63.
23 Quoted in Lydia He Liu, Rebecca E. Karl, and Dorothy Ko (eds.), *The Birth of Chinese Feminism: Essential Texts in Transnational Theory* (New York: Columbia University Press, 2013), 53. On He-Yin Zhen see Peter Zarrow, "He Zhen and Anarcho-Feminism in China," *The Journal of Asian Studies* 47.4 (November 1988), 796–813. Significantly, He-Yin's concept of gender and property rights is closely linked to an evolution of the cultural construct of "labor" in relation to both class and gender. As historian Wang Yan recently demonstrated, excluding the ostensibly exploitative capitalist class from the notion of "labor" opened up space to reclaim women's work previously relegated to the domestic margins. The result was a Marxist-inflected reimagination of the plowing/weaving public labor concept delineated above. See Wang Yan, "Women's Domestic Work under the Concept of 'Labor' from the Late Qing Dynasty to the Republic of China," *Journal of East China Normal University* 6 (2019), 72–5. For more on Marx's reception in Japanese revolutionary circles see Hiroshi Uchida, "Marx in Japan," *Socialism and Democracy* 24.3 (November 2020), 205–11.
24 Guoqi Xu, *Chinese and Americans: A Shared History* (Cambridge, MA: Harvard University Press, 2014), 208.
25 For more see Louise Edwards, "Policing the Modern Woman in Republican China," *Modern China* 26.2 (April 2000), 115–47.
26 Christian Sorace, Ivan Franceschini, and Nicholas Loubere (eds.), *Afterlives of Chinese Communism: Political Concepts from Mao to Xi* (Canberra: Australia National University Press, 2019), 317.
27 Ibid., 170.
28 Yihong Pan, "Feminism and Nationalism in China's War of Resistance against Japan," *The International History Review* 19.1 (February 1997), 117.

29 Deborah Davis and Steven Harrell, *Chinese Families in the Post-Mao Era* (Berkeley: University of California Press, 1993), 116.
30 Noborom Niida, "Land Reform and New Marriage Law in China," *Developing Economies* 48.2 (June 2010), 4.
31 A. John Jowett, "Patterns of Literacy in the People's Republic of China," *GeoJournal* 18 (1989), 417–27.
32 Yuhui Li, "Women's Movement and Change of Women's Status in China," *Journal of International Women's Studies* 1.1 (January 2000), 36–7.
33 Ibid.
34 Gail Hershatter, "Women and China's Socialist Construction, 1949–78," *The Asia Pacific Journal* 17.12 (June 2019), 4.
35 For detailed breakdown see Lin Xiu and Morley Gunderson, "Gender Earnings Differences in China: Base Pay, Performance Pay, and Total Pay," *Contemporary Economic Policy* 31.1 (January 2013), 235–54.
36 He-Yin Zhen, "Feminist Manifesto," quoted in Liu, Karl and Ko, *The Birth of Chinese Feminism*.
37 Hershatter, "Women and China's Socialist Construction," 20.
38 Ibid. For more on this topic, see Wenqi Yang and Fei Yan, "The Annihilation of Femininity in Mao's China: Gender Inequality of Sent-Down Youth during the Cultural Revolution," *China Information* 31.1 (2017), 63–83.
39 James Hoge, *The Rise of China* (New York: Foreign Affairs/Council on Foreign Relations, 2002), 76.
40 For detailed analysis see Kimberly Singer Babiarz, Karen Eggleston, Grant Miller, and Qiong Zhang "An Exploration of China's Mortality Decline under Mao: A Provincial Analysis, 1950–80," *Population Studies* 69.1 (2015), 39–56.
41 Sui-Lee Wee, "After One-Child Policy, Outrage at China's Offer to Remove IUDs," *New York Times* (January 7, 2017).
42 Pan Suiming, "Three 'Red Light Districts' in China." Executive Summary in English of the originally Chinese text of the book: *"Cun Zai Yu Huang Miu"—Zhong Guo Di Xia Xing Chan Ye Kao Cha* (Beijing: Qunyan Publishing House, January 1999).

43 Monica Merlin, "Cui Xiuwen Interview," Tate Research Centre online resource compendium (2018).
44 Merlin interview supplemented by author correspondence with Eli Klein Gallery (August 2020). Quoting Cui from the gallery files: "The original Chinese characters of my name was not 崔岫闻 but the homophone 崔秀文 ... An anecdote in a mysterious cave adds a layer of story-telling."
45 Ibid.
46 Patricia Eichenbaum Karetzky, "Cui Xiuwen, 'Walking on Broken Glass,'" *Yishu: Journal of Contemporary Chinese Art* 9.3 (2010), 18.
47 Richard Vine, "Post Mao Photo Lessons," *Art in America* (April 2011), 113.
48 While Cui claimed that she was stood up by the model for *Toot*, the ambiguity between self and other is apt in her work more broadly. See Klaus Hammer, "Cui Xiuwen: Existential Emptiness and Characteristic of Essence," Hammer Gallery exhibition pamphlet (2011), 9.
49 Cui Xiuwen, Artist statement on *One Day* published on Australia China Art Foundation website. https://acaf.org.au/en/artwork/one_day_in_2004_no4 (Last accessed 2/15/2022).
50 Sophia Powers, "Interview with Cui Xiuwen," *Artslant* (February 2011).
51 Merlin, "Cui Xiuwen Interview."
52 Ibid.
53 "Cui Xiuwen: Existential Emptiness." Exhibition profile on Eli Klein gallery website (2011).
54 Patricia Eichenbaum Karetzky, "Cui Xiuwen," *Yishu Magazine* (Fall 2016), 42.
55 Lilly Wei, "Cui Xiuwen Obituary," *Studio International* (May 2018).

Chapter 4

1 Qin Chong (ed.), *Qin Feng: To Badashanren* (Beijing: Beijing Museum of Contemporary Art, 2008), 9.
2 Jennifer L. Roberts, *Mirror-Travels: Robert Smithson and History* (New Haven: Yale University Press, 2004), 15–40.

3 Qin Chong, *Qin Feng*, 307. See for example *Civilization Landscape* (2012) in the collection of the Harvard Art Museum, which draws heavily on Uyghur script.
4 Hao Sheng, "Interview with Qin Feng," *Asia Contemporary Art Week* (March 29, 2011); http://www.acaw.info/?p=1239 (Last accessed 6/10/2022).
5 James A. Millward, *Beyond the Pass: Economy, Ethnicity, and Empire in Qing Central Asia, 1759–1864* (Palo Alto, CA: Stanford University Press, 1998), 124–40.
6 Ibid., 4–8.
7 See for example, Chunxiang Li, Hongjie Li, Yinqiu Cui, et al., "Evidence that a West-East Admixed Population Lived in the Tarim Basin as Early as the Early Bronze Age," *BMC Biology* 8, no. 15 (2010). https://doi.org/10.1186/1741-7007-8-15 (Last accessed 6/10/2022).
8 Li Feng, *Landscape and Power in Early China: The Crisis and Fall of the Western Zhou 1045–771 BC* (Cambridge: Cambridge University Press, 2006), 345–50.
9 For the importance of this mythology to contemporary claims on Xinjiang, see Alessandro Rippa, "Re-Writing Mythology in Xinjiang: The Case of the Queen Mother of the West, King Mu and the Kunlun," *The China Journal* 71 (January 2014), 43–64.
10 Thomas M. Kane, *Postmodern War: Enduring Ideas from the Chinese Strategic Tradition* (New York: Routledge, 2007), 42–4.
11 Feng, *Landscape and Power*, 348–52.
12 Frances Wood, *China's First Emperor and His Terracotta Warriors* (New York: St. Martin's Publishing Group, 2008), 3–13.
13 Lin Gan, *General History of the Xiongnu* (Salt Lake City, UT: American Academic Press, 2020), 31–4.
14 Pan Yihong, "Early Chinese Settlement Policies towards the Nomads," *Asia Major* 5.2 (1992), 42–5.
15 Valerie Hansen, *The Silk Road: A New History* (Oxford: Oxford University Press, 2015), 32–4.
16 Quoted in Rachel Mairs, *The Hellenistic Far East: Archaeology, Language, and Identity in Greek Central Asia* (Berkeley, CA: University of California Press, 2014), 154.

17 Craig Benjamin, *Empires of Ancient Eurasia: The First Silk Roads Era, 100 BCE–250 CE* (Cambridge: Cambridge University Press, 2018), 71–5 for Xiongnu, 162–70 for ancient Rome.
18 Yi Wang, *Transforming Inner Mongolia: Commerce, Migration, and Colonization on the Qing Frontier* (Latham, MD: Rowman & Littlefield, 2021), 30, 72.
19 Kurt A. Raaflaub, "Caesar and Genocide: Confronting the Dark Side of Caesar's Gallic Wars," *New England Classical Journal* 48.1 (2021), 54–80.
20 John W. Dardess, *Governing China, 150–1850* (Cambridge, MA: Hackett Publishing, 2010), 9–11.
21 Victor H. Mair and Jane Hickman, *Reconfiguring the Silk Road New Research on East-West Exchange in Antiquity* (Philadelphia, PA: University of Pennsylvania Press, 2014), 18–20.
22 Wang Mingming, *The West As the Other: A Genealogy of Chinese Occidentalism* (Hong Kong: The Chinese University of Hong Kong Press, 2014), 185; Joseph Mitsuo Kitagawa, *The Religious Traditions of Asia: Religion, History, and Culture* (New York: Psychology Press, 2002), 283.
23 James Millward, *Eurasian Crossroads: A History of Xinjiang, Revised and Updated* (New York: Columbia University Press, 2021), 62–70.
24 Rico Isaacs, "Tengrism," in Rico Isaacs and Erica Marat (eds.), *Routledge Handbook of Contemporary Central Asia* (New York: Routledge, 2021), 451–60.
25 See for example Ben Westcott and Yong Xiong, "Xinjiang's Uyghurs Didn't Choose to be Muslim, New Chinese Report Says," *CNN* (July 22, 2019) https://www.cnn.com/2019/07/22/asia/china-xinjiang-uyghur-muslim-intl-hnk/index.html (Last accesed 6/10/2022).
26 Isaacs, "Tengrism," 455–6.
27 For an update to date overview see Timothy May, *The Mongol Empire* (Edinburgh: Edinburgh University Press, 2018).
28 Timothy May, *The Mongol Empire: A Historical Encyclopedia* (Santa Barbara, CA: ABC-Clio, 2016), 250–5.
29 Ahmad Hasan Dani and Vadim Mikhaïlovich Masson, *History of Civilizations of Central Asia: Development in Contrast: From*

the Sixteenth to the Mid-Nineteenth Century (Paris, FR: UNESCO Publishing, 2003), 197–203.

30 After the Qing conquest of Dzungaria, the ascendant dynasty began to promote the new vision of "Nèiwài yījiā" (内外一家; "Interior and exterior as one family"). See Ruth W. Dunnell, Mark C. Elliott, Philippe Foret, and James A Millward, *New Qing Imperial History: The Making of Inner Asian Empire at Qing Chengde* (New York:, Routledge, 2004), 76. Additionally, in the wake of the of the founding of the modern CCP, student intellectuals began to promote an inclusive vision of Zhōnghuá (華/中华), that encompassed 56 minority ethnic groups and the Han Chinese, as comprising a single "Chinese" cultural and political entity. See Robert Crane, *Building Bridges Among the BRICs* (New York: Palgrave MacMillan, 2015), 165.

31 Millward, *Beyond the Pass*, 4.

32 Nicola Di Cosmo, "Qing Colonial Administration in Inner Asia, *The International History Review* 20.2 (June 1998), 287–309.

33 Peter C. Perdue, *China Marches West: The Qing Conquest of Central Eurasia* (Cambridge, MA: Harvard University Press, 2009), 283.

34 Justin Jon Rudelson, *Oasis Identities: Uyghur Nationalism Along China's Silk Road* (New York: Columbia University Press, 1997), 29.

35 Perdue, *China Marches West*, 757–93.

36 Millward, *Beyond the Pass*, 51.

37 See for example the Ush Rebellion (1765), the Jahriyya Revolt (1781), and the Dungan Revolt (1862).

38 Hodong Kim, *Holy War in China: The Muslim Rebellion and State in Chinese Central Asia, 1864–1877* (Palo Alto, CA: Stanford University Press, 2004), 137; Branko Soucek and Svat Soucek, *A History of Inner Asia* (Cambridge: Cambridge University Press, 2000), 267.

39 For an overview of his minority policy see David Brophy, "Five Races, One Parliament? Xinhai in Xinjiang and the Problem of Minority Representation in the Chinese Republic," *Inner Asia* 14.2 (2012), 343–63. For foreign relations see Justin Jacobs, "Empire Besieged: The Preservation of Chinese Rule in Xinjiang, 1884–1971" (PhD Dissertation, University of San Diego, 2011), particularly 390–450.

40 David D. Wang, "East Turkestan Movement in Xinjiang," *Journal of Chinese Political Science* 4 (1998), 1–18.

41 James Z. Gao, "The Call of the Oases: The 'Peaceful Liberation' of Xinjiang, 1949–53," in *Dilemmas of Victory: The Early Years of the People's Republic of China*, ed. Jeremy Brown and Paul Pickowicz (Cambridge, MA: Harvard University Press, 2010), 184–204; Michael Dillon, *China: A Modern History* (London: Bloomsbury Publishing, 2010), 377.

42 Gao, "The Call of the Oases," 202–4.

43 For a detailed analysis of this period, see chapter 6 of Michael Evans, "A Nearly Perfect Storm: The Rise and Fall of the Eastern Turkistan People's Revolutionary Party" (PhD Dissertation: Indiana University, 2017).

44 Author interview with Qin Feng (September 2022).

45 Chinese Communist Party Central Committee Document Central Committee, "Record of the Meeting of the Standing Committee of the Political Bureau of the Chinese Communist Party concerning the maintenance of Stability in Xinjiang." Reproduced as leaked document on https://caccp.freedomsherald.org/conf/doc7.html (Last accessed 6/11/2022).

46 Zubayra Shamseden, "The Ghulja Massacre of 1997 and the Face of Uyghur Genocide Today," *The Diplomat* (February 2021) https://thediplomat.com/2021/02/the-ghulja-massacre-of-1997-and-the-face-of-uyghur-genocide-today/ (Last accessed 6/11/2022).

47 For GDP see "China GDP Growth Rate 1961–2022," on *Macro Trends* https://www.macrotrends.net/countries/CHN/china/gdp-growth-rate (Last accessed June 6/11/2022); for stimulus see Christine Wong "The Fiscal Stimulus Programme and Public Governance Issues in China," *OECD Journal on Budgeting* 11.3 (2011) http://dx.doi.org/10.1787/budget-11-5kg3nhljqrjl

48 Anthony Kuhn, "China Tries to Export Culture as Influence Increases," *NPR* (April 2, 2008) https://www.npr.org/2008/04/02/89306145/china-tries-to-export-culture-as-influence-increases (Last accessed 6/11/2022). The high priority given to Confucius's teaching marks a

complete reversal from the previous ban on these works during the Cultural Revolution. Also note that this strategy of cultural diplomacy was deeply imbricated in China's increasing economic and military involvement in the African continent.

49 Quoted in Qin Chong, *Qin Feng*, 3. Grammar changed slightly for clarity.
50 Ibid., 211. Note that the Chinese state has long presented abstracted elements of Uyghur script as a metonym for difference within a harmonious whole. See Jacobs, "Empire Besieged," 438.
51 Edward Wong, "Doubt Arises in Account of an Attack in China," *New York Times* (September 28, 2008) https://www.nytimes.com/2008/09/29/world/asia/29kashgar.html (Last accessed 6/11/2022).
52 Austin Ramzy and Chris Buckley, "'Absolutely No Mercy': Leaked Files Expose How China Organized Mass Detentions of Muslims," *New York Times* (November 16, 2019) https://www.nytimes.com/interactive/2019/11/16/world/asia/china-xinjiang-documents.html (Last accessed 6/11/2022).
53 Staff, "China Holds Mass Police Rally in Xinjiang as Hundreds sent to Anti-Terror 'Frontline,'" *Reuters* (February 27, 2017) https://www.reuters.com/article/uk-china-xinjiang-idUKKBN1670B7 (Last accessed 6/11/2022).
54 US State Department, "China Inclusive 2019 Human Rights Report." Accessible online at https://2017-2021.state.gov/wp-content/uploads/2020/03/CHINA-INCLUSIVE-2019-HUMAN-RIGHTS-REPORT.pdf (Last accessed 6/11/2022).
55 Matthew Hill, David Campanale, and Joel Gunter, "'Their Goal is to Destroy Everyone': Uighur Camp Detainees Allege Systematic Rape," *BBC News* (February 2, 2021) https://www.bbc.com/news/world-asia-china-55794071
56 Quoted in By Chun Han Wong, "Xi Says China Will Continue Efforts to Assimilate Muslims in Xinjiang," *Wall Street Journal* (September, 26, 2020) https://www.wsj.com/articles/xi-says-china-will-continue-efforts-to-assimilate-muslims-in-xinjiang-11601133450 (Last accessed 6/11/2022).

57 Ministry of Foreign Affairs of the People's Republic of China, "The American Genocide of the Indians—Historical Facts and Real Evidence," March 2, 2022 communique. Accessible online at https://www.fmprc.gov.cn/mfa_eng/wjdt_665385/2649_665393/202203/t20220302_10647120.html (Last accessed 6/11/2022).
58 Qin Chong, *Qin Feng*, 213.

Chapter 5

1 Edward Lucie Smith text reproduced in Joshua Gong, *Hsiao Chin and Punto: Mapping the Post-War Avant-Garde* (London: Unicorn Press, 2020), 8.
2 See Hsiao Chin's biography on the artist's foundation website. http://www.hsiaochin.org.tw/ENG/home01.aspx?ID=1 (Last accessed 5/4/2020).
3 Su-chiu Kuo, *New Frontiers in the Neolithic Archaeology of Taiwan (5600–1800 BP): A Perspective of Maritime Cultural Interaction* (New York: Springer, 2019), 28–30.
4 In addition to Kuo, please see John Robert Shepherd, *Statecraft and Political Economy on the Taiwan Frontier, 1600–1800* (Palo Alto, CA: Stanford University Press, 1993), 28.
5 For the most recent scholarship on premodern Chinese demography, see Xie Jing, *Chinese Urbanism: Urban Form And Life In The Tang-song Dynasties* (Singapore: World Scientific Press, 2020), 79–85.
6 Chinhua Lei, "The Emergence of Organized Water Transport in Early China: Its Social and Geographic Contexts," in *Voyages, Migration, and the Maritime World: On China's Global Historical Role*, ed. Clara Wing-chung Ho, Ricardo King Sang Mak, and Yue-him Tam (Berlin: Walter de Gruyter, 2018), 87–92.
7 Young-tsu Wong, *China's Conquest of Taiwan in the Seventeenth Century: Victory at Full Moon* (New York: Springer, 2017), 82–3.
8 Ibid., 29–35.
9 Shepherd, *Statecraft*, 46–50.

10 Wong, *China's Conquest*, 92.
11 For an excellent and highly entertaining overview of Koxinga, Tonio Andrade, *Lost Colony: The Untold Story of China's First Great Victory over the West* (Princeton: Princeton University Press, 2013).
12 Charles J. McCarthy, "On The Koxinga Threat of 1662," *Philippine Studies* 18.1 (January 1970), 190; Chiu Hsin-Hui, *The Colonial 'Civilizing Process' in Dutch Formosa: 1624–1662* (Boston, MA: Brill, 2008), 33–48.
13 Emma Jinhua Teng, *Taiwan's Imagined Geography: Chinese Colonial Travel Writing and Pictures, 1683–1895* (Boston, MA: Brill, 2020), 34.
14 Ibid., 72.
15 Ibid., 215.
16 Murray A. Rubinstein, *Taiwan: A New History* (New York: Routledge, 2020), 148–52. See also Mark Munsterhjelm, *Living Dead in the Pacific: Contested Sovereignty and Racism in Genetic Research on Taiwan Aborigines* (Vancouver: UBC Press, 2014), 13–14.
17 Paul D. Barclay, *Outcasts of Empire: Japan's Rule on Taiwan's "Savage Border," 1874–1945* (Berkeley, CA: University of California Press, 2017), 18–30. For an authoritative treatment of Japanese Taiwan, see Andrew D. Morris, *Japanese Taiwan: Colonial Rule and its Contested Legacy* (London: Bloomsbury Publishing, 2015).
18 Alan M. Wachman, *Why Taiwan? Geostrategic Rationales for China's Territorial Integrity* (Singapore: NUS Press, 2008), 65–73.
19 Barclay, *Outcasts of Empire*, 96–105.
20 For more see Robert Eskildsen, *Transforming Empire in Japan and East Asia: The Taiwan Expedition and the Birth of Japanese Imperialism* (New York: Springer, 2019).
21 For the authoritative treatment see Phyllis Birnbaum, *Glory in a Line: A Life of Foujita. The Artist Caught Between East and West* (New York: Macmillan, 2007).
22 Tao Wen-Yue, "The Evocative Imagery of an Art Giant: A Review of the Modern Art Development in Taiwan under the Influence of Li Chun-Shan (Zhongsheng)." https://themefile.culture.tw/file/2019-03-04/1419499e-91a1-40b3-826b-d24809f007b9/策展論述_陶文岳 (英).pdf

23 Ibid.
24 For more see Sarah C.M. Paine, *The Wars for Asia, 1911–1949* (Cambridge: Cambridge University Press, 2012).
25 Ibid, 53.
26 Ibid., 126.
27 For more see Daniel Kurtz-Phelan, *The China Mission: George Marshall's Unfinished War, 1945–1947* (New York: W.W. Norton & Company, 2018).
28 See Tak-Wing Ngo and Yi-Chi Chen, "The Genesis of Responsible Government under Authoritarian Conditions: Taiwan during Martial Law," *China Review* 8.2 (Fall 2008), 15–48.
29 Hsiao-Ting Lin, "U.S.-Taiwan Military Diplomacy Revisited: Chiang Kai-shek, 'Baituan', and the 1954 Mutual Defense Pact," *Diplomatic History* 37.5 (November 2013), 971–94.
30 Wen-Yue, "The Evocative Imagery of an Art Giant."
31 Gong, *Hsiao Chin and Punto*, 12–15.
32 Ibid.
33 Quoted in Diana Yeh, "Under the Spectre of Orientalism and Nation: Translocal Crossing and Discrepant Modernities," in *The Reception of Chinese Art Across Cultures*, ed. Michelle Huang (Newcastle upon Tyne: Cambridge Scholars Publishing, 2014), 242.
34 Jessica Vahrenkamp, "Interview: Hsiao Chin," *Design Anthology* (March 2018). Reproduced online at https://designanthologymag.com/story/hsiao-chin (Last accessed 5/04/2020).
35 See for example Francis Frascina, "Institutions, Culture, and America's 'Cold War Years': The Making of Greenberg's 'Modernist Painting,'" *Oxford Art Journal* 26.1 (Winter 2003), 71–97; Michael Leja, *Reframing Abstract Expressionism: Subjectivity and Painting in the 1940s* (New Haven: Yale University Press, 1993); Erika Doss, *Benton, Pollock, and the Politics of Modernism: From Regionalism to Abstract Expressionism* (Chicago: University of Chicago, 1993).
36 Harold Rosenberg, *Art on the Edge: Creators and Situations* (Chicago: University of Chicago Press, 1983), 54.

37 Michael R. McBride, "How Jackson Pollock and the CIA Teamed Up to Win The Cold War," *Medium* (October 2017) https://medium.com/@MichaelMcBride/how-jackson-pollock-and-the-cia-teamed-up-to-win-the-cold-war-6734c40f5b14 (Last accessed 05/ 04/2020).

38 For detailed account see Jennifer Miller, *Cold War Democracy: The United States and Japan* (Cambridge, MA: Harvard University Press, 2019), 114–54.

39 Much more work remains to be done on this global territory. Within East Asia, a handful of scholars have probed the political dimensions of *gutai*. See for example Alexandra Munroe's positioning of *gutai* as an manifestation of attempts to foster Western style democracy in *Japanese Art After 1945: Scream Against the Sky* (Harry N. Abrams: New York, 1994), 84, as well as Paul Schimmel's similar conjecture in "Leap into the Void: Performance and the Object," in *Out of Action: Between Performance and the Object 1949–1979* (Museum of Contemporary Art and Thames and Hudson: Los Angeles, 1998), 25.

40 Gong, *Hsiao Chin and Punto*, 16–20. See also D. Sicard, "Hsiao Chin Biography," *Chinese New Art*. Accessible online at https://www.chinesenewart.com/hsiaochin/hsiaochin-english/biographie.htm (Last accessed 05/04/2020).

41 For a very interesting exploration of connections between fascism in Spain and Japan (an antecedent for Chiang's Taiwan) see Reto Hofmann, *The Fascist Effect: Japan and Italy, 1915–1952* (Ithaca, NY: Cornell University Press, 2015).

42 Wayne H. Bowen, *Truman, Franco's Spain, and the Cold War* (Columbia, MO: University of Missouri Press, 2017), 77–98.

43 Ivan Iglesias, "Performing the 'Anti-Spanish' Body: Jazz and Biopolitics in the Early Franco Regime (1939–1957)," in *Jazz and Totalitarianism*, ed. Bruce Johnson (New York: Routledge, 2016), 157–73.

44 Gong, *Hsiao Chin and Punto*, 13–18.

45 Ibid.

46 Sicard, "Hsiao Chin Biography."

47 Paul Wood (ed.), *Varieties of Modernism* (New Haven: Yale University Press, 2004), 284. For more on Burri see Emily Braun

(ed.), *Alberto Burri: The Trauma of Painting* (New York: Guggenheim Museum, 2015).

48 Jaleh Mansoor, *Marshall Plan Modernism: Italian Postwar Abstraction and the Beginnings of Autonomia* (Raleigh-Durham, NC: Duke University Press, 2016), 28.

49 Jessica Vahrenkamp, "Interview: Hsiao Chin."

50 Ibid.

51 An-yi Pan, "Modern Taiwan Ink Art: Postwar Internationalism" Conference Proceedings: Postwar Abstraction in Japan, South Korea, And Taiwan, *M+ Matters* (June 2014). Accessible online at https://www.mplusmatters.hk/postwar/paper_topic3.php?l=en (Last accessed 05/04/2020).

52 Armin Medosch, *New Tendencies: Art at the Threshold of the Information Revolution (1961–1978)* (Cambridge, MA: MIT Press, 2016), 44.

53 This analysis was inspired by art historian T.J. Clark's analysis of modernism in light of Weber's idea. See *Farewell to an Idea* (New Haven, CT: Yale University Press, 2001), 7.

54 Sicard, "Hsiao Chin Biography."

55 Joseph A. Martellaro, "United States-Taiwan Trade Relations and the Trade Deficit," *Business Economics* 22.3 (July 1987), 28–33.

Chapter 6

1 Theodor W. Adorno, *Quasi Una Fantasia*, trans. Rodney Livingstone (London: Verso, 1998), 43.

2 Staff, "Defying the Online Censors with Jokes about Chinese Smog," *BBC What's Trending* (12/12/ 2015). Accessible online at https://www.bbc.com/news/blogs-trending-35044681 (Last accessed 1/1/3/20).

3 Alvin Lum and Sum Lok-kei "'Record 3,000' Hong Kong Lawyers in Silent March Against Controversial Extradition Bill," *South China Morning Post* (6/5/2019). https://www.scmp.com/news/hong-kong/politics/article/3013461/thousands-hong-kong-lawyers-launch-silent-march-against (Last accessed 1/13/20). Staff, "Hong Kong

Hospital Workers Protest Against Police Violence," *Channel News Asia* (8/13/2019) https://www.channelnewsasia.com/news/asia/hong-kong-hospital-workers-protest-against-police-government-11805870 (Last accessed 1/1/3/20).

4 Samson Young, "Private notes public (presto from the top)." Undated statement published on artist's website https://www.thismusicisfalse.com/text (Last accessed 2/28/22).

5 For an excellent history of Macau during the Ming period, see Christina Miu Bing Cheng, *Macau: A Cultural Janus* (Hong Kong: Hong Kong University Press, 1999), especially 9–47.

6 Charles Horner, *Rising China and Its Postmodern Fate: Memories of Empire in a New Global Context* (Athens, GA: University of Georgia Press, 2009), 60–5.

7 For more see Mio Kishimoto-Nakayama, "The Kangxi Depression and Early Qing Local Markets," *Modern China* 10.2 (April, 1984), 227–56.

8 Eric Tagliacozzo, Helen F. Siu, and Peter C. Perdue, *Asia Inside Out: Connected Places* (Cambridge, MA: Harvard University Press, 2015), 79–84. NB, the 10 percent is extrapolated from a frequently cited study of the representative area around Hong Kong. See James Hayes, "The Hong Kong Region: Its Place in Traditional Chinese Historiography and Principal Events since the Establishment of Hsin-an County in 1573," *Journal of the Royal Asiatic Society Hong Kong Branch* 14 (1974), 108–35.

9 Christopher M.S. Johns, *China and the Church: Chinoiserie in Global Context* (Oakland, CA: University of California Press, 2016), 35.

10 For an in-depth look at East/West diplomatic negotiations in the period, see John M. Carroll, "The Canton System: Conflict And Accommodation In The Contact Zone," *Journal of the Royal Asiatic Society* 50 (2010), 51–66.

11 The Treaty of Nanking, which ended the First Opium War, encompassed an indemnity due to the British crown, the ceding of the territory of Hong Kong, and the opening of additional treaty ports. For more, see Julia Lovell Abrams, *The Opium War: Drugs, Dreams, and the Making of Modern China* (New York: Abrams, 2015).

12　Ibid., 25–30.
13　Stephen Chiu and Tai-Lok Lui, *Hong Kong: Becoming a Chinese Global City* (New York: Routledge, 2009), 55–65.
14　For an in-depth look at this period, see Philip Snow, *The Fall of Hong Kong: Britain, China, and the Japanese Occupation* (New Haven, CT: Yale University Press, 2004).
15　See N.J. Miners, "Plans for Constitutional Reform in Hong Kong, 1946–52," *The China Quarterly* 107 (September, 1986), 463–82.
16　Y.C. Jao, "The Rise of Hong Kong as a Financial Center," *Asian Survey* 19.7 (July, 1979), 678–85. See also Catherine R. Schenk, "The Origins of Anti-Competitive Regulation: Was Hong Kong 'Over-Banked' in the 1960s?" *Hong Kong Institute For Monetary Research Working Papers* 9 (July 2006), 1–5.
17　Staff, "Hong Kong GDP 1960–2020" Macro Trends Research. Accessible online at https://www.macrotrends.net/countries/HKG/hong-kong/gdp-gross-domestic-product (Last accessed 1/14/2020).
18　For more, see Daniel Chua, *Absolute Music and the Construction of Meaning* (Cambridge: Cambridge University Press, 1999).
19　Quoted in Bennett Zon, *Evolution and Victorian Musical Culture* (Cambridge: Cambridge University Press, 2017), 304.
20　Samson Young, "Lest I forget who I am to_." Undated statement published on artist's website https://www.thismusicisfalse.com/text (last accessed 3/4/2022).
21　See for example the discussion of La Monte Young's ostensible Orientalism in Branden Wayne Joseph, *Beyond the Dream Syndicate: Tony Conrad and the Arts After Cage (A "Minor" History)* (New York: Zone Books, 2008), 200–3.
22　"Joint Declaration of the Government of the United Kingdom of Great Britain and Northern Ireland and the Government of the People's Republic of China on the Question of Hong Kong." Full text accessible on the Hong Kong government website: https://www.cmab.gov.hk/en/issues/jd2.htm (Last accessed 1/15/20).
23　Ibid.

24 Fredric Jameson, *Postmodernism, Or, The Cultural Logic of Late Capitalism* (Durham, NC: Duke University Press, 1991), 170. Francis Fukuyama, *The End of History and the Last Man* (New York: Simon and Schuster, 1992).

25 Li Xianting, "New Perspectives of Contemporary Chinese Art After Political Pop." Accessible in digital reproduction through the Asia Art Society Archive: https://aaa.org.hk/en/collections/search/archive/li-xianting-archive-writings-by-li-xianting/object/new-perspectives-of-contemporary-chinese-art-after-political-pop (Last accessed 3/04/22).

26 Samson Young, "3 cases of echoic mimicry: (Or, 3 attempts at hearing outside of my own fucking head)" (2019). Published on artist's website www.thismusicisfalse.com (Last accessed 3/4/2022). Importantly, Young's follow up *Muted Situations* work enacted a similar silence—this time of a union hall—whispering or silently lip synching the lyrics to the mass pop tune Michael Jackson and Lionel Richie's iconic "We Are the World" (1985). The workers' new ideology figured as global pan-Americanism.

27 Karl Kambra, *Two Original Chinese Songs: Moo Lee Chwa and Higho Highau for the pianoforte or harpsichord* (London: Printed for the Author, 1796), 1.

28 Samson Young, "When I close my eyes, everything is so damn pretty (Can't do the thing you want)" https://www.thismusicisfalse.com/text (Last accessed 1/15/20).

29 Ibid.

30 Jameson, *Postmodernism*, 18.

31 Quotations are from a viral video of Hu that has been circulating since the millennium. See Bethany Allen-Ebrahimian, "The Rant About Hong Kong That's Still Viral—14 Years Later," *Foreign Policy*, October 28, 2014. https://foreignpolicy.com/2014/10/28/the-rant-about-hong-kong-thats-still-viral-14-years-later/ (Last accessed 1/1/5/2020). Tung Chee Hwa has recently returned to the headlines, suggesting that the US was secretly fomenting the rebellion in Hong Kong.

32 "Phonography: Samson Young's Sonic Art," *Songs for Disaster Relief: A Mixtape*, a publication accompanying the exhibition "Samson

Young: Songs for Disaster Relief," Hong Kong in Venice, May–November 2017. Accessible on Christopher Cox' faculty website: http://faculty.hampshire.edu/ccox/writing.html (last accessed 3/04/2022). Young's best-known engagement with the physical border is probably his 2016 work *Canon*, presented at Art Basel Hong Kong. The work included a long-range acoustic device (or LRAD), a nonlethal sonic weapon used for crowd dispersal. The piece connects both with the 1979 Vietnamese refugee crisis in Hong Kong as well as the European tradition of impossible musical instruments. For more, see Seth Kim-Cohen, "The Sound Canon of Samson Young," available on SKC personal website https://kim-cohen.com/ (last accessed 3/04/2022).

33 Lucas Niewenhuis, "Hongkongers Write Their Own Anthem, 'Glory To Hong Kong," *SUP China* (September 12, 2019) https://supchina.com/2019/09/12/hongkongers-write-their-own-anthem-glory-to-hong-kong/ (Last accessed 5/02/2020).

34 https://www.washingtonpost.com/world/2022/03/02/hong-kong-china-pandemic-beijing/

Chapter 7

1 See for example: Jonathan I. Israel, *Radical Enlightenment: Philosophy and the Making of Modernity 1650–1750* (Oxford: Oxford University Press, 2002), xl; Galen Strawson, *Locke on Personal Identity: Consciousness and Concernment* (Princeton, NJ: Princeton University Press, 2014), 104; Olga Poznjakova, "Kant's Concept of Enlightenment: Individual and Universal Dimensions," in *Thinking about the Enlightenment: Modernity and its Ramifications*, ed. Martin L. Davies (New York: Routledge, 2016), 39; Arthur Schopenhauer, "*The World as Will and Representation*": Volume 1, ed. Christopher Janaway (Cambridge: Cambridge University Press, 2010), 318; Claude Lévi-Strauss, *Structural Anthropology*, trans. Claire Jacobson and Brooke Grundfest Schoef (New York: Basic Books, 2008), 56.

2 See primarily Jürgen Habermas, *The Structural Transformation of the Public Sphere*, trans. Thomas Burger (New York: John Wiley, 2015), 266 and Michel Foucault, *Discipline and Punish*, trans. Alan Sheridan (New York: Vintage Books/Random House, 1995), 218.
3 See for example Habermas, *Structural Transformation*, 104.
4 Samuel Fleischacker, "Adam Smith's Reception Among the American Founders, 1776–1790," *The William and Mary Quarterly* 59.4 (October, 2002), 897–924; John Dewey, *Individualism Old and New* (New York: Capricorn Books, 1930); Milton Friedman, *Capitalism and Freedom* (Chicago: University of Chicago Press, 1962).
5 David Harvey, "Freedom's Just Another Word," in his *A Brief History of Neoliberalism* (Oxford: Oxford University Press, 2007), 5–38.
6 Habermas, *Structural Transformation*, xvii. This section is indebted to William T. Rowe, "The Public Sphere in Modern China," *Modern China* 16.3 (July, 1990), 309–29.
7 Rowe, "Public Sphere," 316.
8 Alexander V. Avakov (ed.), *Two Thousand Years of Economic Statistics, Years 1–2012: Population, GDP at PPP, and GDP Per* (New York: Algora Publishing, 2015), 9.
9 Rowe, "Public Sphere," 317.
10 Quoted in Walter Wallbank and Alastair M. Taylor (eds.), *Civilization: Past and Present* (Glenview, IL: Scott, Foresman, & Company, 1960), 285.
11 For more see, Zhengyuan Fu, *Autocratic Tradition and Chinese Politics* (Cambridge: Cambridge University Press, 1993), 90.
12 Ronald C. Po, *The Blue Frontier: Maritime Vision and Power in the Qing Empire* (Cambridge: Cambridge University Press, 2018), 103–4.
13 Jack Weatherford, *The History of Money* (New York: Crown Publishing Group/Penguin Random House, 2009), 64–71.
14 Ibid., 80–95.
15 For more, see David Summers, *Real Spaces* (London: Phaidon Press, 2003), 489–575.
16 For an excellent introduction to this territory, see John Micklethwait and Adrian Wooldridge, *The Company: A Short History Of A*

Revolutionary Idea (New York: Random House/A Modern Library, 2005), 55–78, 159–92.

17 Haijian Mao, *The Qing Empire and the Opium War* (Cambridge: Cambridge University Press, 2016), 271–304.

18 David Riazanov, "Karl Marx on China," *Labour Monthly* (February, 1926). Reprinted online at Marxist Internet Archive.

19 T.J. Clarke, *Farewell to an Idea* (New Haven: Yale University Press, 1999), 7.

20 Suisheng Zhao, *China and Democracy: The Prospect for a Democratic China* (New York: Psychology Press, 2000), 77–82.

21 Kevin Peraino, *A Force So Swift: Mao, Truman, and the Birth of Modern China, 1949* (New York: Crown/Archetype, 2017), 265.

22 For more see Patricia Thornton, "Retrofitting the Steel Frame: From Mobilizing the Masses to Surveying the Public," in *Mao's Invisible Hand: The Political Foundations of Adaptive Governance in China*, ed. Sebastian Heilmann and Elizabeth J. Perry (Cambridge, MA: Harvard University Asia Center, 2011), 237–68.

23 For an excellent, short introduction to themes of individualism in the work of New York School painters against the backdrop of the Cold War, see Fred Orton, "Action, Revolution and Painting," *Oxford Art Journal* 14.2 (1991), 3–17.

24 Clark, *Farewell to an Idea*, 9.

25 Frank Dikötter, *The Cultural Revolution: A People's History, 1962–1976* (New York: Bloomsbury Publishing USA, 2017), 299.

26 Karen Smith, *Nine Lives: The Birth of Avant-garde Art in New China* (Beijing/New York: Timezone8/DAP, 2008), 259.

27 For more on the key exhibitions that shaped the emergence of contemporary Chinese art, see Gao Minglu, *Total Modernity and the Avant-Garde in Twentieth-Century Chinese Art* (Cambridge, MA: MIT Press, 2011), 261–80.

28 Bo Zheng, "The Pursuit of Publicness: A Study of Four Chinese Contemporary Art Projects" (PhD Dissertation, University of Rochester, 2012), 22.

29 For a comprehensive analysis of this theme in post-Marxian politics and culture see Marshall Berman, *All that is Solid Melts Into Air: The Experience of Modernity* (New York: Verso, 1983).
30 For an excellent primer on this topic, see *#Accelerate: The Accelerationist Reader* (Cambridge, MA: MIT Press, 2019).
31 This phrase, often used by critics as a euphemism for the horrors of the Cultural Revolution, extends from Mao's own political thought deep into the ideas of Marx and Engels. Building on latter pair's notion of a "permanent revolution"—an epistemic shift to a socialist world order— Mao insisted that old political and cultural habits had to be continually, actively suppressed. For more see Stuart R. Schram, "Mao Tse-tung and the Theory of the Permanent Revolution, 1958–69," *The China Quarterly* 46 (April–June, 1971), pp. 221–44.
32 Steven Shaviro, "Introduction," *No Speed Limit: Three Essays on Accelerationism* (Minneapolis: University of Minnesota Press, 2019) (online publication).
33 Satoshi Nakamoto, "Bitcoin: A Peer-to-Peer Electronic Cash System." Accessible online at https://bitcoin.org/bitcoin.pdf (Last accessed 3/02/22).
34 For an accessible introduction see Jerry Brito and Andrea Castillo, *Bitcoin: A Primer for Policymakers* (Arlington, VA: Mercatus Center, 2013), especially pages 3–15. Accessible online at https://www.mercatus.org/system/files/Brito_BitcoinPrimer.pdf (Last accessed 3/2/22).
35 https://www.thebalance.com/how-much-power-does-the-bitcoin-network-use-391280
36 Aviva Sonenreich, "NFTs and the Future Of Commercial Real Estate," *Forbes* (February 16, 2022). Accessible online at https://www.forbes.com/sites/forbesbusinesscouncil/2022/02/16/nfts-and-the-future-of-commercial-real-estate/ (Last accessed 03/02/22).
37 James Vincent, "Bitcoin Consumes More Energy than Switzerland…," *The Verge* (July 4, 2019). https://www.theverge.com/2019/7/4/20682109/bitcoin-energy-consumption-annual-calculation-cambridge-index-cbeci-country-comparison (Last accessed 3/02/22). Importantly, the enormous power input of proof of work solutions is being improved by new models such as Proof of

Stake, which promises to reduce power consumption by as much as 99 percent. The Ethereum Blockchain, which drives most of the real world smart contract use cases, plans to switch to POS in mid-2022. Additionally, even more low-energy cost solutions such as Proof of History are emerging from smaller blockchains such as Solana. Finally, numerous prominent cryptocurrency advocates have made the case that the very energy intensity of Bitcoin mining can be leveraged to drive the adoption of renewable power sources. See for example Ark Invest, "Big Ideas 2022" particularly pages 53–60. Available for download from https://ark-invest.com/big-ideas-2022/ (Last accessed 3/02/22).

38 Staff, "A Deep Dive in a Real-World Bitcoin Mine," *Digiconomist* (October 25, 2017). https://digiconomist.net/deep-dive-real-world-bitcoin-mine. For excellent ongoing coverage of the cryptocurrency world in China see Shuyao Kong's *Decrypt* blog Da Bing (https://decrypt.co/).

39 Staff, "China's Plan to Sideline Bitcoin," *Bloomberg* (December 13, 2018). https://www.bloomberg.com/news/articles/2018-12-13/china-s-plan-to-sideline-bitcoin

40 Lorand Laskai and Graham Webster, "Translation: Chinese Researchers Take On Blockchain Security," New America Blog (October 2018) https://www.newamerica.org/cybersecurity-initiative/digichina/blog/chinese-researchers-take-blockchain-security-translation/ (Last accessed 3/02/22) https://forkast.news/headlines/china-blockchain-patent-applications-us-south-korea/

41 https://fortune.com/2022/01/04/crypto-banned-china-other-countries https://cryptoslate.com/china-still-accounts-for-10-of-bitcoin-transactions/

42 Leigh Cuen, "How Texas is becoming a Bitcoin Mining Hub," Tech Crunch (February 11, 2022) https://techcrunch.com/2022/02/11/how-texas-is-becoming-a-bitcoin-mining-hub/ (Last accessed 3/2/22). John Ruwith and Emily Fang, "How the U.S. Benefits when China Turns Its Back on Bitcoin," NPR Morning Edition (February 24, 2022) https://www.npr.org/2022/02/24/1081252187/bitcoin-cryptocurrency-china-us (Last accessed 3/2/22).

Further Reading

Kerry Brown, *The Trouble with Taiwan: History, the United States and a Rising China* (Bloomsbury, 2023).
Martin Chorzempa, *The Cashless Revolution: China's Reinvention of Money* (Public Affairs, 2022).
Paul Clark, *The Chinese Cultural Revolution: A History* (Cambridge, 2008).
John Fairbank, *A New China* (HUP, 2006).
Jacopo Galimberti (ed.), *Art, Global Maoism and the Chinese Cultural Revolution* (Manchester University Press, 2020).
Hou Hanru, *One Hand Clapping* (Guggenheim, 2018).
Jiang Jiehong, *The Art of Contemporary China* (Thames and Hudson, 2021).
David Joselit, *Cai Guo-Qiang: I Want to Believe* (Guggenheim, 2008).
Henry Kissinger, *On China* (Penguin, 2012).
Kai Fu Lee, *AI Superpowers: China, Silicon Valley, and the New World Order* (Harper's Business, 2018).
Louisa Lim, *Indelible City: Dispossession and Defiance in Hong Kong* (Riverhead, 2022).
James Millward, *Eurasian Crossroads: A History of Xinjiang* (Columbia University, 2021).
Alexandra Munroe, *Art and China after 1989: Theater of the World* (Guggenheim, 2017).
Kevin O'Brien, *Popular Protest in China* (Harvard University Press, 2008).
Daniel Kurtz-Phelan, *The China Mission: George Marshall's Unfinished War* (Norton, 2018).
Michael Pillsbury, *The Hundred-Year Marathon: China's Secret Strategy to Replace America as the Global Superpower* (Henry Holt, 2015).
Barbara Pollack, *Brand New Art From China* (IB Tauris, 2018).
Stephen Roach, *Accidental Conflict: America, China, and the Clash of False Narratives* (Yale, 2022).
Jeremy L. Wallace, *Seeking Truth and Hiding Facts: Information, Ideology, and Authoritarianism in China* (Oxford, 2022).

Winnie Wong, *Van Gogh on Demand: China and the Readymade* (University of Chicago, 2014).

Kejia Wu, *A Modern History of China's Art Market* (Routledge, 2023).

Hentyle Yapp, *Minor China: Method, Materialisms, and the Aesthetic* (Duke University, 2021).

Ping Yao, *Women, Gender, and Sexuality in China: A Brief History* (Routledge, 2021).

Esther Yau, *At Full Speed: Hong Kong Cinema in a Borderless World* (University of Minnesota, 2001).

Index

"One Country, Two Systems" 151, 154, 157, 166

Abbasid Caliphate 106–7, 112
Achille Bonito Oliva 29–30, 202
Andy Warhol Viii, 5, 8, 10–11, 14, 22, 33, 49, 183, 198

Biographies of Exemplary Women 67–8

Cai Guo Qiang Viii, 1, 31–3, 202, 231
Chiang Kai Shek 78, 127, 138–40, 144–5, 149, 160–1, 185
COVID-19 2, 58–59, 174, 188
cryptocurrency 177, 182, 191–4
Cui Xiuwen 63–6, 84–93
Cultural Revolution 11, 15, 19, 21, 43, 45, 80–2, 115
cynical realism 11, 29, 36, 55, 203

David Teng Olsen 4, 6, 176
Deng Xiaoping 2, 6, 20, 21–2, 26, 28, 31, 37, 44–5, 81–2, 114, 165–6, 170–200
Dutch Formosa (Taiwan) 125–30, 134, 140
Dzungar massacre 110–11

facial recognition 49–53, 188, 206
floating migrants 42, 52
foot binding 63, 71–4, 209
Franz Kline 96, 145

Golden Lotus 73

haijin policies 156, 161, 194
He-Yin Zhen 76–80, 210, 211
Hong Kong Special Administrative Region 151, 165

Hongwu Emperor 72, 182
Hsiao Chin 4, 12, 50, 139–45, 218, 220
Hu Jieming viii, 4, 34–38, 48–60, 205–6
Huá-Yí distinction 104, 109–111, 119
Huang Rui Viii, 23–4
hukou system 42–3, 52, 204

Jackson Pollock 96, 125–6, 137, 142, 163
Jiang Qing 45, 70, 85
joint ventures 9, 13–14, 18, 21, 29
Jürgen Habermas 179–81, 184

Kangxi Emperor 131, 156–57
Karl Marx 76–7, 184, 187
King Mu of Zhou 100–1
Kingdom of Qocho. 106–13
Koxinga 130–3, 140

Leonard (Tsuguharu) Fujita 127, 135–7, 141, 144
Li Xianting 12, 21, 25, 29, 36, 166, 197, 200–7, 225
Li Zhongsheng 127, 136
Lin Zexu 17, 112
Liu Xiang 67–8
Lord Shang 39–41, 44, 67, 203

Mao Tse Tung vii, 2–11, 18, 20, 37, 41, 44–52, 63–70, 78–84, 115–9, 125–6, 149, 161, 165, 185–6, 196, 199, 201, 202
Mark Young 160–1
Middle Kingdom 5, 12, 15–18, 20, 26, 39, 68, 70, 73, 97, 109, 131, 140, 155, 160, 168, 194
Molihua 168–73

New Marriage Law 79–80, 211

One Child Policy 83–5
Opium War 17, 23, 47, 74, 83, 112, 161, 157

Paiwanese aboriginals 133–8
Peng Zheng 46–7
Political Pop 1, 10, 11, 21

Qianlong Emperor 16, 110, 120, 168, 199
Qin Feng 94–6, 116–13
Qiu Jin 75–6, 209, 213
Quanrong 99, 100, 101, 104

Ran Min 104, 110, 120
Rupert Murdoch 53–4

Samson Young 151–2, 163–72
Self Strengthening Movement 4, 74–6
Shanzhai 5, 13–14, 33, 85, 197, 201
Silk Road 15, 101–11, 123
Sino-Soviet relations 10, 21, 41–2, 113–5, 135, 142, 171
social realism 21–2, 142, 200
"Socialism with Chinese Characteristics" 11, 45, 165

Strike Hard campaign 117
Sun Yat Sen 77–8, 137, 140, 160, 185

Television 2, 32–8, 41–7, 53–60, 166, 204–6
Tiananmen Square 10, 12, 22, 27, 28–9, 33–8, 47, 55, 89, 117, 166, 201, 202
Ton Fan Group 141–7

Urbanization 35–8, 42–6, 53–60, 80–3, 153, 204–8, 218

Wang An Shi 39, 181
Wei Zifu 67–8
Wu Zetian (Empress Wu) 70–1, 85, 209

Xiongnu 102–4, 111, 120

Yongli Emperor 73
Yu Youhan Viii, 5, 8–10, 13, 33, 186

Zhang Qian 102–3
Zhou Enlai 15, 22, 28
Zhu Xi 71–2
Zuo Zongtang (General Tso) 113